A Treasury
of
Anglican Art

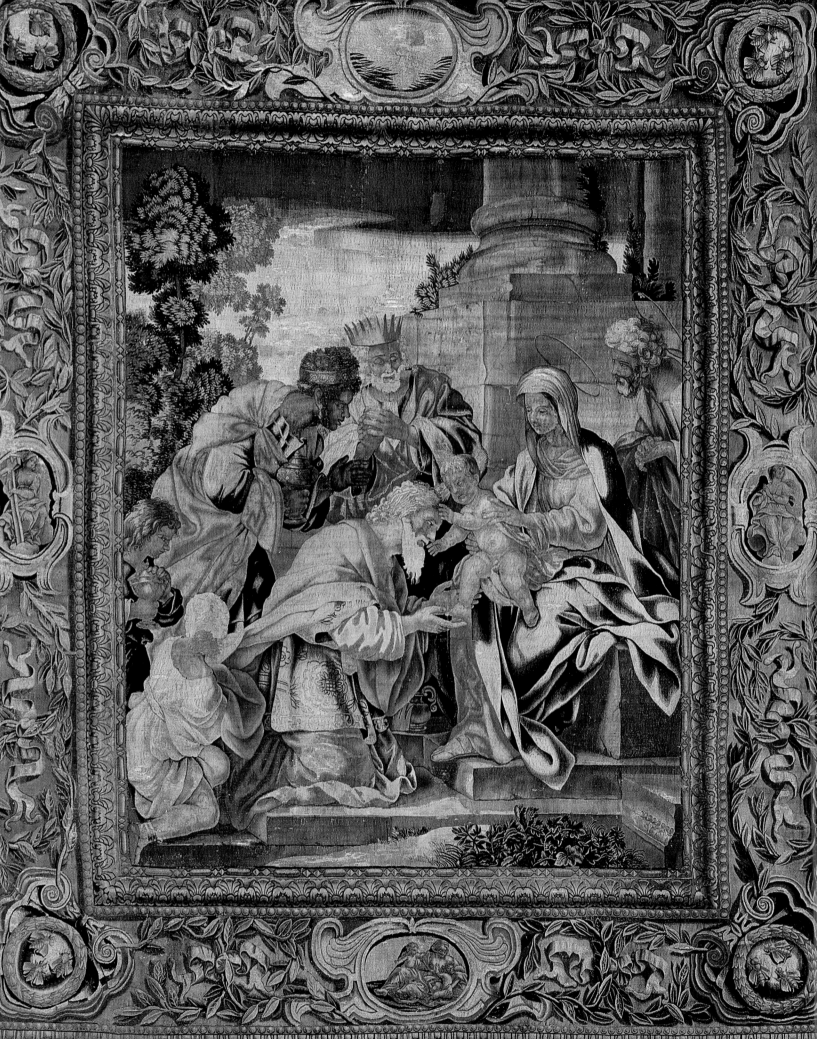

A Treasury
of
Anglican Art

James B. Simpson
and
George H. Eatman

RIZZOLI
NEW YORK



DEDICATION

In doing research for his acclaimed book
on twentieth-century quotations, the late Father
James B. Simpson noted the distinct lack of a volume
documenting the wealth of artwork in the Anglican communion.
Considering this void unacceptable, he started a project to remedy this
condition, the result of which is now before you. His untimely and unex-
pected death in February, 2002 means that he will not share with us the joy of its
publication. I shall miss his friendship and counsel.

Additionally, I thank the following individuals who contributed moral and financial help:

Fr. Edward Storey
Fr. Andrew Sloane
Fr. John Andrew
Fr. Lane Davenport
Fr. James Rosenthal
Fr. George Brandt
Allan Gurganus
Frank S. Wilkinson
The Rt. Rev. James Montgomery
Elizabeth Field
Helen Saxby
Fr. Thomas Paul Miller
Fr. Vickery House
Fr. F. Howard Meisel
Keith Noreika

Jonathan Bryant
Eliza Wolff
Kinlock Bull
William Craig
Joseph Coreth
Elizabeth Baruch
Erleen Skinner
Patrick Sears
Phyllis Cobb
William Carwithen
Lawrence Plumbee
Fr. John David Van Dooren
Charles Graham
Paul McKee

—George H. Eatman

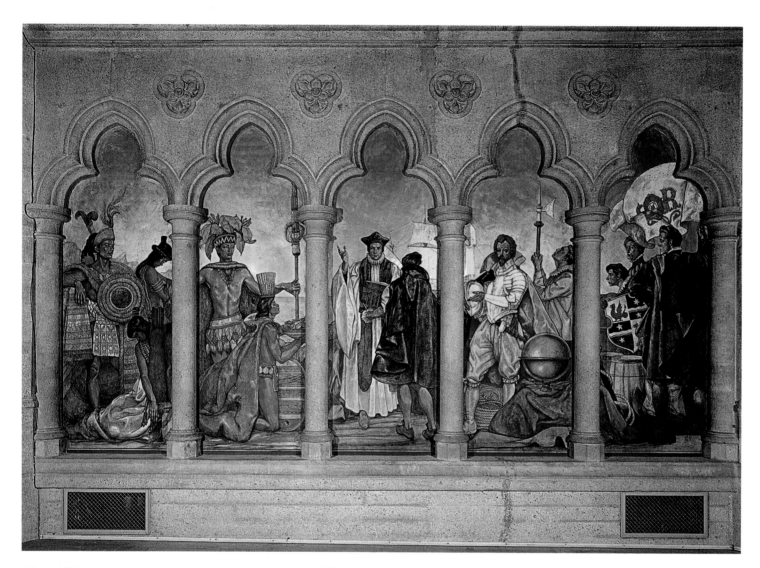

Nova Albion *(New Britain) commemorates the first Anglican service on North American soil, 24 June 1579, celebrated by the priest and crew of Sir Francis Drake's ship, the* Golden Hind. *Painted by John H. DeRosen in 1949, it is the second in a series of murals in the nave of Grace Cathedral, San Francisco.*

OPPOSITE *The processional cross of the Primate of All England, the official title accorded the Archbishop of Canterbury, was given by clergy of the Province of Canterbury in the late nineteenth century; it has been carried in the processions of the nine men who have occupied the ancient office since that time. Designated in the 1970s as a national treasure, it may no longer be taken out of the country.*

CONTENTS

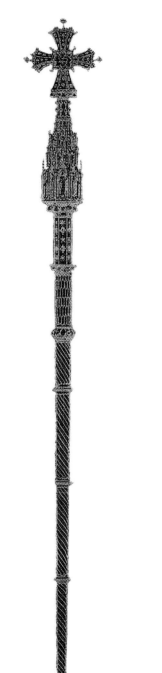

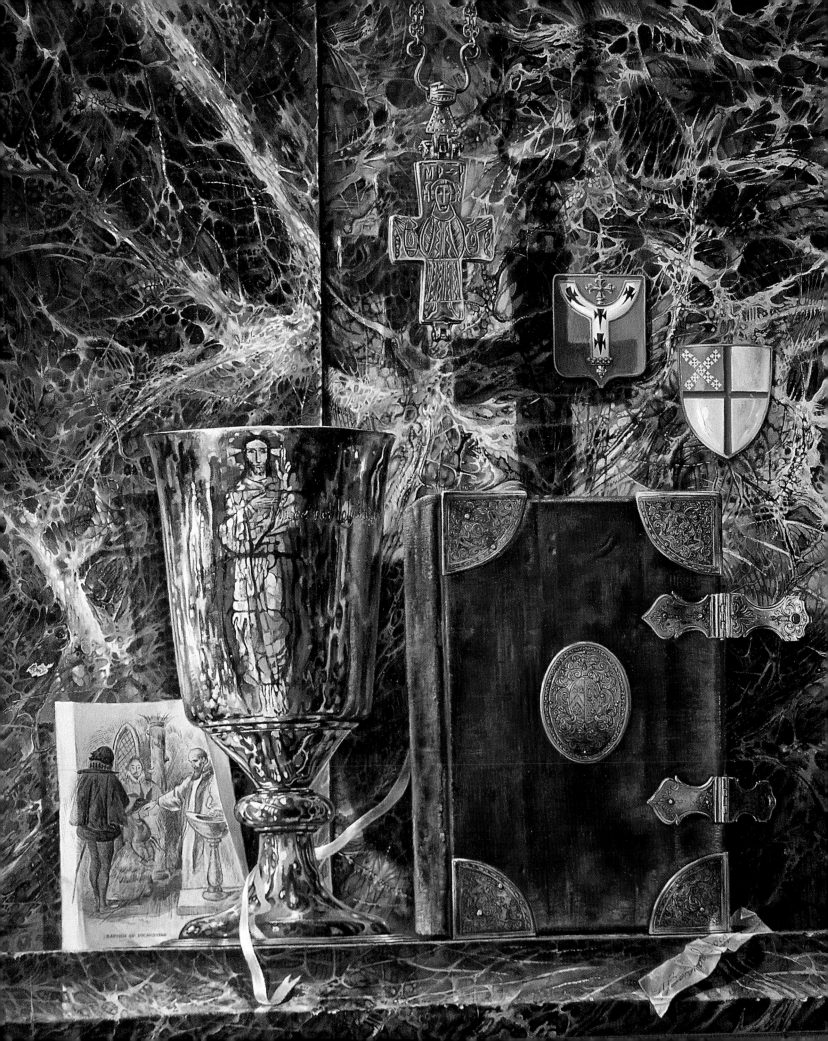

FOREWORD

The Archbishop of Canterbury's primatial shield displays a pallium, *a* **Y***–shaped length of lamb's wool bestowed on holders of the office up to the time of the break with Rome. The* pallium *is marked with crosses with dagger ends that fasten it to vestments in remembrance of Christ's Crucifixion. Such bands are still worn by today's pope, cardinals, and certain archbishops.*

OPPOSITE *The* Episcopalians, *painted by Aaron Bohrod in 1955 for a* Look *magazine series on religious faiths in America, is rich in symbolism. Left to right: the baptism of Pocohontas, stained glass reflected in a Queen Anne chalice, a pectoral cross worn by bishops, the* Book of Common Prayer, *and the shields of the Archbishop of Canterbury and the Episcopal Church. The painting is in the private collection of William F. Koch of Delray Beach, Florida.*

"James B." as some of us came to know him, died days only before I was asked to write this brief introduction. He came into the life of Archbishop Michael Ramsey of Canterbury in the year of Michael's enthronement as the 100th archbishop, in 1961. It so happened that I was then chaplain, and James B. and I came to see a lot of one another as he prepared the popular biography of the saintly giant who gave him that soubriquet. There was a moment of horror for me when a remark in it which could have come only from me and one other person was attributed wrongly and mistakenly to me by an outraged primate: a gross indiscretion. I discovered after an uncomfortable wait until I could reach James B. in the United States that it was indeed the other man, stratospherically senior to me, who had confided the indiscretion. Better late than never…

But this black period never dimmed or diminished the friendship which lasted over forty years. I watched his preparation for priesthood at Nashotah House Seminary, of which a decade later upon my coming to St. Thomas Church on Fifth Avenue in New York, I became a trustee, and James B. added that vocation to his incisive skills as reporter and writer. He possessed an energy of purpose and a direction that marked him out as an unusually rounded priest. His later books are lined up on my shelves with the two he wrote in my employer's time at Lambeth; the second at the time of the 1968 Lambeth Conference of Bishops. His powers of observation were sharp, and at times sharply expressed. I was on one occasion at least the victim. But this remarkable gift of cognition stood him in good stead when he realized that a book on Anglican art could make a real difference. He enlisted the help of a highly intelligent friend and no mean connoisseur (and a friend of mine, too), George Eatman. Together they carefully chose and wrote the subjects of their admiration and educated taste into this anthology of objects of beauty.

George combines his experience of a life spent between Italy and England and America and the great European cities with a life-enhancing enthusiasm for looking at things and savoring their quality. It has been a most effective partnership and sharing of artistic experience and the ability to express what they both have seen in what they were looking at. Asked by George on James B.'s death to write this brief introduction, as a Brit who is really a New Yorker, I am not honored so much as deeply moved by the friendship and trust the request contained. The privilege and pleasure are all mine in commending this work to you.

J.A.
The Reverend Canon John Andrew
New York

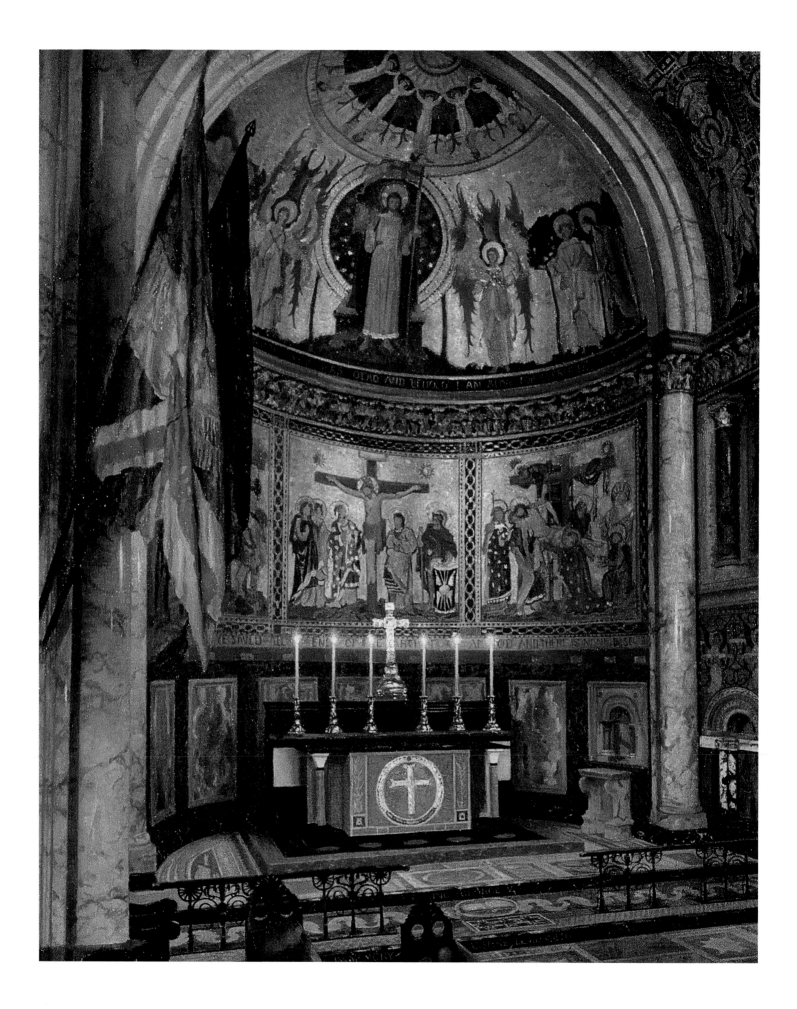

PREFACE

James B. Simpson

Bread and wine, consecrated as the body and blood of Christ, reside beyond a tabernacle door of metal designed by Richard Greening in 1980. Originally placed in the chapel of the Anglican Benedictines at Nashdom Abbey, Buckinghamshire, England, the monks took it with them in their move to Elmore Abbey at Newbury in the Berkshires.

OPPOSITE *The apse of the Guards' Chapel, Birdcage Walk, London SW 1, was erected in 1879, with mosaics completed sixty years later by Leonard Campbell Taylor. They withstood a World War II firebomb that destroyed the nave and killed 126 persons in the congregation. The tall candles in a baroque set of six, a centennial gift from King George VI, remained lighted throughout the raid. The area was incorporated in a starkly modern chapel completed in 1963.*

Producing this book has been a great, volunteer adventure in noble edifices with aspects of a detective story. It is a book on art, not religion, although we cannot help but hope that many who read it, or who are prompted to explore the treasures it describes, may arrive as tourists and leave with new respect for art accomplished to the glory of God. Artistic merit and historical interest have been our first priorities but, in almost all cases, we have also chosen art that may be inspiring or comforting to those we reach.

In drawing to a close, I know that when I fall asleep late tonight, a good portion of the treasures in this book will, like my bedroom, be shrouded in darkness. In other time zones, Anglicanism's treasures will be flooded with the light of a new day. My prayer tonight and every night is that these treasures may continue in their unspoken mission, across the centuries, of touching many lives for good.

It is our privilege and pleasure to introduce you to *some* of the major accomplishments in Anglican art— *some* because, for every picture in this book, ten more could be added. It is just a smattering—but, at least to those who have worked with these pictures for a prolonged period, a glorious smattering! We could spend the rest of our lives happily assembling robust Anglican art. In other words, churches and cathedrals abound in more unique and arresting beauty than a single book could hope to include.

Our initial inspiration in color and creativeness is from II Chronicles 2:4-7: "Behold, I built an house to the name of the Lord my God, to dedicate it to Him....[and so] send me now therefore one cunning to work in gold, and in silver, and in brass, and in iron, and in purple, and crimson, and blue, and that can skill to grave..." When you think Anglican, think Episcopal. When you think Episcopal, think Anglican. They are synonymous. "Anglican" refers to English origin, "Episcopal" to bishops consecrated in succession to the apostles. The Anglican Communion is composed of 27 churches around the world in communion with the See of Canterbury who look to its archbishop as their symbolic head. "Outward for centuries, flowed the tide of British Empire; back, in hurried decades it ebbed," wrote Richard Ossling of *Time* magazine. "On every foreign strand that it touched, the receding tide has left a church uniquely English, yet catholic enough to survive in any climate. Empire is gone, the Church remains." In our quest for treasures, we have found that clergy and laity are often unaware of the treasures they hold: they frequently take them for granted, as little more than house furnishings or uninteresting antiques. Many treasures are uncared for, undocumented, unphotographed,

unevaluated, woefully uninsured, and lack informed spokesmen. Thankfully, that is not always the case. We were especially encouraged by cordial, outstanding archivists such as Michael D. Lampen of Grace Cathedral, San Francisco, and Percy Preston Jr., archivist of St Barthlomew's in New York City.

Whatever the case, we agree with Erwin Bossanyi, whose avant-garde windows are in both Canterbury and Washington, that "only works of art done by passionate, burning love bear the mark of validity in buildings of dignity."

A late Bishop of Coventry put it bluntly in remarking that "if we cannot express our Christian faith in terms of our time, we might as well pack up."

As for time itself, we are aware that the scholarship and theology behind Vatican II casts long shadows across our treasures—pressing some into larger service, relegating others to quiet obscurity. The most apparent are accommodation to free-standing altars with the celebrant facing the people and the removal of the Blessed Sacrament to side oratories and chapels. It is to the credit of ecclesiastical art that it bends to change.

We are grateful for the many people who coordinated pictures and information from all points of the compass. We ourselves have worked from diverse locales. I have been based since 1988 in Washington; my co-author, George H Eatman, was resident in Florence and London; our photographers have been at work in London and elsewhere; and our editor and graphic artist are in New York. These pages have come together only because of the generous financial support of those who love art and love the Church. We are grateful that gifts backing the project could be coordinated through the Rector's Discretionary Fund of Father Andrew L. Sloane of St Paul's, K Street, Washington. Our sincere thanks to a valued mentor, Alan F. Blanchard of the Church Pension Group; to John Woo, expert technical adviser; to Mary Bloom, a skilled and unusually tireless photographer; to James Rosenthal of *Anglican World*; to our agent, Rennie Hare; to Rizzoli International's senior editor, David Morton; and to a knowledgeable churchman and computer facilitator, John E. Overall, sacristan of the Church of the Ascension and St Agnes, the former pro-cathedral of the Episcopal Diocese of Washington.

The Archbishop of Canterbury, George Carey, the 103rd occupant of that ancient office, unknowingly offered us a useful standard of measurement in saying that "sacred spaces...are empty and useless unless they are true lenses through which we perceive something which makes sense of all we are doing elsewhere."

First and last, we have sought those "sacred spaces." But what of a "sense of all we are doing?" On a September morning in 2001, we set out from Union Station, Washington, for an editorial meeting in New York City; we carried two shopping bags bulging with precious transparencies, prints, and pages of this book. We got only as far as Newark when our train was evacuated because of the terrorism at the World Trade Center. We wondered if the possible loss of our fragile cargo would make any difference. What did it count for in the face of such unequaled violence and loss of life? Was it obscene to continue with so much else overshadowing the project? We have concluded that it has validity in the Biblical assurance (Hebrews 12:26-29) "that what cannot be shaken may remain." Aggression rises and wanes but God, in whose Name these treasures were raised and exist, cannot be shaken and He indeed continues to reign. Most of all we are thankful that the mutual pursuit of these treasures raises a strong bond with Him.

James B. Simpson+

Saint Paul's Cathedral, Melbourne, Australia, completed in 1891, makes extensive use of tiles and mosaics, including a portrait of its peripatetic patron, Paul, depicted traditionally with a sword. An angel holds an inscription of Christ's promise, Ego sum tecum, "Lo, I am with you always."

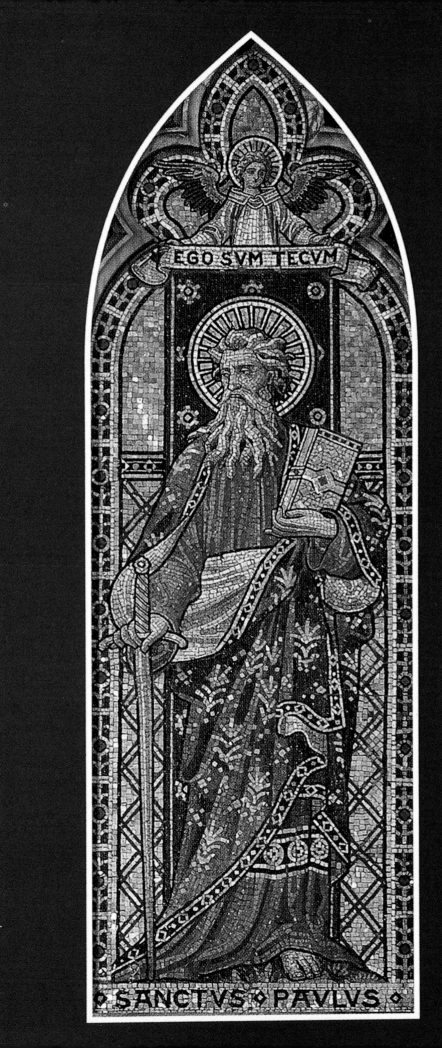

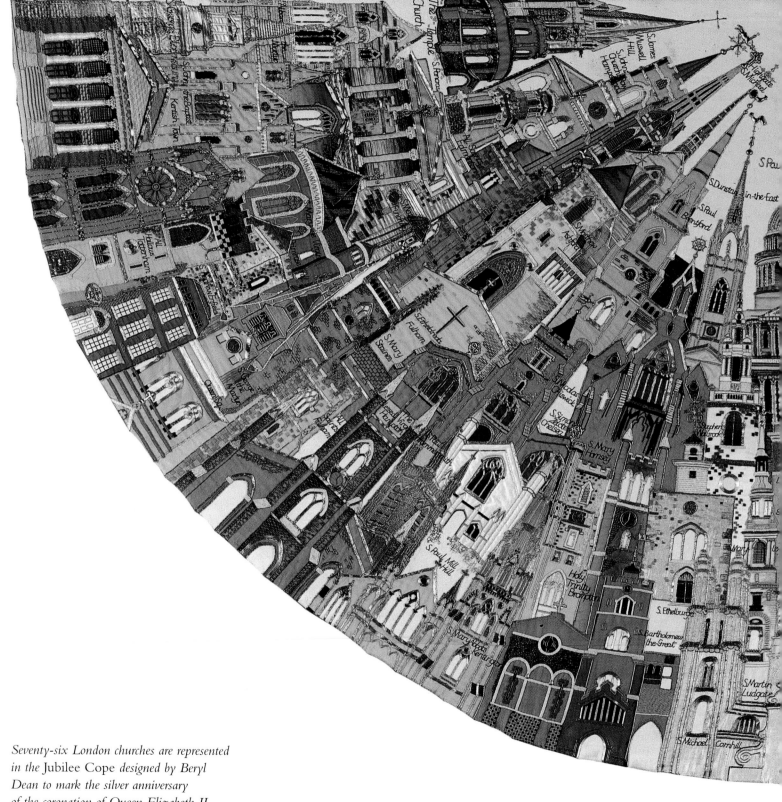

Seventy-six London churches are represented in the Jubilee Cope *designed by Beryl Dean to mark the silver anniversary of the coronation of Queen Elizabeth II. It is displayed in the crypt at Saint Paul's Cathedral, London EC 4.*

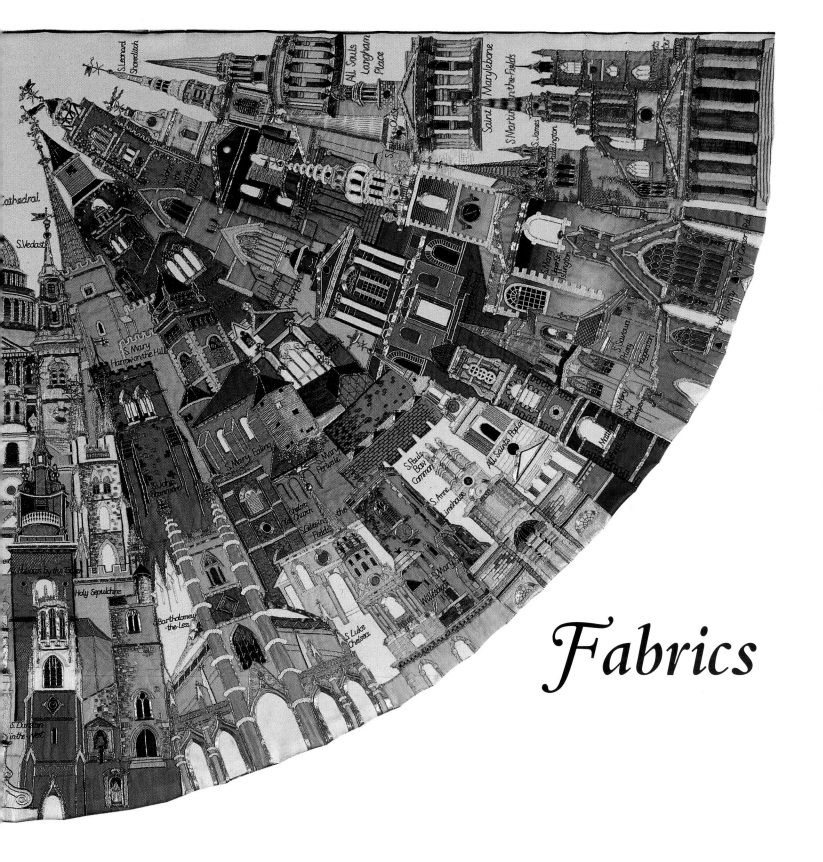

Fabrics

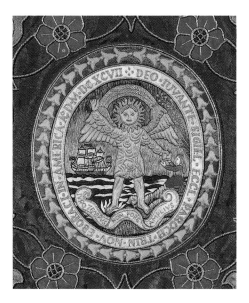

The official seal of New York's Trinity Church, Wall Street, authorized by charter of King William III in 1697, is based on Revelation 10:1–6, with an angel with one foot on land and the other on the sea.

OPPOSITE TOP Trinity, *John Piper's 1966 tapestry, the reredos of Chichester Cathedral's high altar, conveys its theme of the triune God with the Father's white light amid flames in an equilateral triangle, the tau cross of the Son, and a wing of the Holy Spirit; they are bordered with signs of the elements and emblems of the four Gospels.*

OPPOSITE BOTTOM *The reverse side, Ursula Benker-Schirmer's 1985 reredos, is on the site of the ancient shrine of Saint Richard of Chichester. Handwoven in Sussex and Bavaria, it is dedicated to Anglo-German reconciliation. A cross rises triumphantly from a chalice.*

*T*he Oxford Movement in 1833 marked the return of the beauty and reverence that had been all but lost in the Reformation, calling for full celebration of Holy Communion, the Mass, as the major service in Anglican and Episcopal churches, and stressing the altar as the focus of worship.

Slowly at first, not without objections from the Low Church wing, feast days and seasons of the liturgical year began to be appropriately observed and, with them, use of the traditional colors for eucharistic vestments in white or gold for feasts of Christ, red for martyrs, purple or black for Lent and mourning, and green for growth of the Church during the long Trinitytide season, now called Pentecost. These hues for altar frontals and super-frontals were also carried over to the newly resurrected use of hangings for pulpit and lectern.

Through it all, the Prayer Book rubric that stipulates that "at the Communion-time, the Holy Table shall have upon it a fair white linen cloth," has been universally honored. Equal care is given to altar linens—corporals, lavabo towels, and purificators for wiping the lip of the chalice after a person receives the Sacrament that has, for believers, the "real presence" of the Body and Blood of the Savior.

In an ante-room known as the sacristy, the celebrant, the principal minister of the Mass, says preparatory prayers while vesting in alb, stole, cincture, maniple, and chasuble patterned after the street dress of fourth-century Athens and Rome. He or she carries a veiled chalice topped with a matching burse, the cloth envelope holding the corporal, a white linen square that will be spread beneath the chalice.

Vestments and related textiles may be plainly colored or bear unusual medleys of subdued reds, dull greens, deep purples, and mysterious blues with coordinated trimmings and symbols. Heavy cloth-of-gold lined with stiff, poppy-colored material, would likely be reserved for Christmas midnight and Easter; a memorable set for greater festivals of Our Lady could be silver *peau d'ange* with a lining of palest hyacinth blue.

All in all, *Opus Anglicanum* (English work), flourishes as it did in the hundred years between 1250 and 1350 when it had reached high perfection. Carefully dyed yarns and silks, satins, brocades, fine damasks, and lurex and modern other threads, are the basics. From Anglican convents, looms on the Continent, and commercial houses here and abroad, flow vestments along with copes with sometimes stupendous hoods and jeweled orphreys. They, too, supply rochets, chimeres, and miters for bishops, as well as birettas, cloaks, tippets, preaching-tabs, convocation robes, credence cloths, dossal curtains, scarfs, tapestries, canopies, collages, rugs, banners, flags,

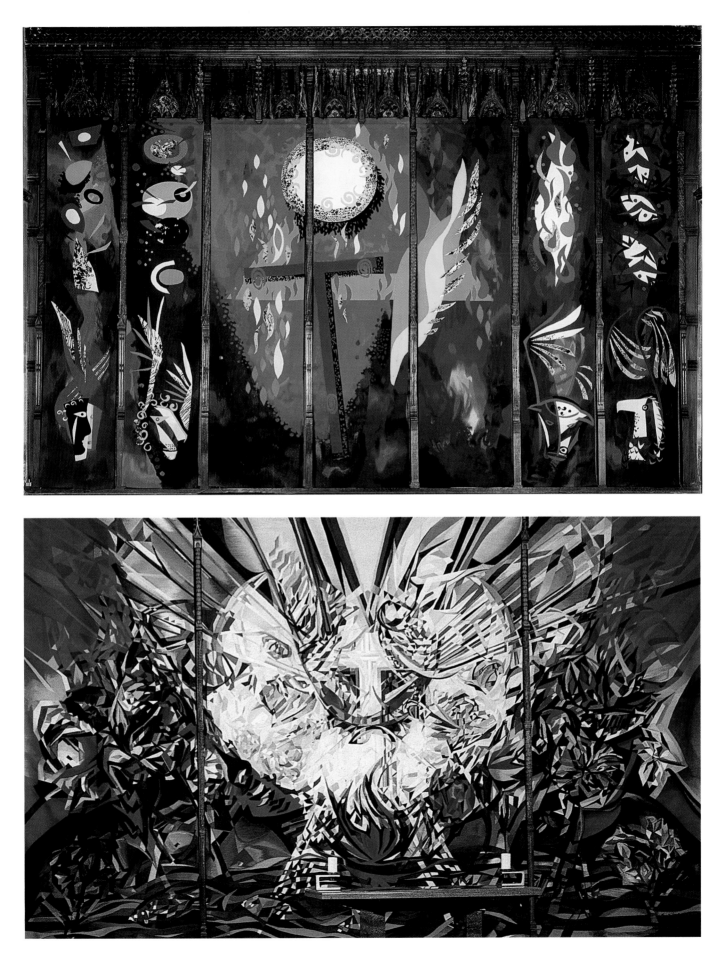

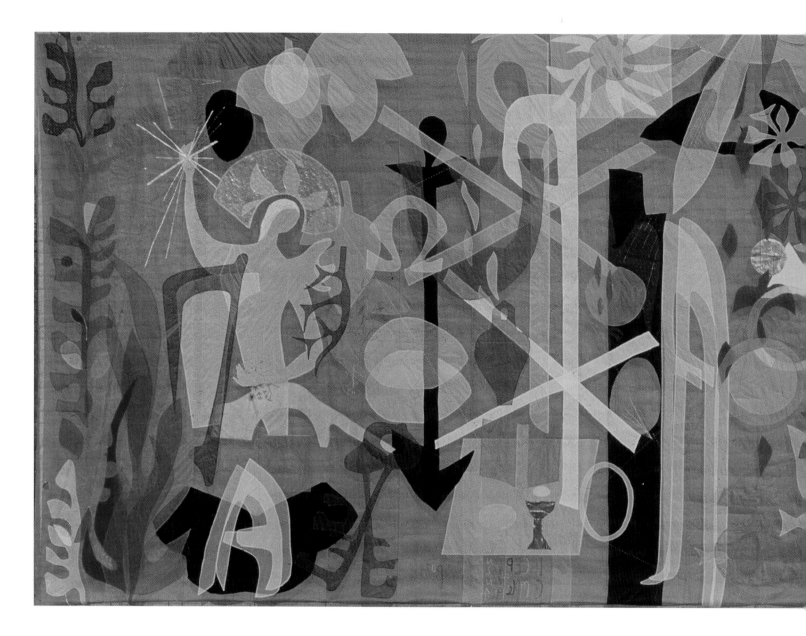

funeral palls, and plain or bright needlepointed kneelers and cushions for chancels and naves in churches around the world.

The use of vestments and all that they connoted about degrees of churchmanship—High, Broad, or Low—has become far less divisive than was the case a century ago. It is true that the emphasis on more participative services of Holy Communion, plus incense, sanctus bells, genuflecting, the sign of the Cross, may not be found in every parish. But, on the whole, clergy and lay people are less threatened, more tolerant and patient, and more accepting. Carping about too much ceremonial or the opposite point of view, being a "spike" about ceremonial's finer points, is the passé, gossipy currency of yesteryear. Prejudices of the past have given way to deeper, more important concern for personal and corporate spirituality, to Communion as food for a soul's journey, and to serious searching for Biblical truths that meet the challenges of life in the twenty-first century.

ABOVE *At the Church of Saint Barnabas-on-the-Desert at Paradise Valley, near Scottsdale, Arizona, Lee Porzio's 18' x 24' collage,* Ode to Joy, *is the reredos for the high altar and also functions as a screen that cloaks the organ pipes, but does not mask the sound. Fifty sacred figures and symbols in earth tones were appliquéd on a field of firm, open-weave Irish linen. The collage was unveiled at Easter 1964.*

RIGHT *A chancel rug, taking its design from an ornamental carpet page in the indisfarne Gospels, brightens the austere chapel on Holy Island, Lindisfarne, where the missionary Aidan arrived from Iona in the year 635.*

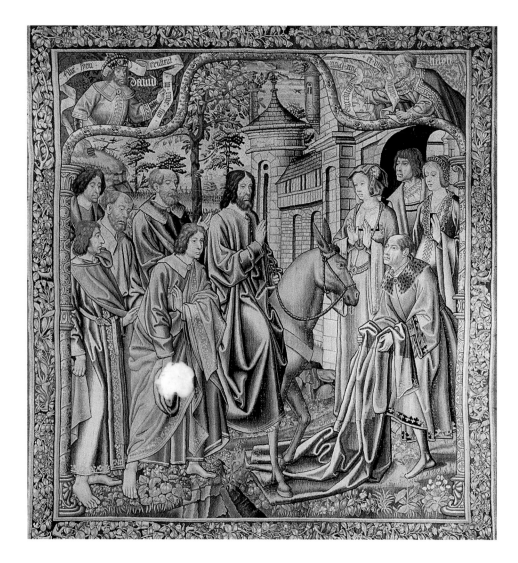

*Christ's Entry Into Jerusalem had hung
for 260 years in Saint Andrew's Church,
Presteigne, Wales, before discovery that it
was a Flemish pre-Reformation tapestry
woven from cartoons commissioned by
Canterbury Cathedral in 1511. A petition
of 700 persons, plus grants for its care, saved
it from the auction block in London. A
smaller example of the same scene is in San
Francisco's Fine Arts Museum.*

OPPOSITE *Another Belgian tapestry of
the same period,* The Risen Christ with
Saint Peter, *was given to Grace Cathedral,
San Francisco, by the Crocker family. It may
have been made for Margaret of Austria,
regent of the Hapsburg Netherlands, before
passing to the dukes of Alba and much later
into American hands. While Saint Peter
holds center stage, a montage of other events
of the Resurrection includes Peter's denial
of the Lord, the angel at the empty tomb,
and the appearance of Christ to Mary
Magdalene. A rich surround of plant and
animal symbolism evokes the new Eden
in threads of wool, silk, and gold.*

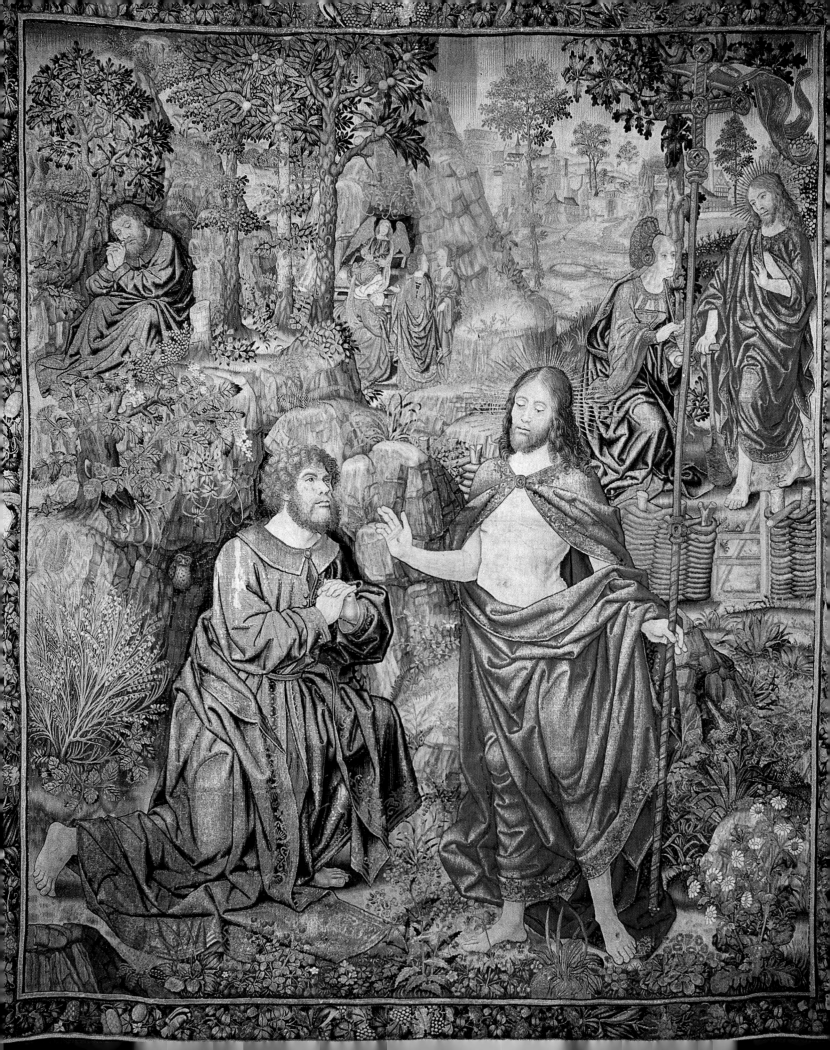

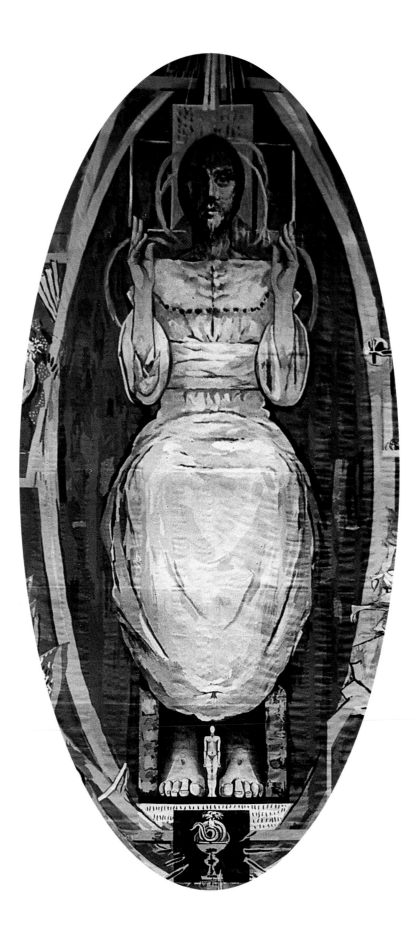

An immense tapestry, Christ in Glory in the Tetramorph, *designed by Graham Sutherland, presides over the new Coventry Cathedral, opened in 1962. The Messiah is seen in an oval within an oval, a figure of humankind at his feet.*

OPPOSITE *In the early nineteen hundreds, an intricate frontal was worked for the Lady Chapel of the new Liverpool Cathedral, with Maria Comber embroidering the bodies of angels, and her sister, Margaret, the faces. It is part of a unique treasure of fabrics designed by one person, the architect George Frederick Bodley, and executed by the same group of people, thereby providing a rare continuity and consistency. Although Bodley died in 1907, the group worked steadily on what he had provided for altar furnishings and completed their task in time for the cathedral's dedication in 1924.*

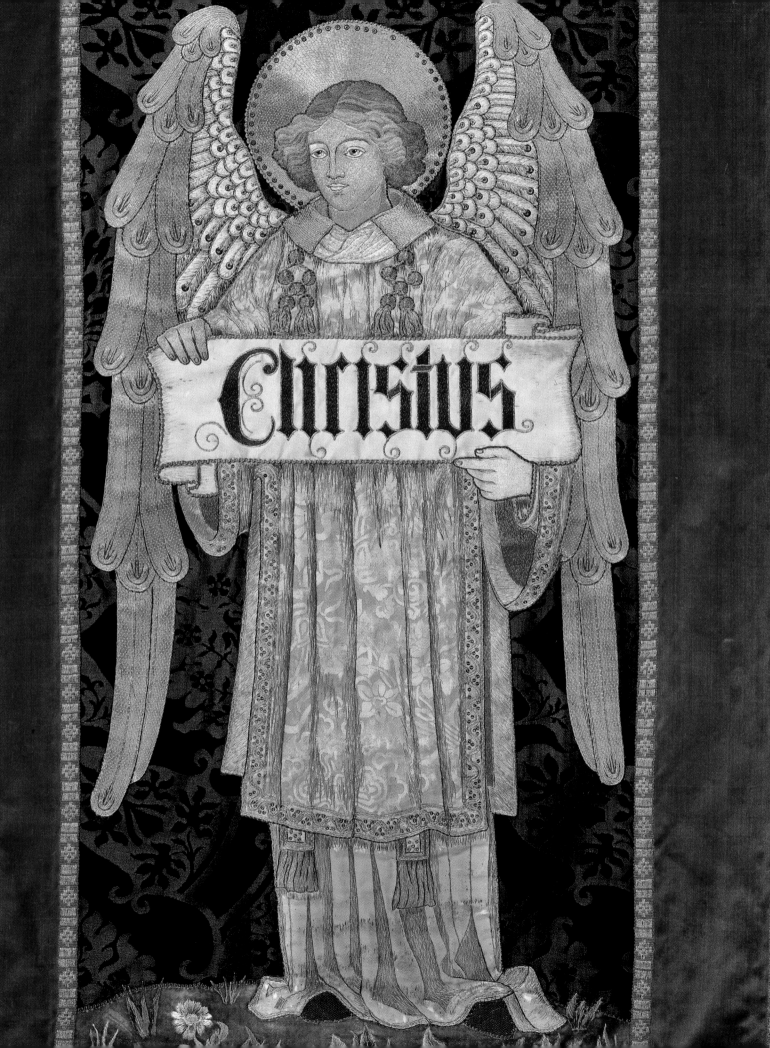

Glass

Although they appear to have been cut from the same great sheet of glass at Washington National Cathedral, nearly thirty years elapsed between the installation of the north rose window, Lawrence Saint's Judgment and the south rose, Joseph C. Reynolds's The Church Triumphant. Both artists used traditional blues accented by red and gold, completing their work in 1934 and 1963, respectively.

One of Canterbury's oldest windows, the twelfth-century Adam Delving *occupies the center position at the lowest portion of the cathedral's great west window. It is one of thirty-eight panels that have survived from a clerestory of eighty-four illustrating biblical genealogy that traces the human ancestry of Christ.*

OPPOSITE *Foremost among Canterbury's modern glass is the Hungarian-born Ervin Bossanyi's* Peace. *It represents the gathering of people of all races into the indivisibility of Christ. Other Bossanyi windows are in Washington National Cathedral and York Minster. "Only works of art done by passionate, burning love bear the mark of validity in buildings of dignity," he was to write.*

*T*he light of a million mornings has pierced the windows of York Minster, Britain's largest collection of medieval glass. York's treasures date from the year 1150 and, on the outbreak of war in 1914, were hidden beneath the city wall. Similarly, at Canterbury, glass from 1184, and later, was twice removed and put back again by the same man in both World Wars.

In our own time, etched or engraved glass, is used effectively, especially in Coventry where a huge glass screen separates the bombed-out cathedral from the new cathedral; it is composed of ninety panels, many of them cut with figures of saints and angels by John Hutton, denying, in the words of Canon David L. Edwards, "that there is any division between church and city, united by suffering and recovery."

First developed in Egypt, first glazed in Pompeii, it fell to Greece to take the lead in staining glass and exporting it to the cities of Europe until the twelfth century when France and England took over.

Among its admirers, the architect Sir Christopher Wren found "nothing more beautiful than the divine gift of light." In response to such visions, workers mix various metallic oxides—gold, copper, cobalt, manganese, and others—with sand and potash, unfold it in sheets, blow it into cylinders, and carefully trace and cut the patterns. These procedures have produced walls of glass that soar and sparkle in Bath Abbey and several of the English cathedrals. There are countless colors and combinations of color: symphonies of gray and indigo, for instance, rust-red, and copper-gold.

Hoping to match their predecessors of times gone by, purveyors of glass to Britain and the U.S. were led by Lavers & Westlake of London who installed windows in the side aisles and narthex of All Saints Cathedral, Milwaukee, Wisconsin, in 1892. C. E. Kempe made glass for chuches in New York, Providence, St Louis, and Springfield, Massachusetts. Other old-line firms are Heaton, Butler, and Bayne of London, Powell & Sons, Burleson & Grills, and Edward Frampton Ltd, and, most especially, J. Whippell & Company working from a shop and offices in the shadow of Westminster Abbey.

In the United States, glass on a lesser but more adventuresome, creative scale, reached a zenith in the nineteenth century with artists like John LaFarge and in the dreamy, fanciful designs of Louis Comfort Tiffany. Henry Lee Willet and his family studios in Philadelphia lead the field in creations that are both meditative and blazing, followed by Falch, Judson, J & R Lamb, Rambush, and Rohlf. They are associated with such distinguished artists as England's Edward Burne-Jones to John Piper, Germany's Hans

Kaiser, Charles J. Connick, Wilbur H Burnham, and Rowan and Irene LeCompte.

Artists and workmen in Washington have been untiring in projects spread over several decades. An unusual continuity of design is sometimes achieved by having most of the glass done by one or just a few artists, some of whom collaborate on a single window.

Artists know, perhaps more than most, that in the midst of tiresome sermons, not an uncommon phenomena, worshippers' eyes stray to stained glass, frequently discovering its unique power to teach more about wisdom and courage than may be heard from the pulpit.

"Inside is a gothic forest dappled in violet twilight and vast with quiet," wrote a week-day visitor to New York's St John the Divine, capturing in a single sentence, much of the mood and mute ministry of an exalted art dating back to the earliest years of recorded history.

At the 1978 Lambeth Conference of bishops, one prelate wondered aloud, "What joins us together?" Cutting short what might have been a tedious discussion, up rose the Bishop of northern Indiana, W. C. R. Sheridan. "Actually," he said, "I think it's Wippell!"

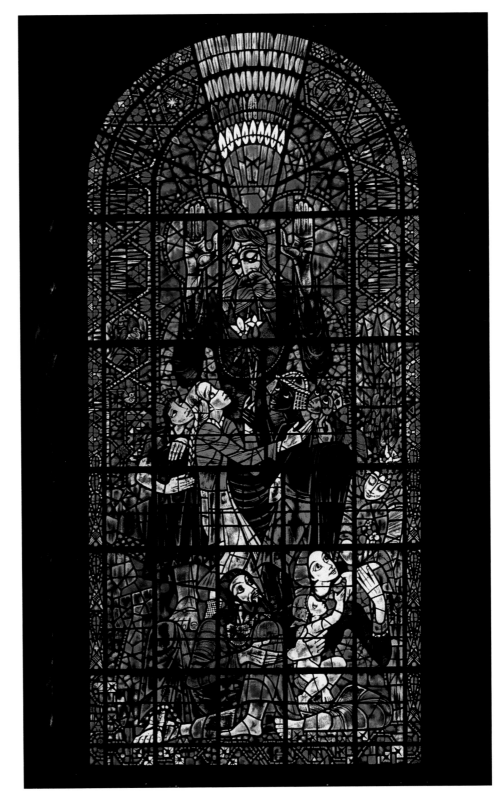

LEFT *An arch of Roman tiles suggests a great age for the south wall of All Saints Church, Brixworth, Northamptonshire.*

OPPOSITE *Forebears shown on a fourteen... of Jesse window in ... Saints Peter and Pa... Oxfordshire. The fig... mond-shaped clear g... augmented by sculpt... the window mullion...*

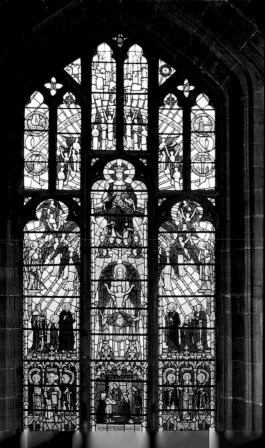

LEFT *Christopher Webb's 1951 window in Exeter Cathedral in Devon is a thank offering for the venerable structure's safekeeping during wartime bombing.*

ABOVE *The scallop shell ... in christenings becomes p... nautical theme in the bap... Saint Ann's, Kennebunkp... a summer chapel where G... Bush's family has worship... four generations. The churc... secrated in 1892.*

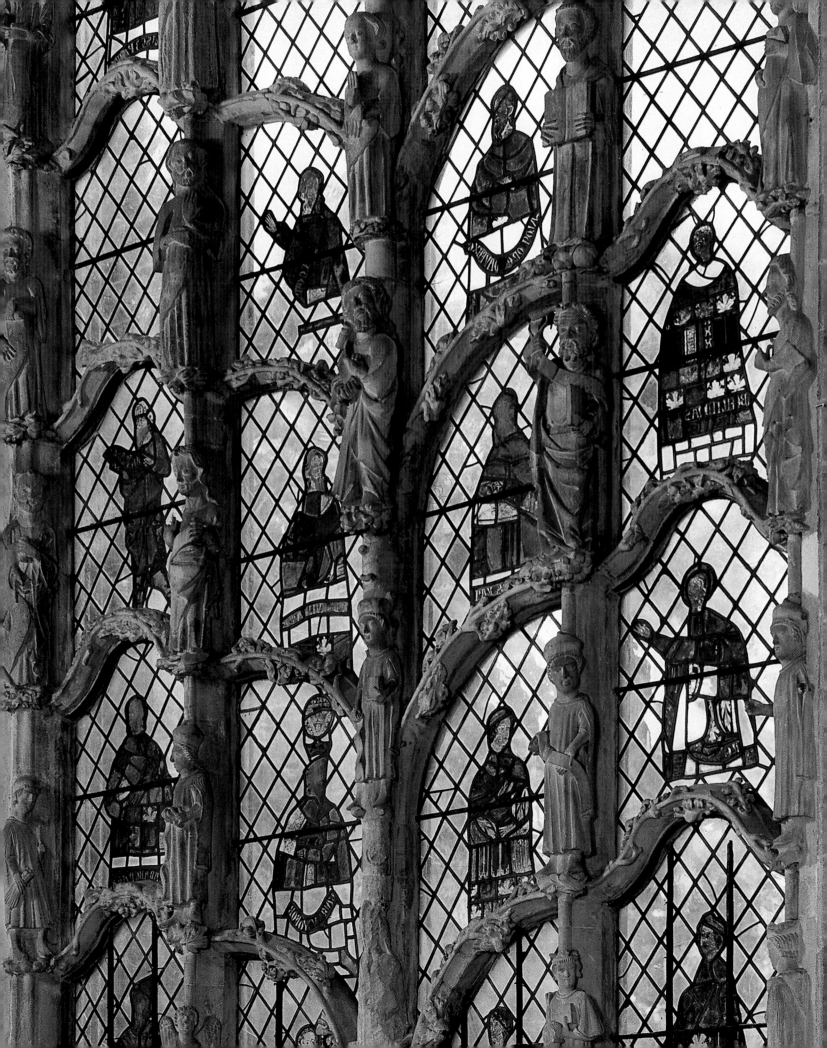

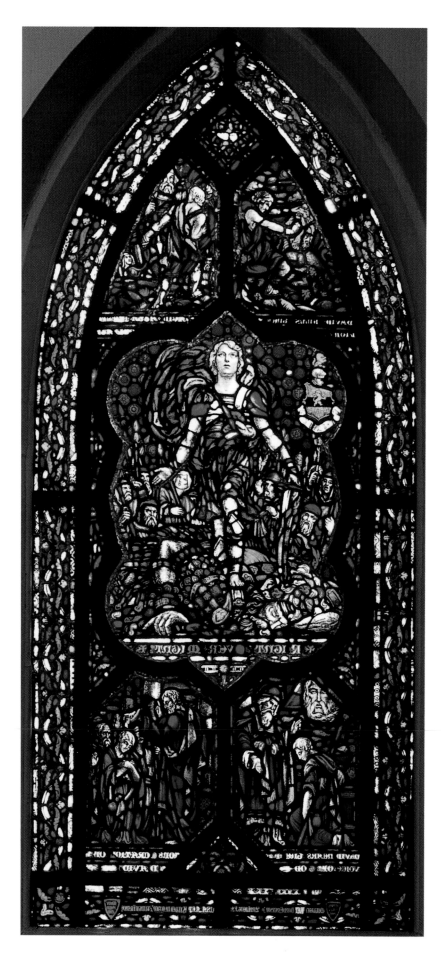

A figure of Saint Michael in shining armor was a memorial gift for the Tyler Room at Episcopal Divinity School, Cambridge, Massachusetts.

In a window dating from 1889, at the American Church of Saint James in Florence, an angel unfolds a banner with Christ's words, "I am the way, the truth, and the light."

At Christ's Church, Rye, New York, a window depicting the crowning of the Virgin, surrounded by faded gold stenciling, was given by the women of the parish in 1885 in memory of Susan Brewster, wife of a former rector. Its border of angels swinging thuribles of incense where incense has rarely, if ever, been burned, suggests at least a brief era of High Church, in the wake of the Oxford Movement.

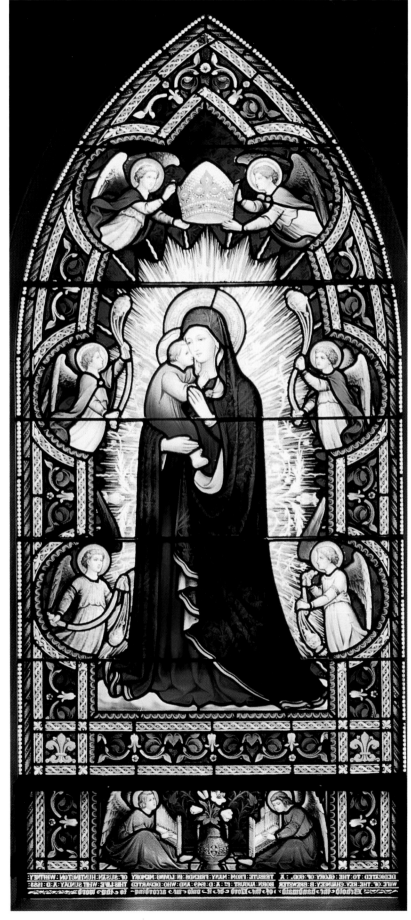

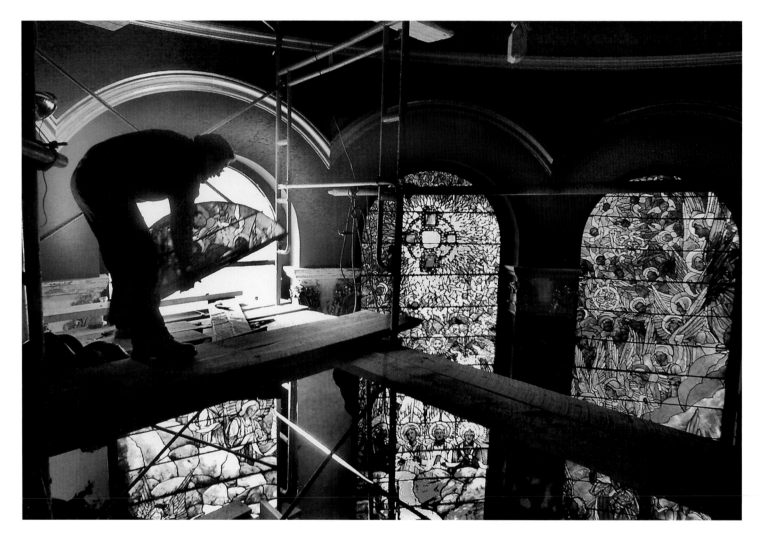

The signature of the master himself is scrawled at the edge of a scenic window to the left of the high altar at All Souls Church in Washington, D.C.

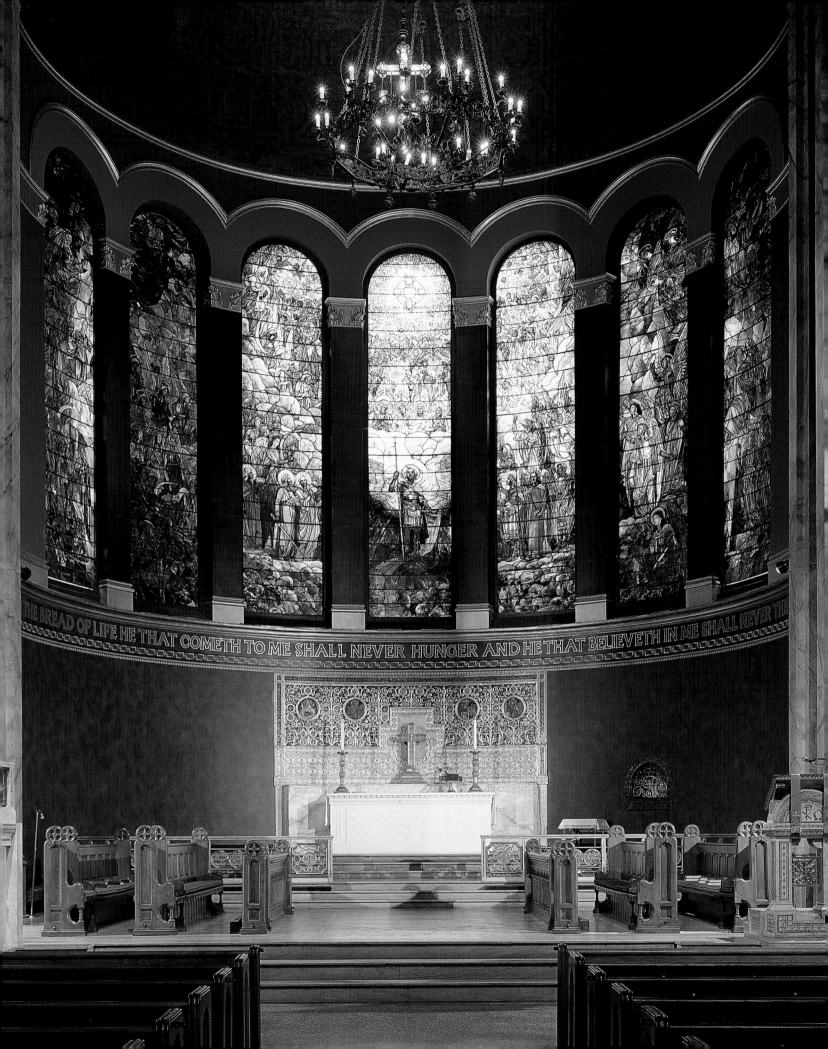

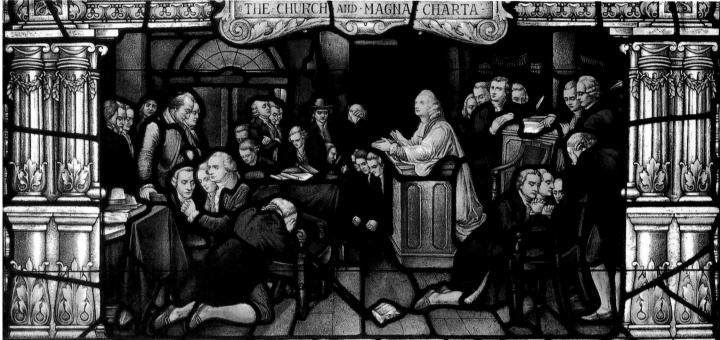

THE CHURCH AND · MAGNA CHARTA

'THE PRAYER IN THE FIRST CONGRESS A.D. 1774'

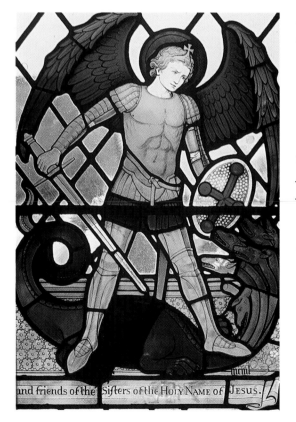

and friends of the Sisters of the Holy Name of Jesus.

ABOVE *The Church and the Magna Carta graced Christ Church, Philadelphia, for some years before it was replaced by clear glass more in keeping with the Georgian architecture. The original window is stored at the church.*

LEFT *One of Sir Ninian Comper's few ventures in stained glass is a figure of Saint George and the dragon in the former Convent of the Holy Name at Malvern Link, Worcestershire, c. 1950.*

OPPOSITE *At Westminster Abbey, the 1940 Battle of Britain, much of it waged in the skies directly above the abbey, is commemorated in painted glass in six undulating panels. Royal Air Force insignia are interspersed with figures of heroic airmen contemplating scenes of glory linking them with the Christian faith: Christ's virgin birth, crucifixion, death, and ascension. At the top, a dozen angels raise wings of blue and purple in perpetual praise.*

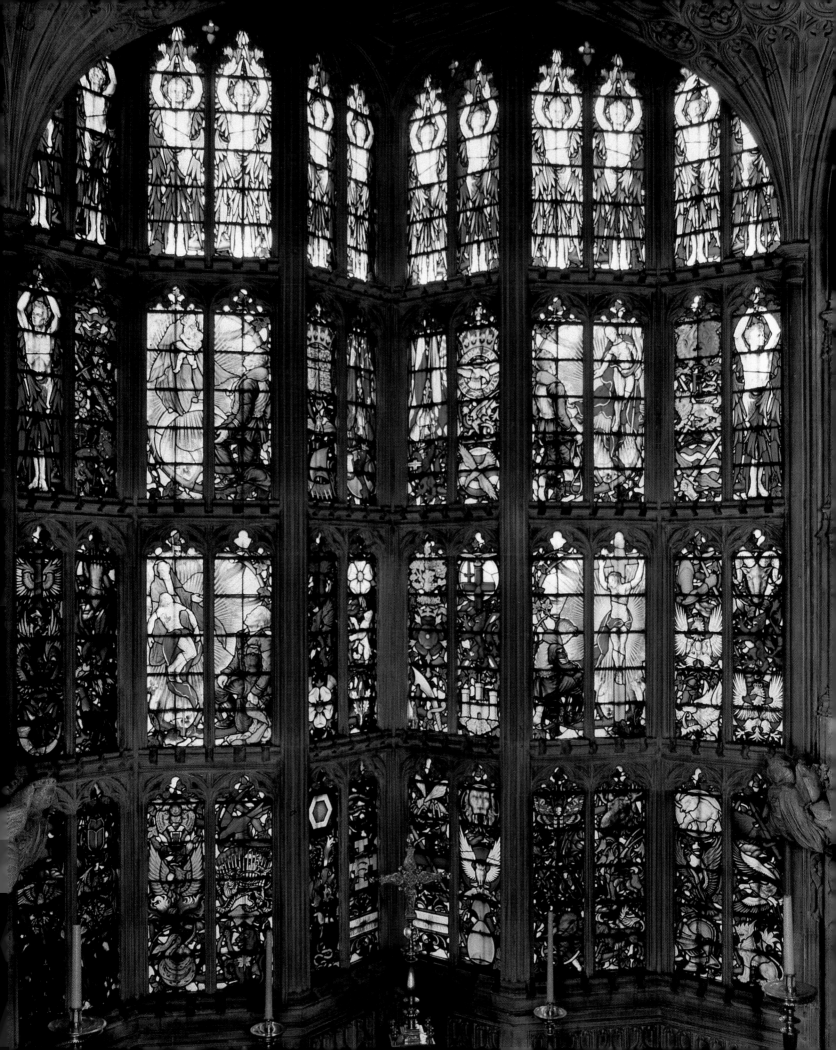

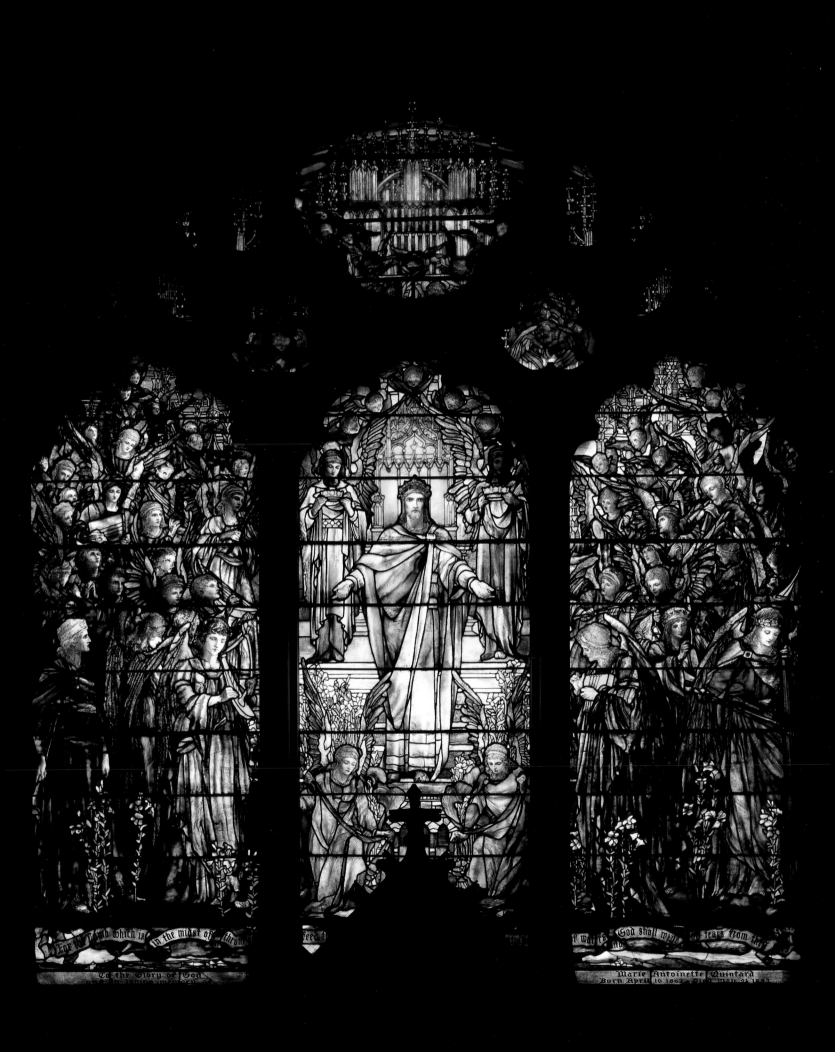

OPPOSITE *In the 1896 reredos window at Christ's Church, Rye, New York, Louis Comfort Tiffany reserved the thinnest glass for the Savior's face so that it is seen first in morning light. Increasingly thicker pieces toward the edges of the figure insure that it is the last seen at eventide. This window was given to Christ's Church by George and James Quintard in memory of their wives.*

Tiffany captures a field of white daisies and other summer scenes of Cape Cod in a set of five nineteenth-century windows in the apse of Saint Paul's, Nantucket, Massachusetts. Four kinds of glass— streamer, opalescent, rippled, and flashed— are held in a copper foil and lead matrix.

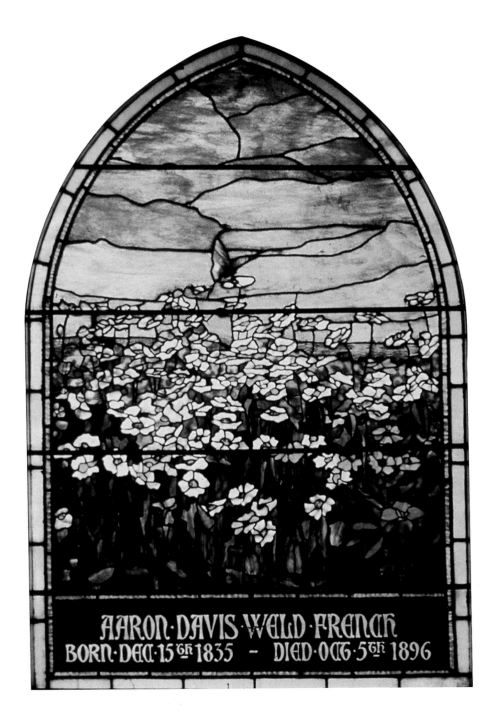

AARON·DAVIS·WELD·FRENCH
BORN·DEC·15TH 1835 — DIED·OCT·5TH·1896

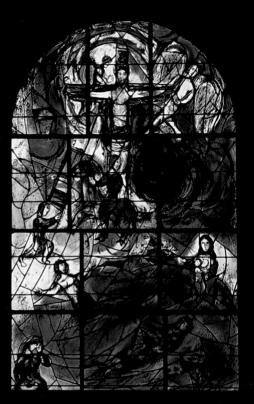

Mark Chagall used deep hues of blue and yellow in a window at All Saints, Tudely, Kent.

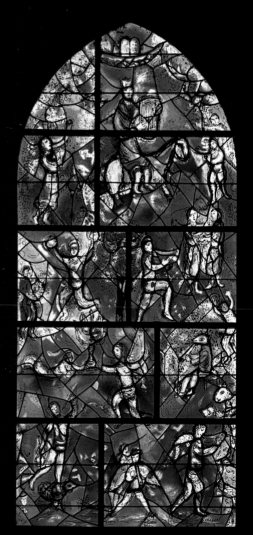

At Chichester Cathedral, red takes over in a window inspired by Psalm 150, "Let everything that hath breath, praise the Lord," completed in 1955. With Chagall, "objects rarely if ever bore their natural hues," wrote the art critic John Russell. "Cows were likely to be blue, horses green, and people red in a world of gravity."

OPPOSITE The Church of the Ascension and Saint Agnes, Washington, D.C.'s oldest Anglo-Catholic parish, celebrates the Te Deum, the Prayer Book's great hymn of praise, with a procession of eight-four clerestory windows (ABOVE) acquired in 1947. While the parish staunchly champions its faithfulness to traditional liturgies, it expresses its relationship to and acceptance of the modern in the nave's nine abstract windows. They present a blazing riot of reds, blues, and gold, in faceted glass designed by Margaret Gaudin and fabricated in France in the 1960s and 1970s for the Willet Studios of Philadelphia.

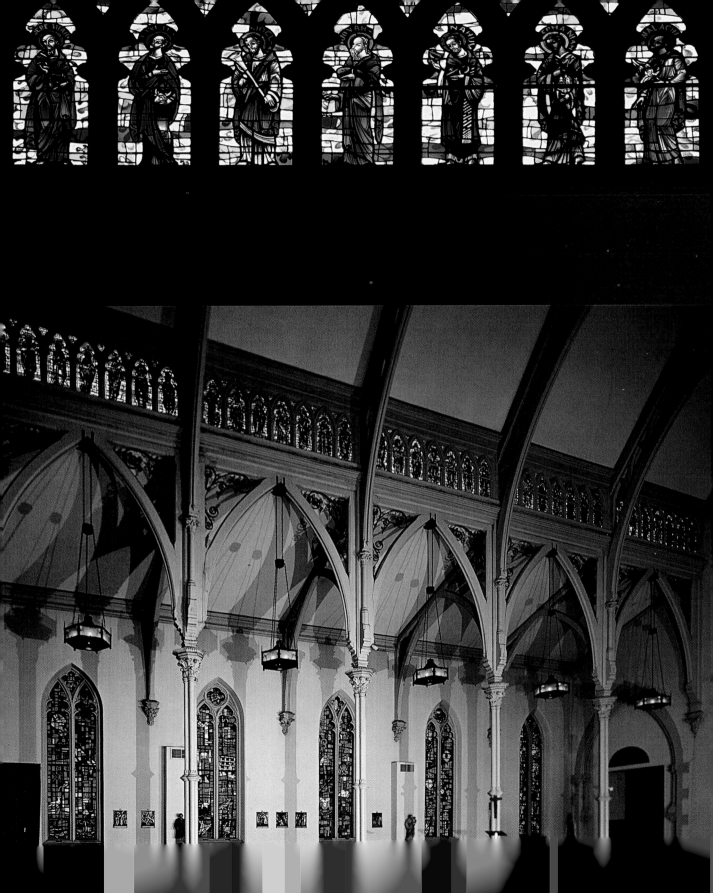

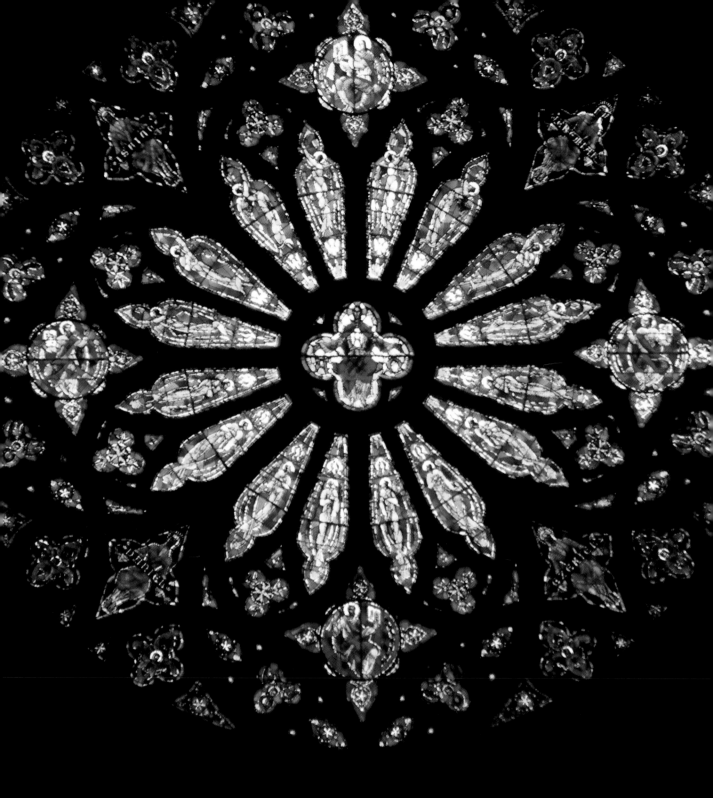

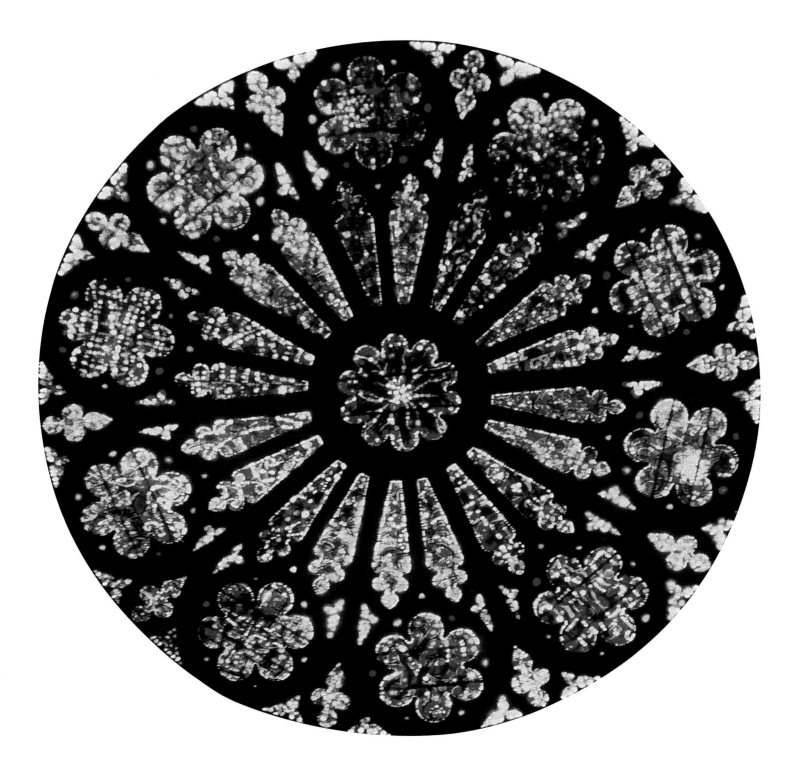

In the words of Stephen Sondheim, "Everything's coming up roses" in Charles J. Connick's 1938 west window (LEFT) and a smaller one just below it in New York's Cathedral Church of Saint John the Divine (ABOVE), and in Rowan LeCompte's west window that blooms in Washington National Cathedral. Although the latter's Cathedral Chapter approved a theme of Creation for the west facade in 1937, more than forty years were to pass before walls rose to accommodate what has become LeCompte's most renowned work. "It seems black and formless, but when we enter, and see it back-lit by the sun, it dazzles in astonishing splendor and reminds us that without faith, we too are but stained-glass windows in the dark," said President George Bush at the cathedral's dedication 29 September 1990.

Continuing his extensive work at Washington National Cathedral, Rowan LeCompte designed the south nave's clerestory windows, the highest—twenty-seven feet—and largest (four panels) of the three levels of the side bays. Sunshine washes Job: Suffering and Redemption as well as its companions, Jeremiah. Baruch, and Nathum *and* The Psalms.

OPPOSITE *In LeCompte's window in the refectory of the College of Preachers, a small jewel of a building tucked into a hillside back of the Washington National Cathedral in 1929, an inscription along the lower edge cuts to the heart of good sermons: "If you do not dramatize the message, they will not listen."*

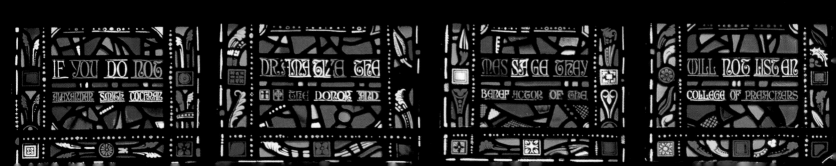

IF YOU DO NOT

ALEXANDER SMITH COCHRAN

DRAMATIZE THE

THE DONOR AND

MESSAGE THEY

BENEFACTOR OF THE

WILL NOT LISTEN

COLLEGE OF PREACHERS

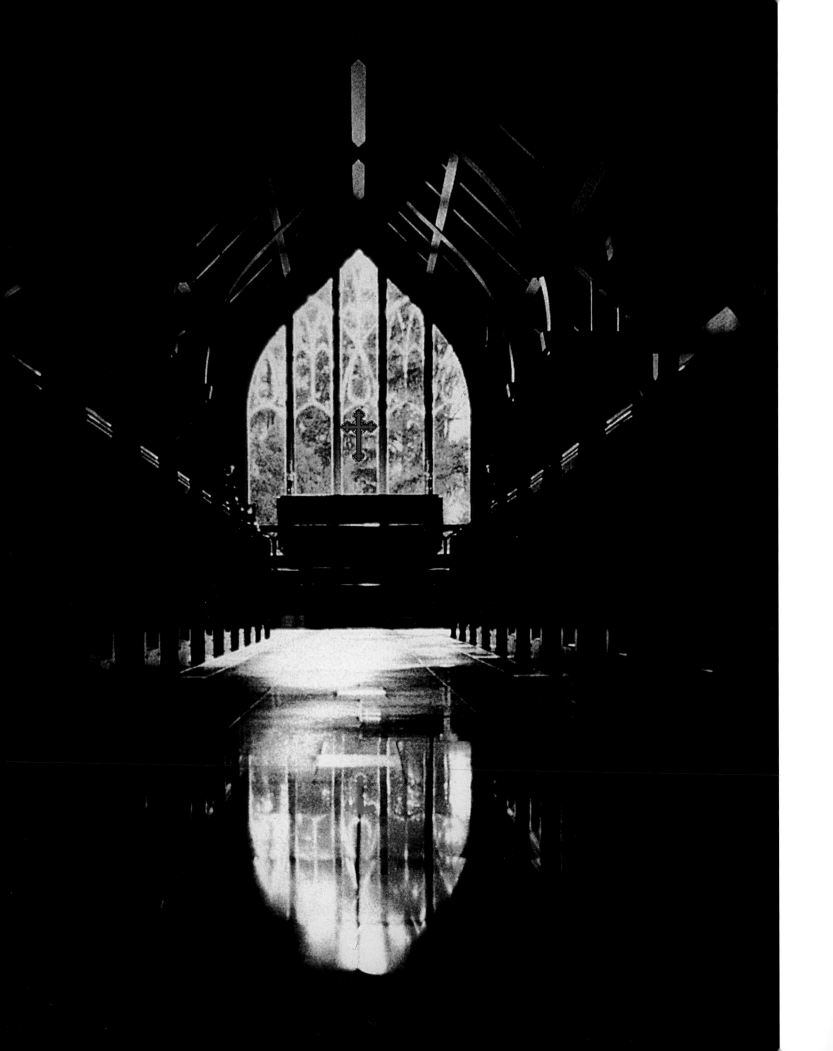

OPPOSITE *On taking over a former carriage house in 1958, parishioners of Our Savior's, Colorado Springs, Colorado, resolved to create a large window looking out on verdant landscape. White Italian marble and gray Mexican marble were combined in the altar and, in 1992, a master craftsman, Thomas Parmiere, put down a floor of matching marble plus red and green slate. Its highly polished surface reflects the ceiling's ribbed beams of black oak.*

RIGHT *In 1997, parishioner Janet Hurst designed a hanging cross of red glass centered on a crown of thorns and incorporating liturgical colors of red, green, gold, blue, and purple—a total of 221 pieces of stained glass. Another master craftsperson, Mike Miller, fabricated the cross and double-framed it in the same black oak as the ceiling beams.*

Bringing the outdoors and sky inside is successfully employed in the Chapel of the Apostles at the University of the South, Sewanee—near Chattanooga—Tennessee. A wooden crucifix is behind the freestanding altar. The on-site architect was Maurice Jennings, a partner of architect E. Fay Jones, who had earlier used a similar approach in the Thorneycrown Chapel at Eureka Springs, Arkansas.

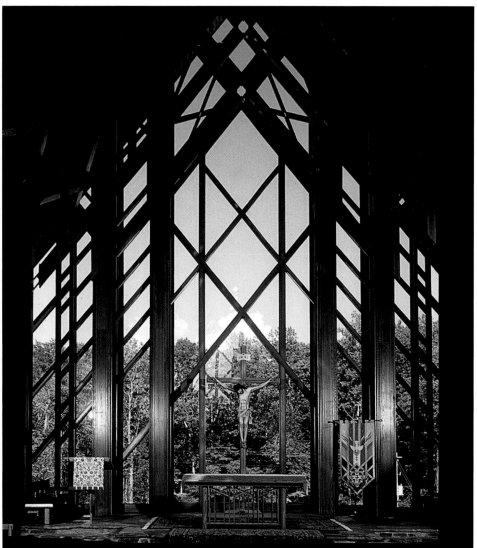

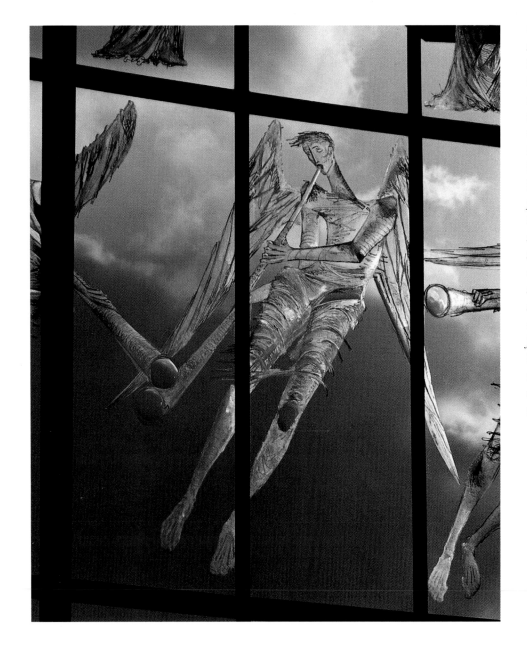

Coventry Cathedral's clear glass screen, separating the new cathedral from the bombed-out ruins of the old, was completed in 1962, flooding the structure with light by day and presenting an awesome spectacle at night. The designer, John Hutton, who had expertly etched angels on glass for the Air Force Memorial at Runnymede, was chosen by the architect, Sir Basil Spence, early in the planning stages because of the complexity of the task. Above the main doors, Hutton gave his elongated figures plenty of space, mixing biblical personages and British saints, with trumpeting angels rising upward and outward in exaltation. Measuring 45' x 70', the glass is hung from the roof and stiffened with tie-rods to withstand wind damage. "Hutton's method was to draw the figures with a turning wheel which could be varied by using different sizes and hardness," Sir Basil Spence wrote. "The effect is a spontaneous drawing, like chalk, of great vitality and expression."

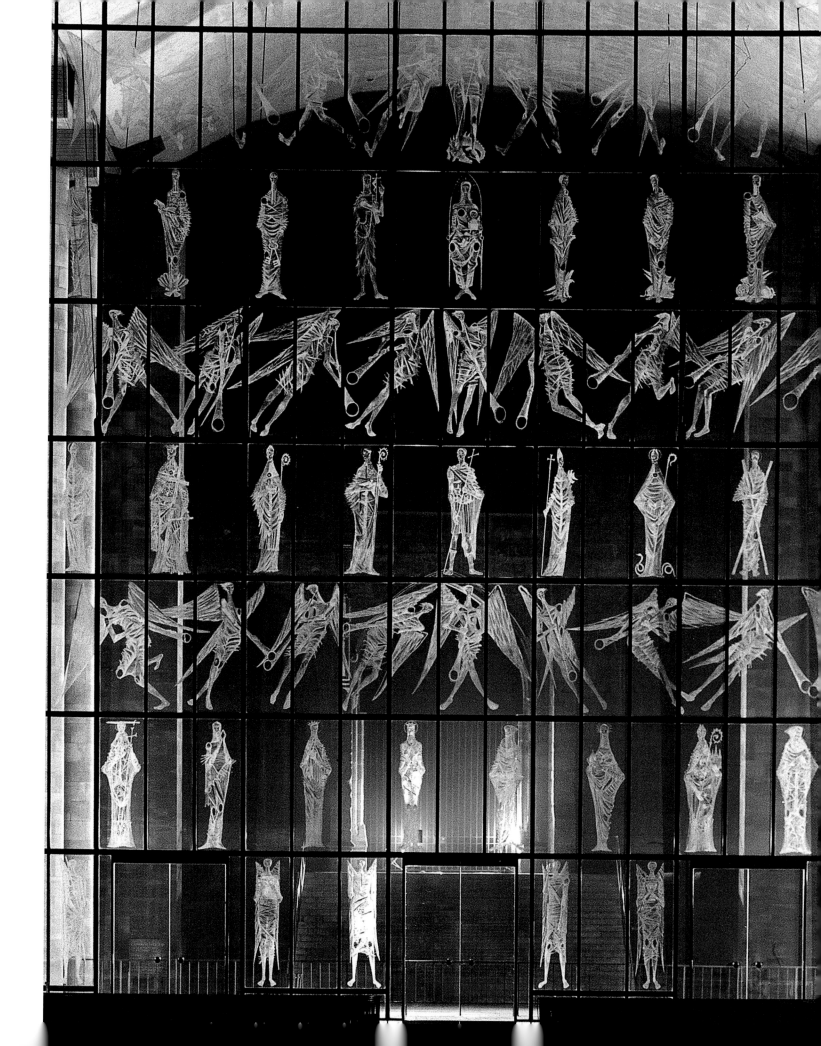

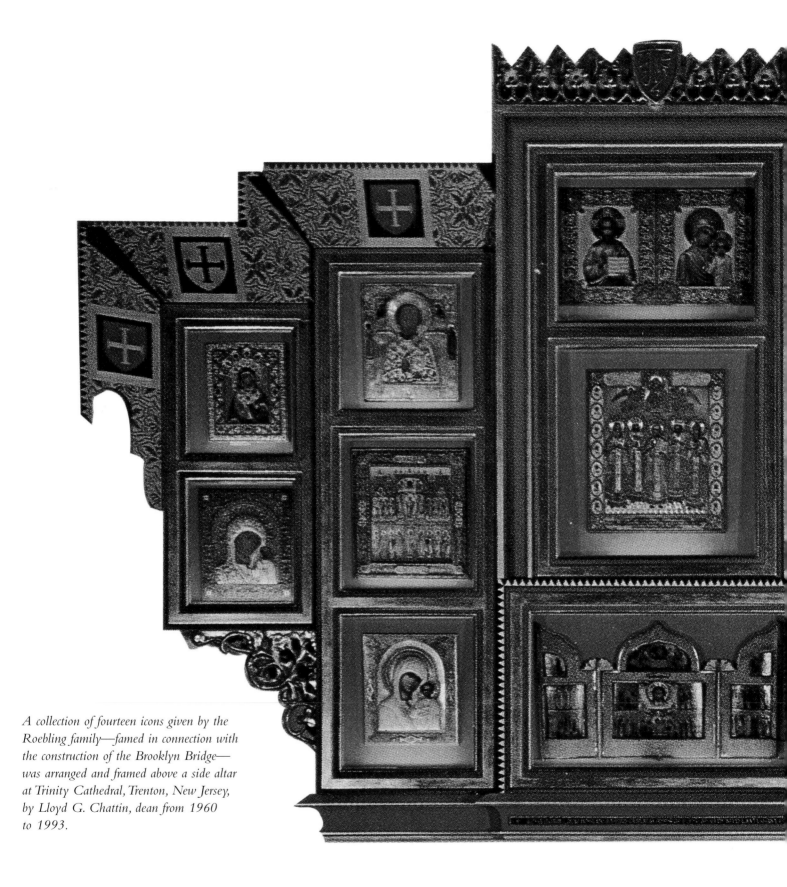

A collection of fourteen icons given by the
Roebling family—famed in connection with
the construction of the Brooklyn Bridge—
was arranged and framed above a side altar
at Trinity Cathedral, Trenton, New Jersey,
by Lloyd G. Chattin, dean from 1960
to 1993.

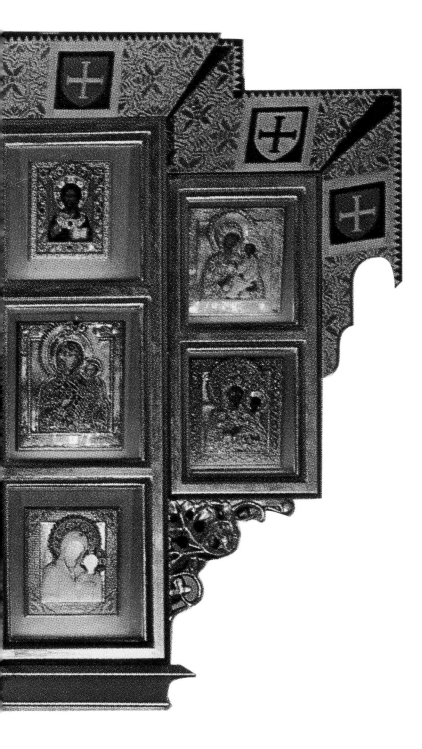

Icons

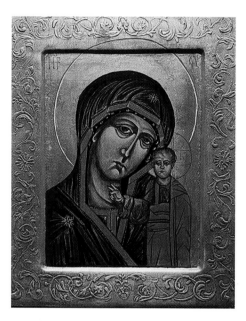

"Our Lady of Kazan" is a twentieth-century interpretation of a traditional Russian subject by John Walsted.

OPPOSITE *Christ Pantocrator (Christ the Omnipotent, Ruler of All) is one of two Greek icons, ca. 1600, that hang near the high altar of Grace Cathedral, San Francisco. The figure raises a hand in blessing while holding a Bible open to Matthew 7:7: "Ask and it shall be given you; seek, and ye shall find; knock, and it shall be opened unto you."*

The history of icons, relatively new to Anglican life and liturgy, begins in Byzantium (later called Constantinople and Istanbul) in the first or second century and was regulated by the Council of Nicea in the year 785. They were quickly taken up by the Orthodox Church in Greece and Russia and have in recent years come down to Anglicanism due to study, scholarship, travel, and increased interest in spirituality in the Eastern Church.

Since World War II, Anglicans have begun to "write" their own icons—*written* because, as with the written word, the icon teaches Christian truth: it is a theology of images—echoes of God's mystery. It is part of the stream of tradition, that is the interior life of the Church, which is the extension of God's incarnation.

Growing out of the Greek word for image, icon was the word St Paul used when speaking of Christ as the image of the invisible God. The term was increasingly restricted to a portable picture on a wooden panel, or in enamel, metal or mosaic.

Undertaking an icon, the artist uses a traditional prayer, "Lord and Divine Master of all that exists, enlighten your servant and direct my soul, heart, and mind. Guide my hands so that I may worthily and perfectly represent your image as well as those of your holy Mother and all the saints,

for the glory, joy, and beautification of your holy Church." An icon's development is layered with a symbolism that begins when the board is cut from the tree recalling the Biblical tree of life or tree of paradise. Prepared with many coats of gesso and linen cloth, it is sanded to a mirror-like finish to provide a pristine surface for the sacred image.

The wood is overlaid with gold leaf although the artist sometimes uses silver, red, or yellow, ocre, or white varnish. Background is called the icon's "light," that, for the believer, "places the entire painting in the atmosphere of heaven," writes Deborah Seddon in a booklet on Gospel icons. Gold symbolizes spiritual nature and the halo is painted with clay to create a vessel to receive the gold and is frequently painted on the sides to represent the Old Testament "frame" for the New Testament. The palette may also offer green, blue, black, purple, black, and brown.

As a composite work, the board's margin symbolizes the body; the picture area, the soul; together, the whole human, the integrated whole.

"The artist is to show all this through the art of colors as in a book that had a tongue to speak with," said St Gregory of Nyssa. "For the silent image can speak from the wall where it is seen by all, and there it renders the greatest service."

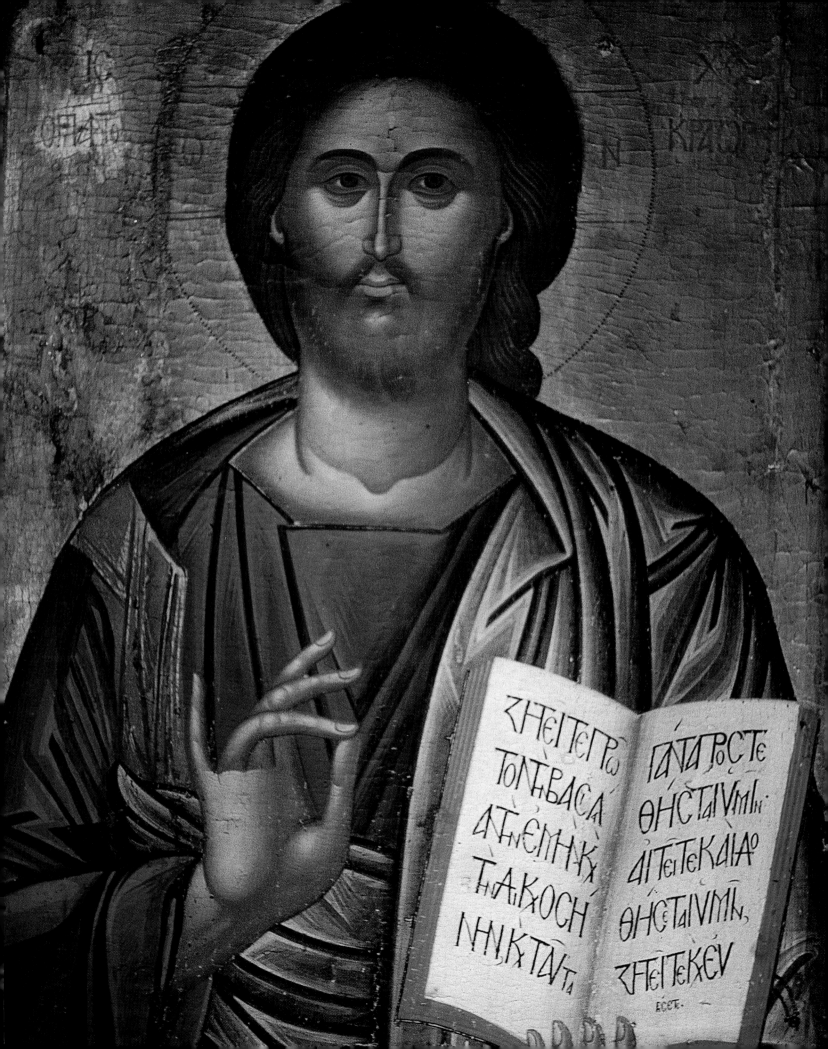

An engraved metal covering over all but the face of a divine figure is seen on some icons to protect it from the saliva of kisses of the faithful who regard it as a door into the divine realm and the interior life.

In recent decades, Anglican icons have invoked physical reality and humanism representing leaps beyond the stylization and flatness of Byzantine art. A new school partially based on iconographic tradition offers a fresh presentation of Biblical personages; subjects include a Choctaw Virgin and Child, explorer John Cabot, Nashotah House founder James Lloyd Breck, spiritualist Evelyn Underhill, and a trio of modern martyrs—Martin Luther King, Episcopal seminarian Joanathan Daniels, and San Francisco's Harvey Milk.

This modern icon is from the private chapel of the Archbishop of Canterbury, Old Palace, Canterbury.

OPPOSITE *An early nineteenth-century Russian icon of the Virgin and Child with angels on a field of gold was purchased at auction by George H. Eatman and donated to Saint Paul's K Street, Washington, D.C. It now hangs in Saint Paul's All Saints Chapel.*

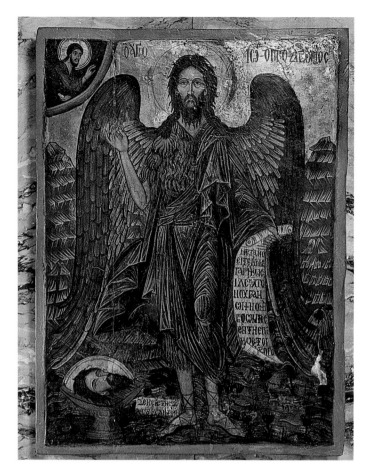

OPPOSITE *The hungering, Old Testament prophet Elijah is fed by ravens in a seventeenth-century icon in the Eastern Orthodox tradition from the island of Crete, off the southeastern coast of Greece. It is cherished by Saint David's Cathedral in the small cathedral town of Saint David's in the county of Pembroke, Wales.*

The risen St. John the Baptist are portrayed in this sixteenth-century Greek icon in Saint Saviour's Chapel, the Cathedral Church of Saint John the Divine, New York. Note St. John's head on a plate in the lower left of this gesso on wood icon.

Christ Pantocrator (Christ the Omnipotent, Ruler of All) is one of two Greek icons, ca. 1600, that hang near the high altar of Grace Cathedral, San Francisco. The figure raises a hand in blessing while holding a Bible open to Matthew 7:7: "Ask and it shall be given you; seek, and ye shall find; knock, and it shall be opened unto you."

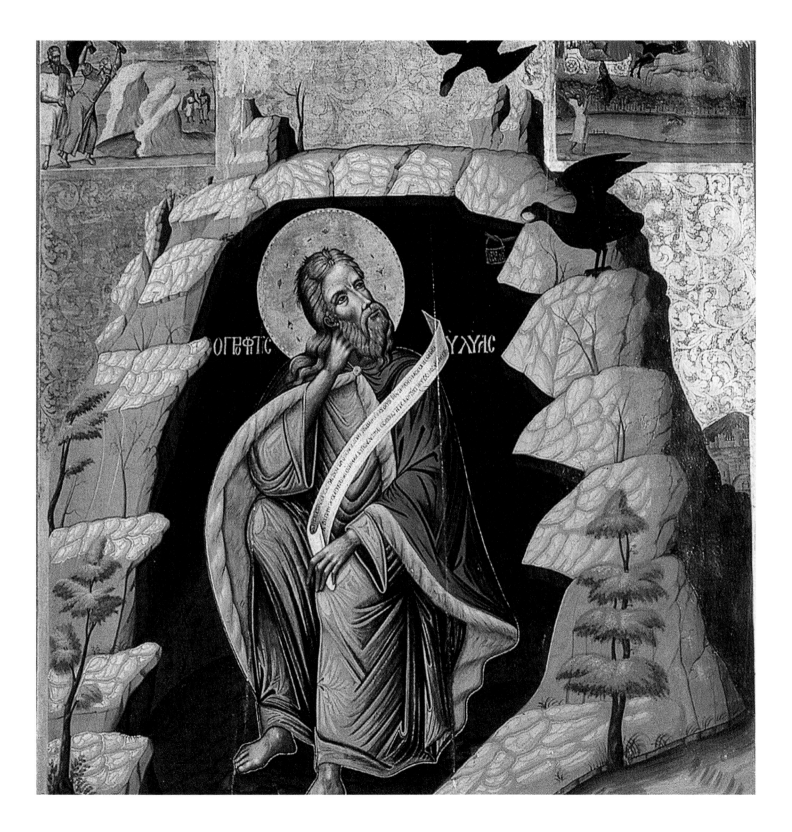

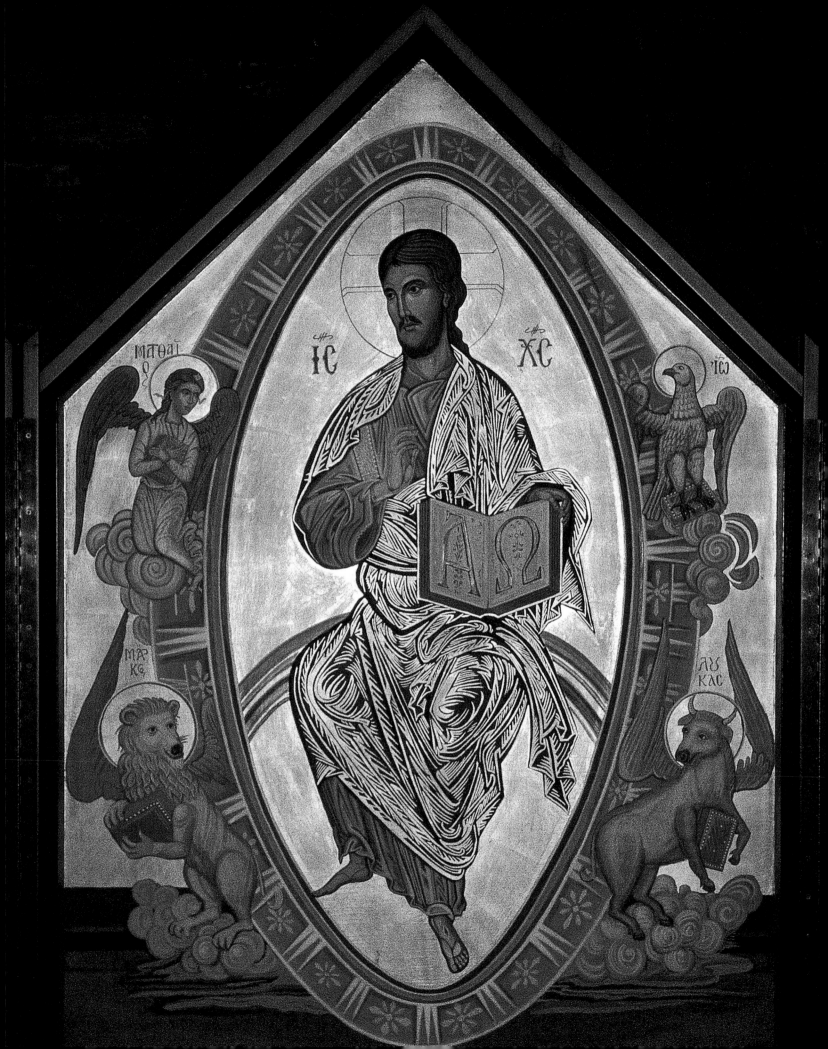

OPPOSITE *The extraordinary use of an icon
at the center of a triptych that, in turn,
is a reredos, is seen at the Church of Saint
John's in the Village on Waverly Place
in New York City. Working in 1981,
the painter Christopher Cosmos placed
Christ within an oval with the symbols
of the four Gospels. Saint John's stations
of the cross are also iconic.*

*This icon of the Annunciation hangs
in the Chapel of Saint Gabriel Crypt,
Canterbury Cathedral.*

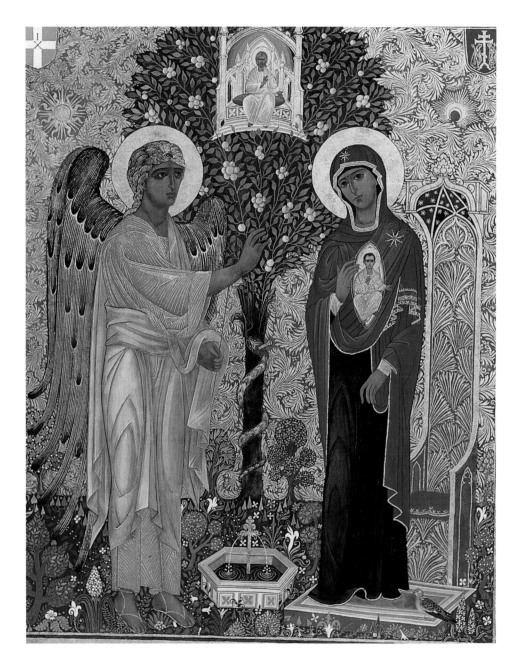

This twentieth-century icon is entitled "All Creation Praises Thee" was the creation of John Walsted, as was the icon to the right.

OPPOSITE "St. George and the Dragon" depicts the well-known story of England's patron saint.

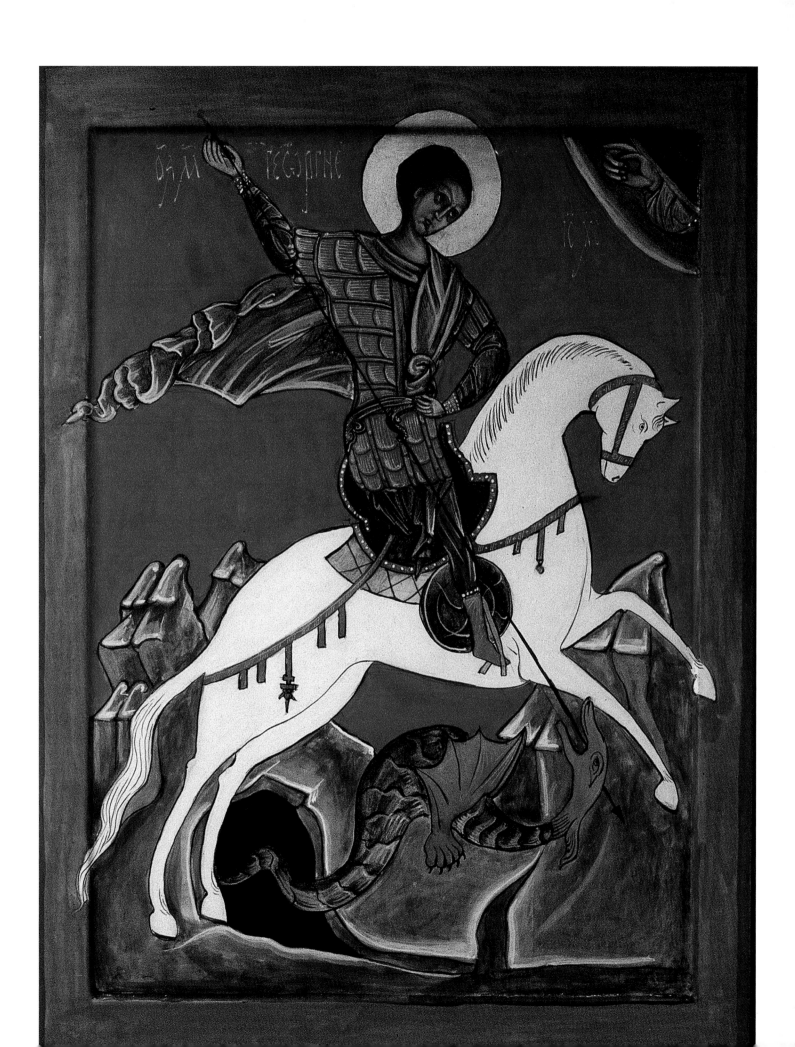

William Bancroft began the Lambeth Palace Library, depository of Elephant & Castle *and other historic manuscripts, in 1610, bequeathing "all my books in my study over the cloisters unto my successors and the Archbishops of Canterbury successively forever." The collection was to grow to more than 4,000 manuscripts and 200,000 books.*

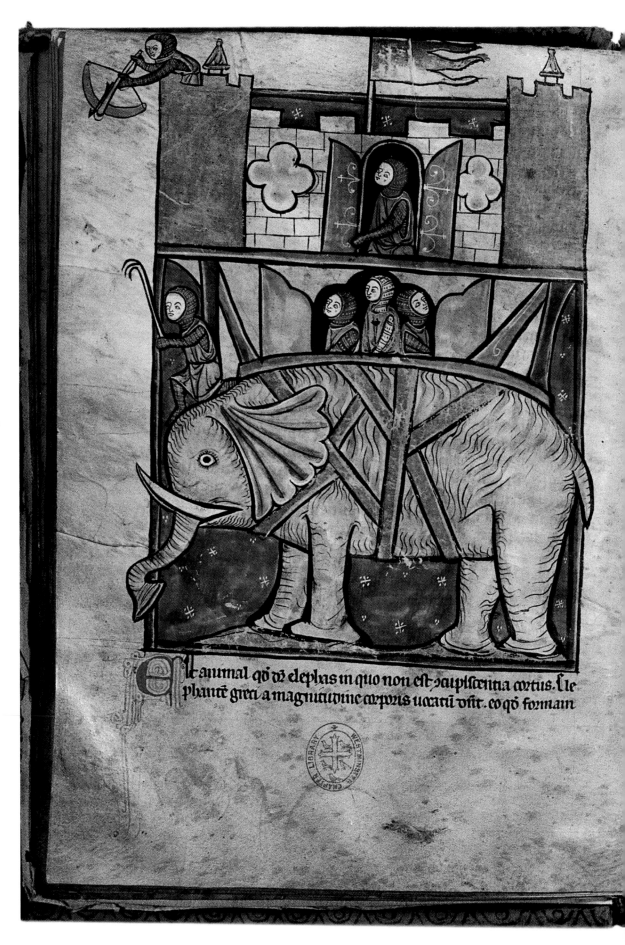

montis pfertat. hec. n. mons elipho di. Aput nidos aut a uoce burro
uocatur. cui est t uox eius burritus. t dentes ebur. Rostru ai p manus
ciam di qd illo pibulo oi admouet. Est angui similis uallo munu
ta eburneo. Gregatim incedunt. murem fugiunt. adiisi coeunt. In
tellectu et memoria multa uigent. Uiuit aii annos trecentos. Ap
solam indiam t affricam prius elephantes nascebantur. Nuc oi sola
india gignit. Hos boues lucas dictos putant ab antiquis romanis.
Boues quia nullum animal maius uidebant. Lucas qr i lucania il
los prius in prelio romanis pmo obiecit. Est. n. h genus reb; belli
cis aptum. In eis namq pse t nidi ligneis turrib; collocatis tacan
de muro dimicant. Nullu animal gignturs huis uidetur. Biennio
aii pruniunt nec amplius q semel gignit ii plures. s; tin unu. Si a
uoluerit face filios uadit ad oriente pp prohsii t est ibi arbor que uo
cat mandragore t uadit cu femina sua que prius accepit de arbore t po
rigit masculo suo t seducit eu donec t ipe manducet. statiq; i utero co
cipit. Cum uo tempus pariendi aduenit. uadit ui est stagnu. t ingre
ditur in aqua usq ad ubera t sup aqa parit ip dracone q insidiat illi.
Na si ext aq pepent. draco petus illo rapit t deuorat. ido iaq; aii in
isulas parit. Est formidabil taurus elephas tii murem timet. Est
talia ei naturi qr cu ceciderit no potest surgere. Non. n. ht iuncturas ge
niculor. Cadit aii cu se inclinat. iclinat i arbore ut dormiat. Uenator
uo arbore ex pte incidit ut elephas cu se sup ea inclinauit. similit cu
arbore cadit. Cadens a clamat fortiter. Et statim magnus elephas
exit t no potest cu leuare. Tuc clamat ambo t ueniut. xij. elephantes
t no possut cu leuare q ceccidit. Deinde clamat omis. Et stati ueit pu
sillus elephas t mittit os suu cu pmiscedia subtr magnu elephante t
eleuat eum. Habet t pusillus elephas huc naturam. ui incensum fuerit
de capillis t ossibz eius. neq aliquid postiferi accidit neq draco.

O Agni elephas t mulier eius psona hut. Ada t eue. Cu. n. carne
erent placentes do ai ipor puaricatone no sciebat coitu neq noti
ciam pcti habuerunt. Postqin a mulier manducauit de ligno hoc est de
intelligibili mandragora dedit uiro suo. Propt qd de prohso expulsi.
Usic misdu iactati sit t aq in stagnu aquaru militar. Cui hic mu

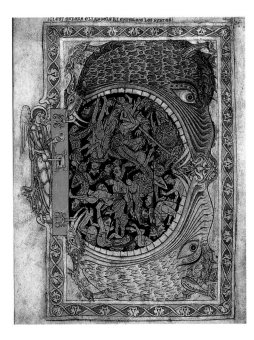

An Angel Locking the Gates of Hell
is in the Winchester Psalter, ca. 1150.

OPPOSITE *Elaborate initial letters character-
ize a German manuscript, the Regensburg
Lectionary ca. 1270, at Keble College,
Oxford.*

*I*n one of the four large paint-
ings that Edward Laning com-
pleted in 1940 for the third
floor rotunda of the main staircase of
the New York Public Library, a
cowled monk in the creamy, encom-
passing habit of the Dominican
Order, bends to the absorbing work
of a medieval scriptorium—a startling
reminder to readers who pass by that,
in the middle ages, books were made
one by one for monastics and a small
number of fortunate seculars who had
learned to read.

In monasteries and convents, scribes
worked in solitude with quills and
hand-mixed inks, pressed parchments
and milk-white vellum, weights, and
brushes of every conceivable texture
and shape and size not only for texts
but also for initial letters and decorat-
ed margins of missals for the altar and
public documents.

Later scriptoriums offered pencils of
almost metallic hardness, used for tracing
designs on vellum, from which not the
slightest mark can be erased. Near at
hand were saucers and shells of gold and
silver, agates for burnishing, cases of gold
leaf, gum arabic for mixing with pow-
dered gold and paint, dusted pumice
with which to remove all grease from
the surface of vellum and parchment,
bottles of ox-gall and gouache and
paints, small cakes and tubes and pans
and bottles; and scarlet and emerald
and peacock-blue and flame and olive-
green—colors that cause pages to
glow with the brilliance of gems.

Fragments of ancient Bibles, bre-
viaries, and some of the ceremonials
and other volumes that issued from
the early scriptoriums rest now in the
libraries of a handful of English
cathedrals, episcopal residences such
as Lambeth Palace in London and
Bishopthorpe in York, and a few sem-
inaries and societies in Britain, the
Commonwealth, and the U.S.
Salisbury, which owns 187 ancient
manuscripts, including the most per-
fect of four existing copies of the
Magna Carta. Winchester prizes the
book of antiphons from which the
Os of Advent ("O come, O come,
Emmanuel...") sung annually in
Anglican and Episcopal churches. In
New York, General Seminary, until
recently, owned a copy of the original
Gutenburg Bible.

Ely and Exeter's trove of books are of
inestimable value, but the most dis-
tinctive storehouse of venerable man-
uscripts is Hereford Cathedral's
"Library of Chained Books" where
tomes produced by hand are fastened
to shelf after shelf and where the first
map of the world, *Mappa Mundi*,
1290, is displayed on a weathered strip
of leather. Wells Cathedral honors the
materials used by a twelfth-century
College of Vicars and Vicars Choral,
corporate bodies that survived until
the Reformation. Carlisle lodges its
collection in a small building called
the Fratry.

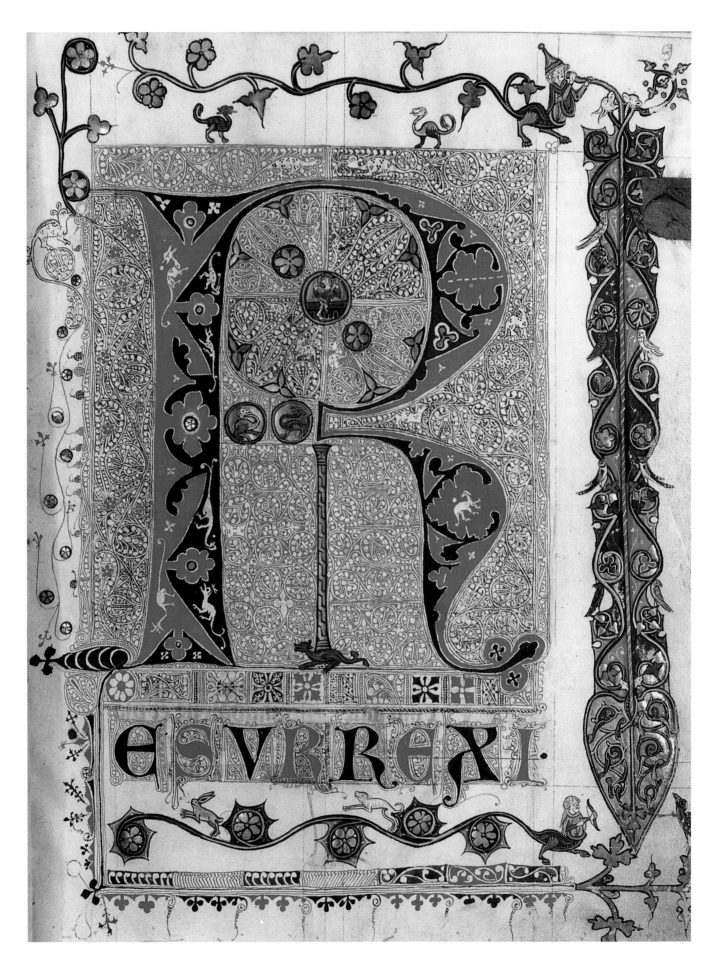

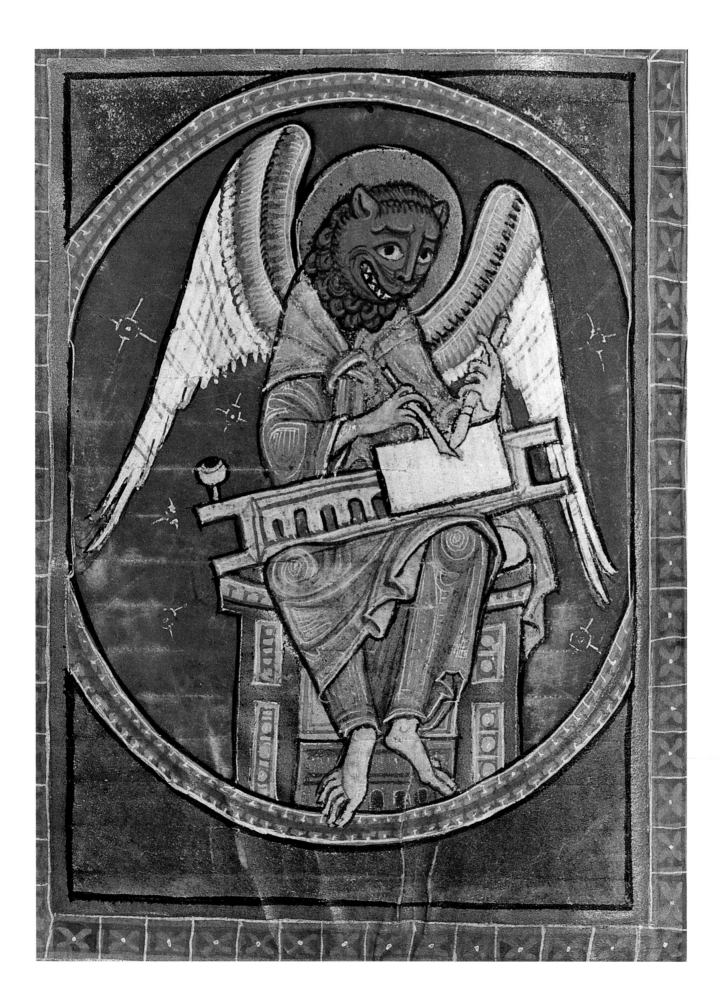

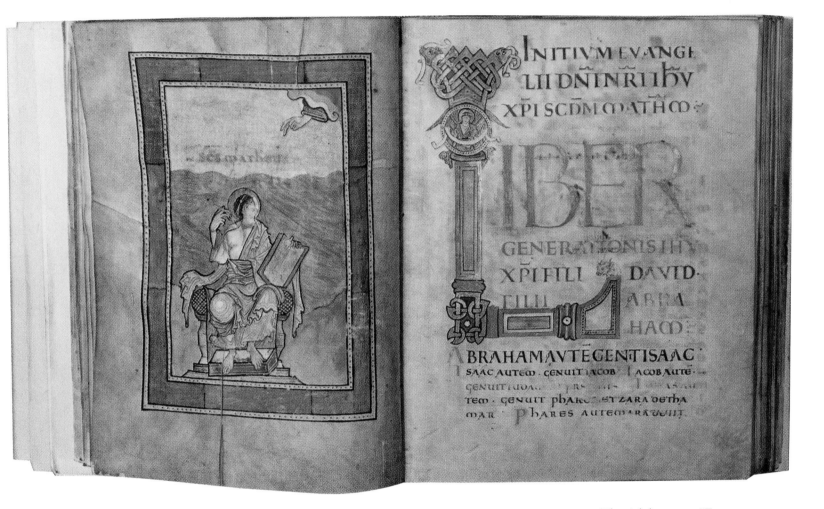

The eighth-century "Four Gospels" manuscript was given to Hereford Cathedral in the twelfth century by Bishop Athelstan. It is the oldest book in the cathedral's renowned library.

The York Gospels, dating from 1020, on which archbishops of York take their oath of office, is in the library of York Minster.

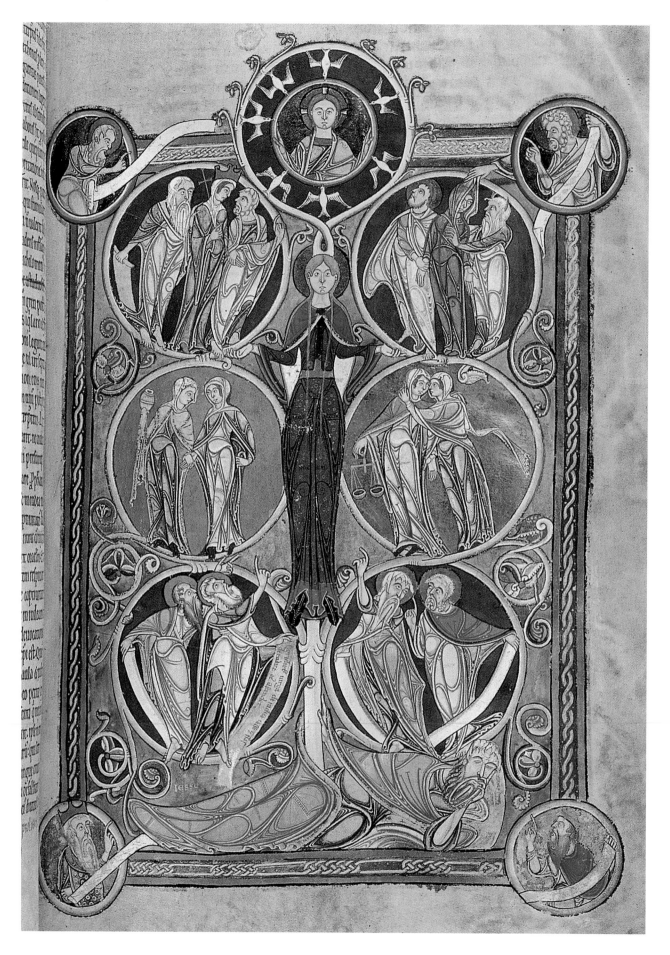

OPPOSTIE *The Tree of Jesse from the Lambeth Bible, ca. 1140–1150, part of Archbishop William Bancroft's collection that provided the beginnings of the Lambeth Library, is a superb example of English Romanesque art.*

RIGHT *The* Great Bible *of 1539 is believed to have belonged to Archbishop Thomas Cranmer, Biblical revisionist and author of much of* The Book of Common Prayer.

An illustrated initial from the Litlyngton Missal, *1383–1384, in Westminster Abbey.*

OPPOSITE *A scene of Saint John on the island of Patmos, is one of thity miniatures in* The Rhodes Missal *of 1500. The missal is housed in the library of the Order of Saint John of the Hospital of Jerusalem at Saint John's Gate, London EC 1.*

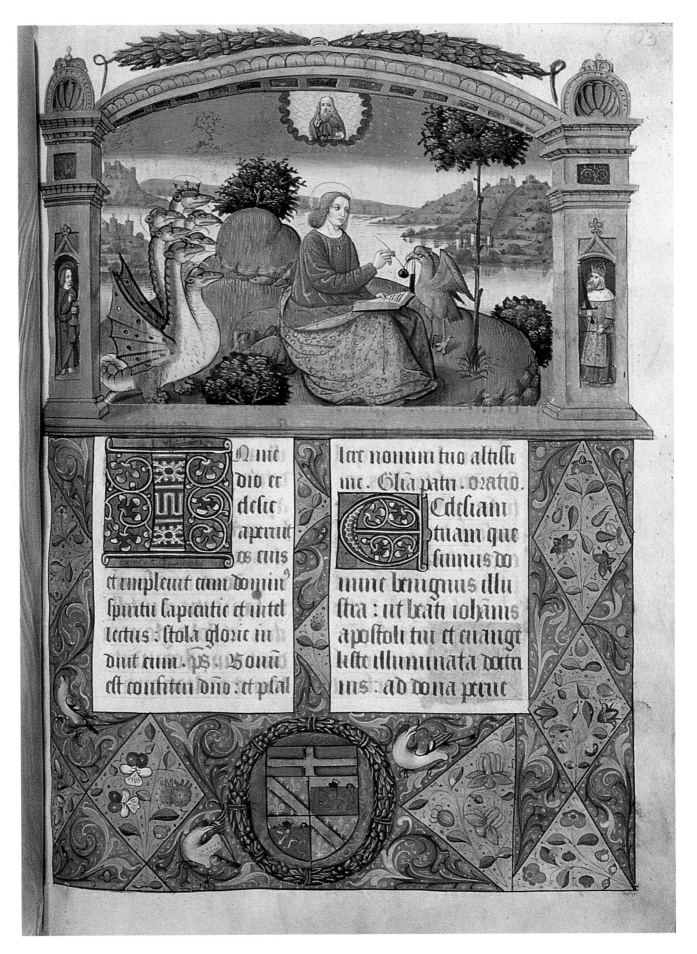

On mé
dio ec
clesie
apitur
os eius
et implenit eum domi⁹
spiritu sapientie et intel
lectus : stola glozie in
duit eum. ps. 25 onū
est confiteri dño : et psal

lat nomui tuo altissi
me. Glía patri. ozatio.
Ecclesiam
tuam que
sumus do
mine benignus illu
stra : ut beati iohānis
apostoli tui et euange
liste illuminata dortri
nis : ad dona preue

Metal

The sculptor Clark B. Fitz-Gerald of Castine, Maine, used contrasting metals in a depiction of a modern skyline with God's plumb line coming down out of Heaven to test a city's life as straight and true (Amos 7:8). A similar construction, commissioned in 1963 by Christ Church Cathedral, Cincinnati, Ohio, was sent from Cincinnati to Coventry Cathedral in 1963. Still another Fitz-Gerald sculpture is owned by the Episcopal Theological Seminary of the Southwest, Austin, Texas.

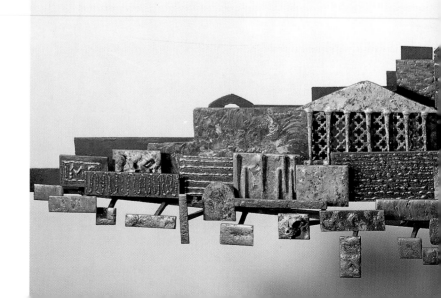

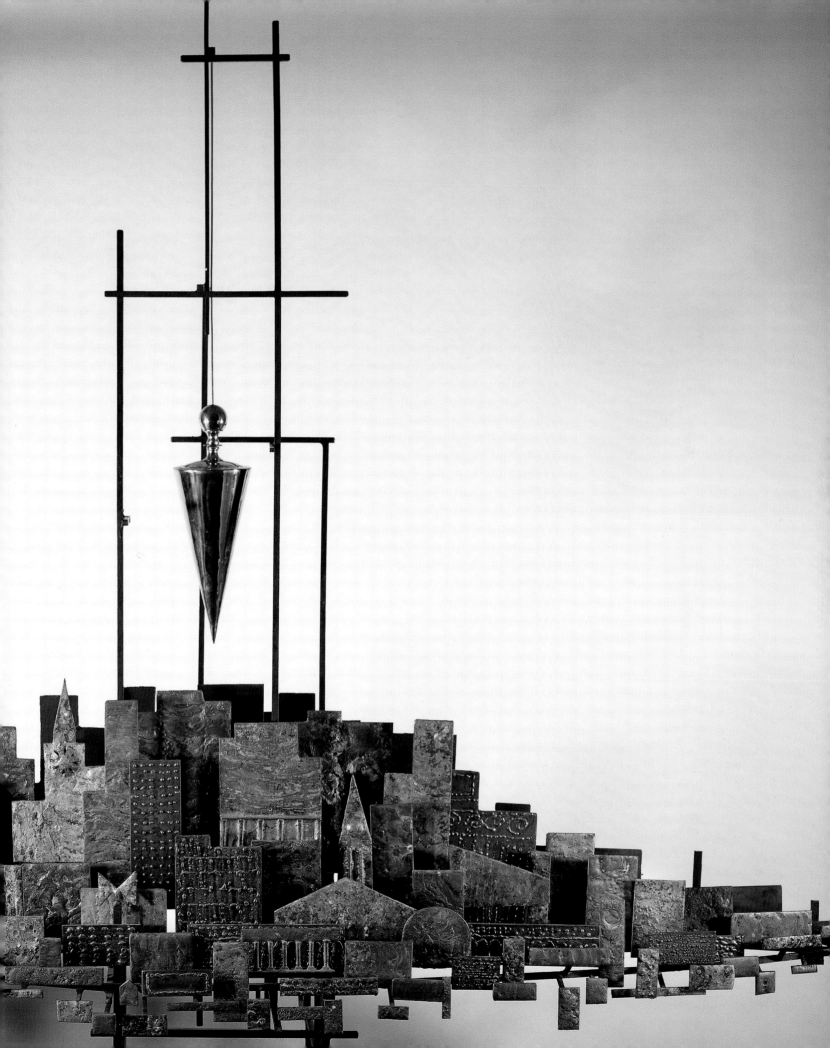

The American merchant prince Rodman Wanamaker gave the fifteenth-century Spanish processional cross (LEFT) to the Church of Saint Mary Magdalen on the royal estate at Sandringham, Norfolk, in 1915.

Metal is cold to the touch and speaks more of discipline than of love. Yet metal lends itself well to some of the Church's finest art.

Think of the altar and the cross, plain, inscribed, or bearing a keenly wrought corpus of the finest gold or silver. Recall the candlesticks that vary from the baroque to the sleekly modern—from two candles on simple altars to the great eucharistic candles, three on each side of the tabernacle, in Anglo-Catholic churches.

It is highly appropriate that American steel producers fashioned a steel table to serve as the altar for Trinity Cathedral, Pittsburgh, Pennsylvania, the center of U.S. steel production. The Church relies on metal for the pectoral crosses, rings, and crosiers that it bestows on the episcopate. It looks to metal for much that is needed at the altar besides the cross and sacred vessels, be they cruets and flagons, missal stands, candlesticks, or tabernacles; and for furnishings of the sanctuary from vigil lights, gates, altar rails, thuribles, memorial brasses, medallions, offering-plates, Paschal candlesticks, even organ pipes.

Then there are the great bronze doors of affluent churches and cathedrals. At New York's St John the Divine there have been since 1930 two large menorahs, flanking the high altar. Designed in bronze overlaid with gold, after those used in the temple at Jerusalem, they speak

majestically of Christianity's links with the Old Testament and more recently have been designated as memorials of the Holocaust.

Think, too, of the slender columns of a fine choir screen, the golden leaves of Hereford Cathedral's hanging corona, the sharp edges of a crown of thorns, and the Compass rose emblem of international Anglicanism in the chancel floors of Canterbury, New York, Washington, and elsewhere. Call to mind the hand made nails from the wartime ruins of Coventry Cathedral that have been forged into crosses for friends and former foes united in the world wide Community of Nails and the shared motto, "Father, forgive."

Bells have long called the faithful to Sunday worship and to prayer in the *Angelus* that punctuated the day; bells rang to warn; they heralded life's gladdest moments, and tolled for the dead, borne on the wind from Canterbury's Bell Harry tower, Washington Cathedral's *Gloria in Excelsis* tower, or the humble belfries of country churches. While usually hidden from sight and almost inaccessible, whether gentle or deep-throated, bells aren't timid, they make themselves known. They have their own unique mission, have been inscribed, baptized, blessed, and dedicated to long lives marred only by the occasional crack or when fires send them clanking discordantly to the pavements below.

Metal, almost indestructible, sets up shop and *dwells*—like faith.

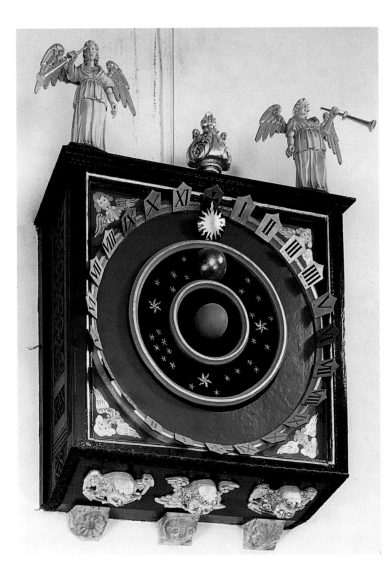

England's carefully crafted astronomical clocks, such as (ABOVE) the fourteenth-century beauty at Wimborne Minster and (RIGHT) a bishop of Exeter's gift to his cathedral in the late fifteenth century, were official timepieces prior to the establishment of Greenwich Mean Time. Amusing mechanisms, like the jousting knights that appear on the hour on a clock at Wells Cathedral, brought in many who could not tell time and would not otherwise be in a church, as well as those who stopped by to follow phases of the moon that certified the day, month, and year. Durham Cathedral's fifteenth-century clock was considered grotesque and ban-

ished to a shadowy transept. At Oxford, a clock ten minutes ahead of London time still dictates services that begin ten minutes after the hour. It fell to York Minster to erect a modern astronomical clock, elegantly styled in the workshop at Greenwich, as a memorial to 18,000 Allied airmen who lost their lives in World War II when flying out of bases in Yorkshire and the northeast. "As dying, and, behold, we live," declares an inscription from II Corinthians 6:9; and a memorial book remembers that "they went through the air and space without fear and the shining stars marked their shining deeds."

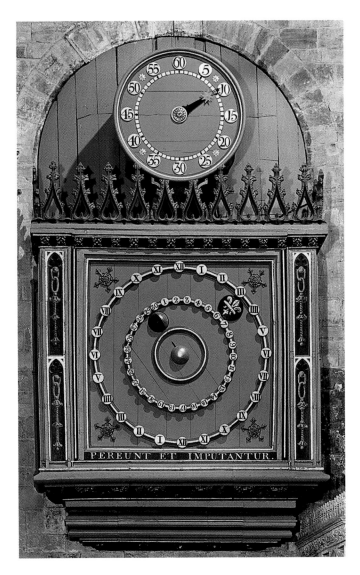

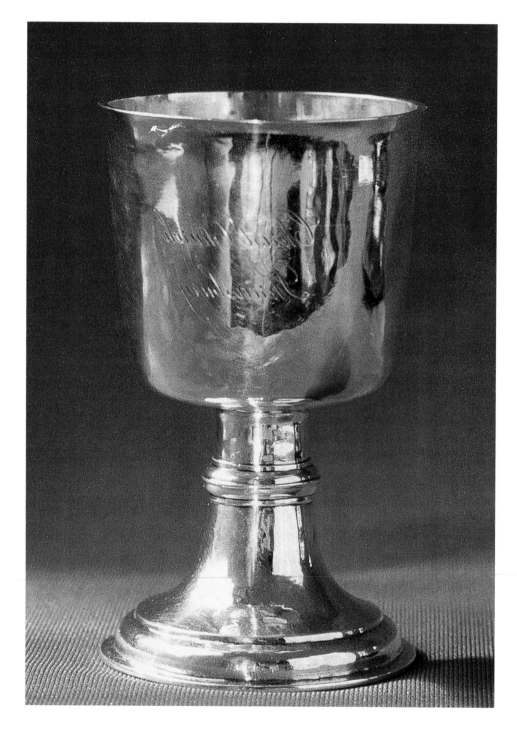

Between the years 1694 and 1779, the Lord Chamberlain's office, as agents of the crown, sent sixty-three gifts of chalices and patens of Britannia silver, as well as pewter alms basins, to the American colonies. Among the recipients was Christ Church in Shrewsbury, New Jersey, which received what is now known as the "Shrewsbury Chalice" (BELOW). When nearby Middletown became a separate parish in 1854, Shrewsbury stressed its custody of the prized vessel by boldly engraving its name on the side, although it might have taken a cue from the inscription on the chalice sent to Bruton Parish Church, Williamsburg, Virginia: "Mix not holy things with profane."

OPPOSITE Westminster Abbey's processional crosses: Pierced metal Coptic cross, given by the Emperor of Abyssinia for the coronation of Edward VII in 1902; the nave cross, given by Rodman Wanamaker in 1922, studded with sapphires plus seventy-two diamonds added by one of his descendants for the Abbey's 900th anniversary; the ivory cross, enhanced with silver and gold; and the Westminster cross. The candlestick is one of a pair purchased for the sum of £80 left by a housekeeper at Westminster School in 1691. The candlesticks have stood ever since on the Abbey's high altar.

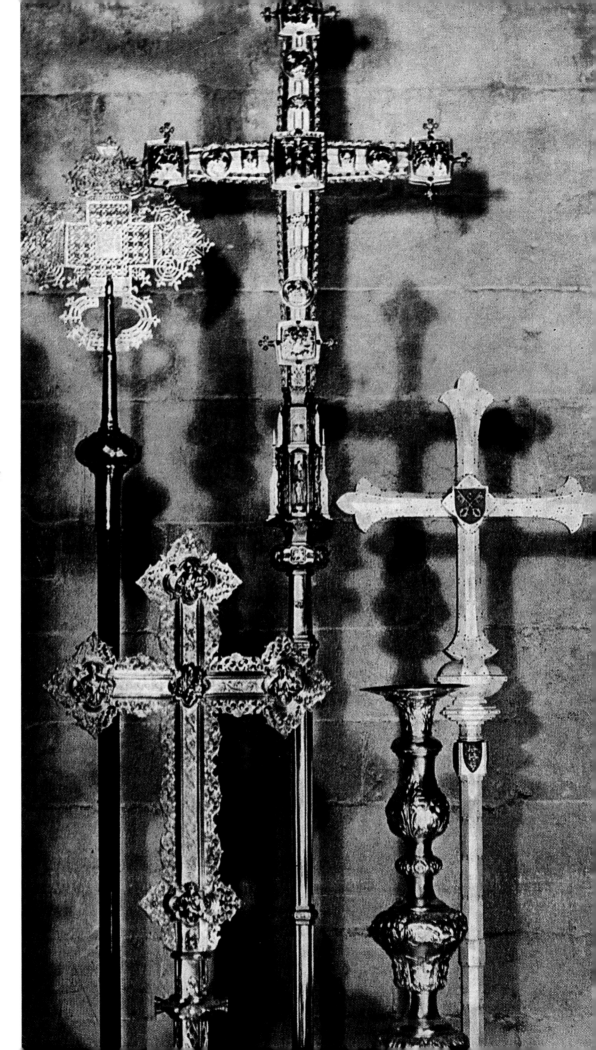

Westminster Abbey's processional crosses: Pierced metal Coptic cross, given by the Emperor of Abyssinia for the coronation of Edward VII in 1902; the nave cross, given by Rodman Wanamaker in 1922, studded with sapphires plus seventy-two diamonds added by one of his descendants for the Abbey's 900th anniversary; the ivory cross, enhanced with silver and gold; and the Westminster cross. The candlestick is one of a pair purchased for the sum of £80 left by a housekeeper at Westminster School in 1691. The candlesticks have stood ever since on the minster's high altar.

OPPOSITE TOP *This baptismal bowl was given by a parishioner to Trinity Church, Newport, Rhode Island, in 1734. Its Latin engraved inscription's English translation is "Bequest of Nathaniel Kay, Esquire, for the use of the Anglican Church, in Newport, in the Island of Rhode Island, in the year of Salvation, 1734."*

OPPOSITE BOTTOM *The scene on a day in 1749 that a schoolhouse fire was kept from spreading to Trinity Church, Wall Street, in New York, was engraved on a silver punch bowl by the silversmith Adrian Bancker. The bowl was placed on anonymous loan to The Metropolitan Museum of Art in 1925.*

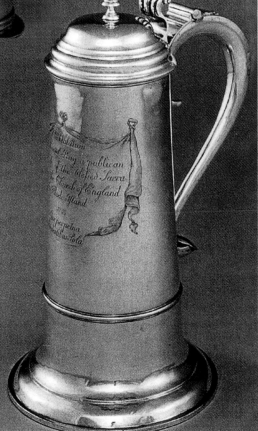

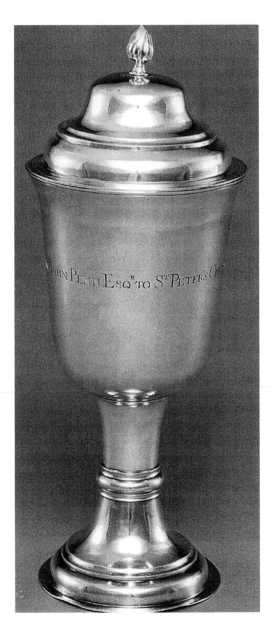

LEFT TO RIGHT *A beaker for Communion wine by the Rouen-born César Ghiselin, Christ Church, Philadelphia, 1772; a flagon by Benjamin Brenton, 1734, Trinity Church, Newport, Rhode Island; and a chalice with paten as lid at Saint Peter's, Lewes, Delaware.*

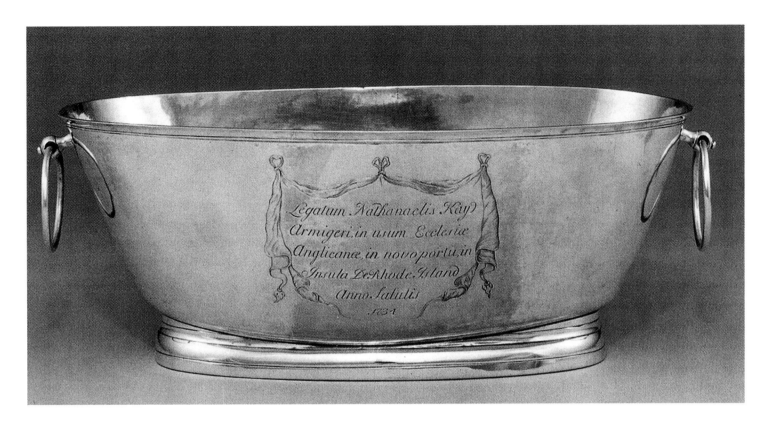

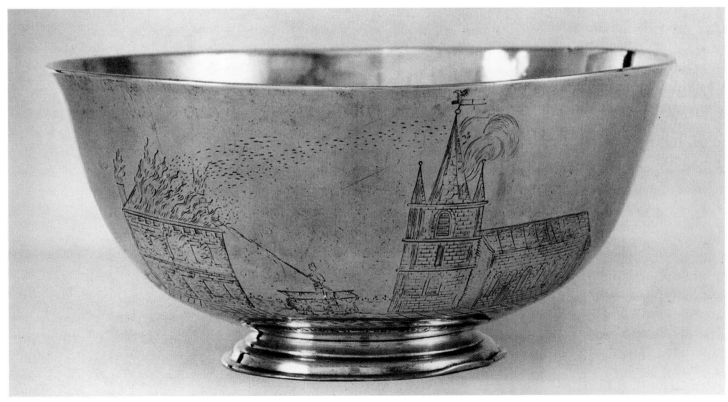

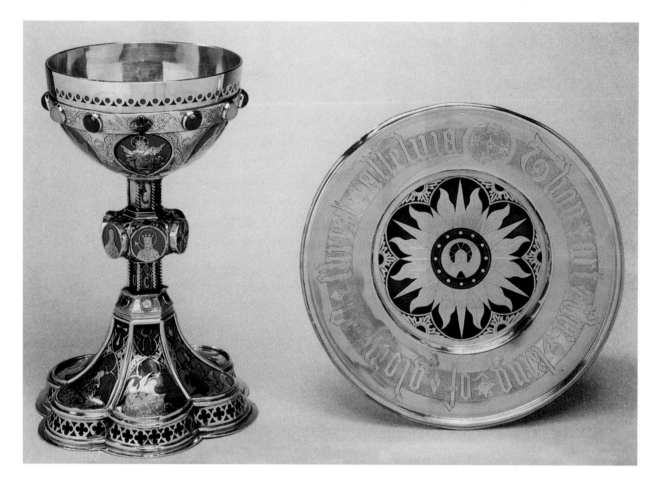

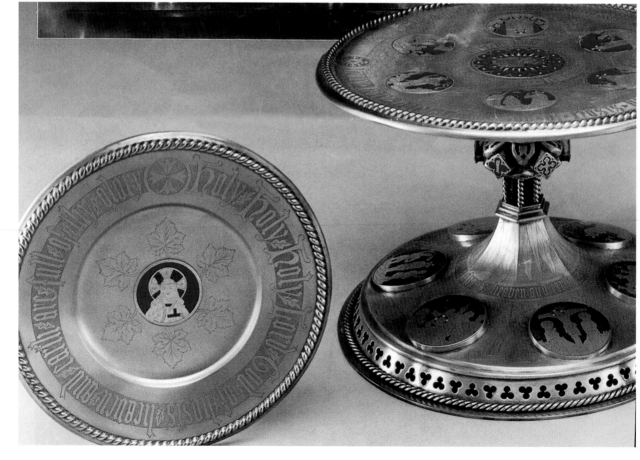

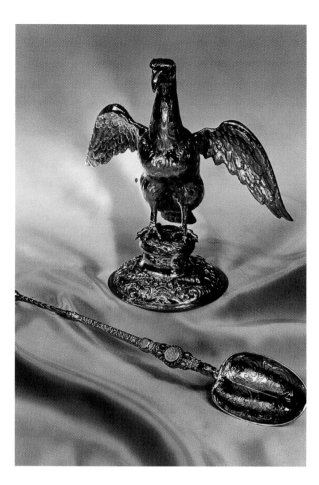

OPPOSITE *Colored enamels distinguish a chalice and paten crafted in 1852 by F.W. Cooper for Grace Church, Brooklyn Heights, New York; ten years later, Cooper working with Richard Fisher, made a paten and footed Communion plate for Trinity Church, Wall Street, New York.*

LEFT *Holy oil for the anointing of a sovereign is contained in this golden eagle and poured through its beak into the spoon in the most solemn moment of coronations at Westminster Abbey.*

BELOW *At Saint Thomas Church on Fifth Avenue in New York, are, from right to left, an 1823 silver ewer, a silver gilt Gospel book, a 1904 chalice with diamonds and turquoise, and a Gospel book designed by Maurice Duvalat with precious and semiprecious stones. They are displayed here with antique needlework on a cream-colored chasuble.*

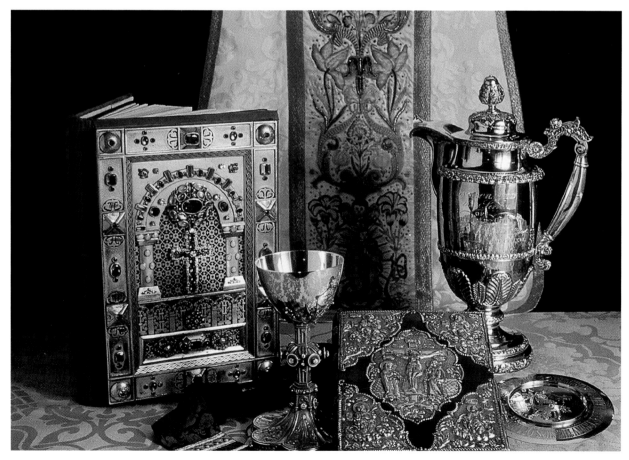

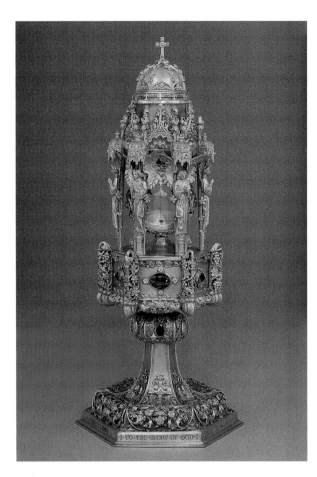

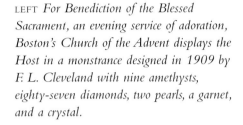

LEFT *For Benediction of the Blessed Sacrament, an evening service of adoration, Boston's Church of the Advent displays the Host in a monstrance designed in 1909 by F. L. Cleveland with nine amethysts, eighty-seven diamonds, two pearls, a garnet, and a crystal.*

BELOW LEFT *At the Convent of the Holy Name at Oakwood, Derby, a hexagonal pyx, designed in 1893 by Sir Ninian Comper, is situated on a circular plate with doors that open to reveal a ciborium with Communion wafers reserved from an earlier Eucharist. Topped with a Maltese cross, the beaded stem and round base are secured in an indentation in the floor. A four-sided steeple with Gothic Revival windows rises above.*

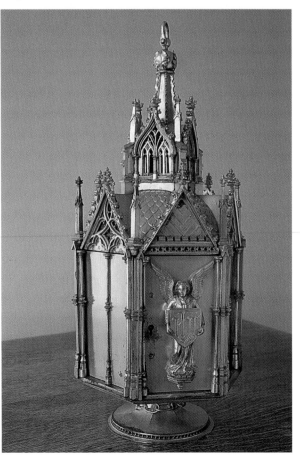

OPPOSITE *At All Saints, Margaret Street, London, Sir Ninian Comper restored the 1859 tableau of saints originally by William Dyce, and in 1928 suspended between them a Comper-designed, three-tiered, nine-foot-high pyx. Modeled as a church with a gabled entrance, it is crowned by a slender spire matched by the baptismal font at the opposite end of the church's nave. The pyx was given by the Duke of Newcastle in 1929 as a memorial to choir members killed in World War I. The altar frontal, designed by Stephen Dykes-Bowers for Watts & Company, was embroidered by the skilled needlewoman Winnie Peppiatt. "She rose to great heights and did all of Sir Ninian's best work," wrote historian Mary Shoeser, "especially in refining the or nué technique, the use of silk floss couching thread, that he had seen in Belgium."*

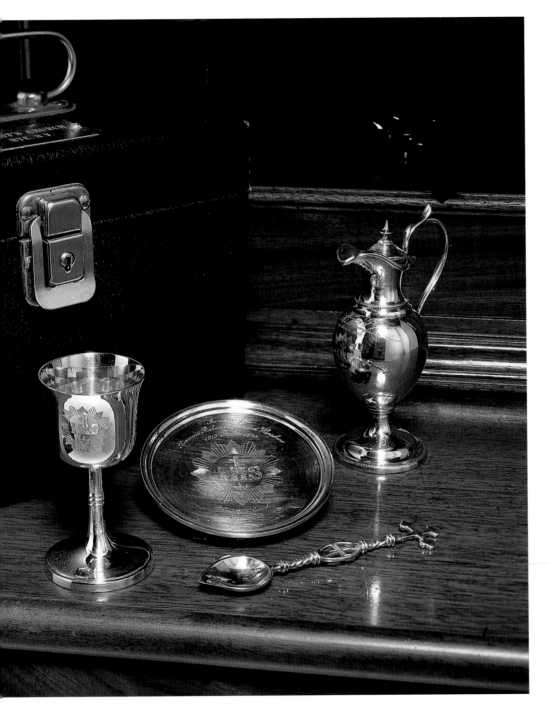

LEFT *This minutely engraved kit for Holy Communion was carried to France in the waning days of World War I by Richard Townsend Henshaw, rector of Christ's Church, Rye, New York.*

OPPOSITE *Lecterns in different materials are:*
TOP LEFT *In stone, at Saint Bartholomew's, Park Avenue, New York*
TOP RIGHT *In bronze, Liverpool Cathedral;*
BOTTOM LEFT *In iron, Trinity Church, Chicago, a winner in the Gorham Company's display at the 1893 Columbian Exposition, and which survived a fire in 1920 that destroyed the old Trinity Church;*
BOTTOM RIGHT *A brass pelican, 1380, at Norwich Cathedral.*

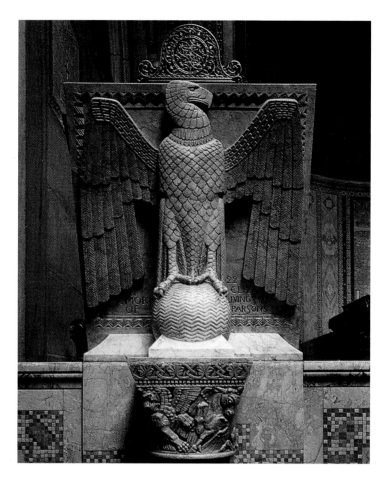

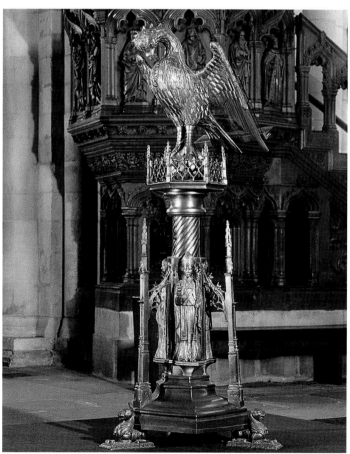

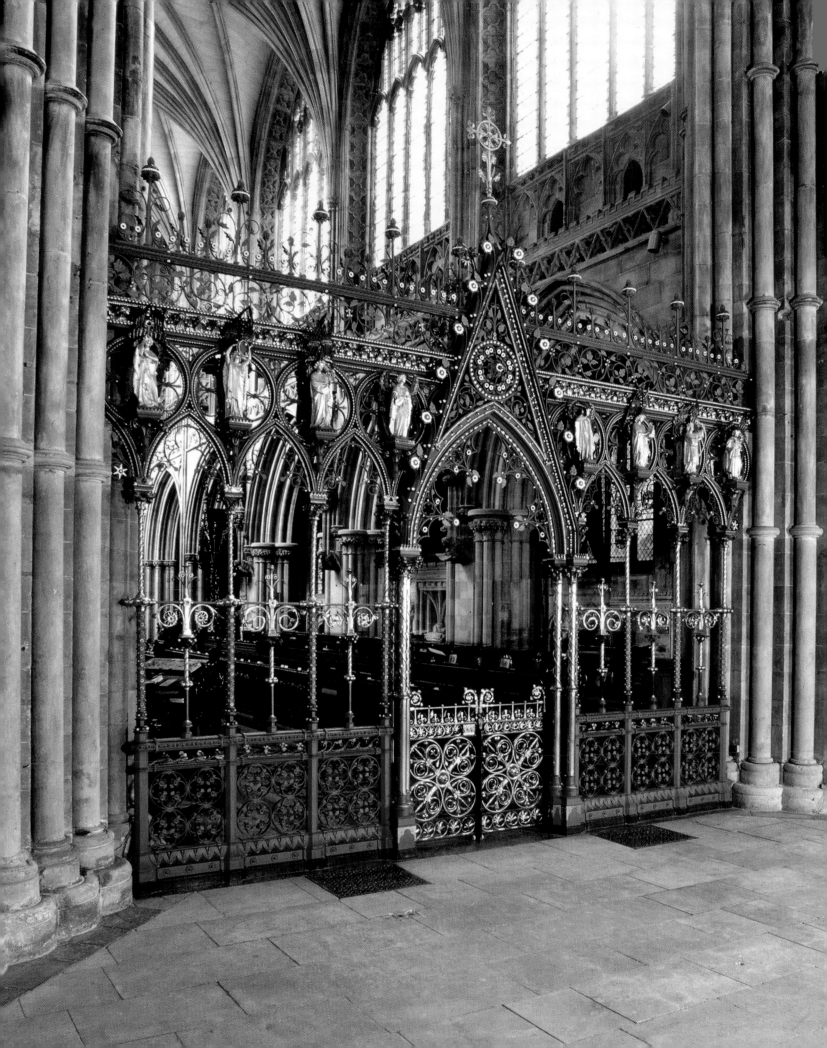

OPPOSITE *On the reordering of the choir at Lichfield in 1855, Sir George Gilbert Scott suggested an openwork screen—the first in an English cathedral.*

RIGHT *The ornate gates standing at the entrance to Saint John's Chapel in Saint Mary's Church, Bristol, are similar to the celebrated sanctuary screens worked by Jean Tijou for Saint Paul's Cathedral, London, between 1691 and 1709.*

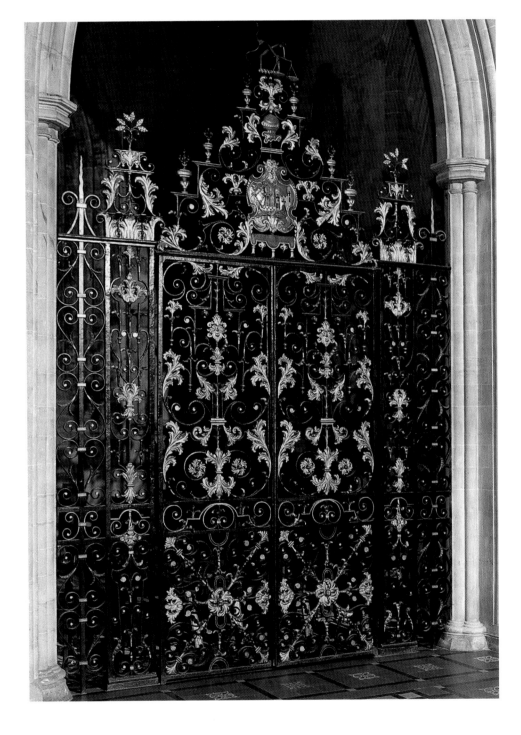

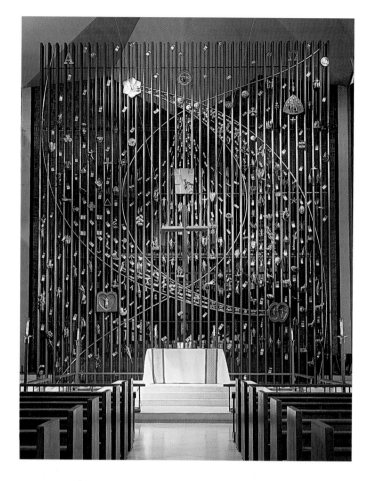

LEFT *Creation, redemption, and infinity are the triune themes of 184 figures and symbols relating to the journey of life in Clark B. Fitz-Gerald's 1961 reredos at Saint Mark's Church, New Canaan, Connecticut. The sculptor used bronze, brass, tin, and wood in the sixty-foot high construction. The figures and symbols are placed on an open grill of vertical bars separating altar and choir.* BELOW LEFT *at the center of the screen, Christ leans down to touch all humankind.*

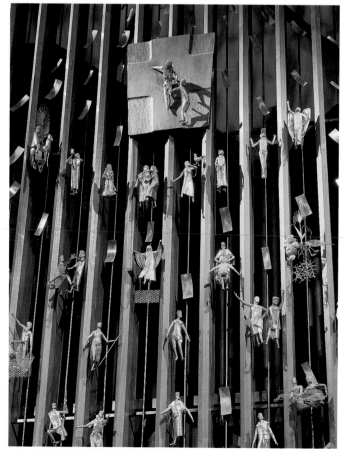

OPPOSITE *At Llandaff Cathedral in Wales, Sir Jacob Epstein's 1957* Majestas *reigns in stark power over a nave that had been left roofless by wartime bombing. The unpolished, 700-pound aluminum figure fronts a* pulpitum *that houses a positive organ and provides niches for gilded teak figures salvaged from the ruined choir. "[The figure was] conceived in the spirit of Byzantine mosaics," wrote Sir Jacob's biographer, Richard Buckle. "The open, giving hands and the hanging feet touching no floor are modeled with a large and simplified realism; only El Greco and Rembrandt have rivaled Epstein in making heads of Jesus in which virile beauty is balanced by intellectual power."*

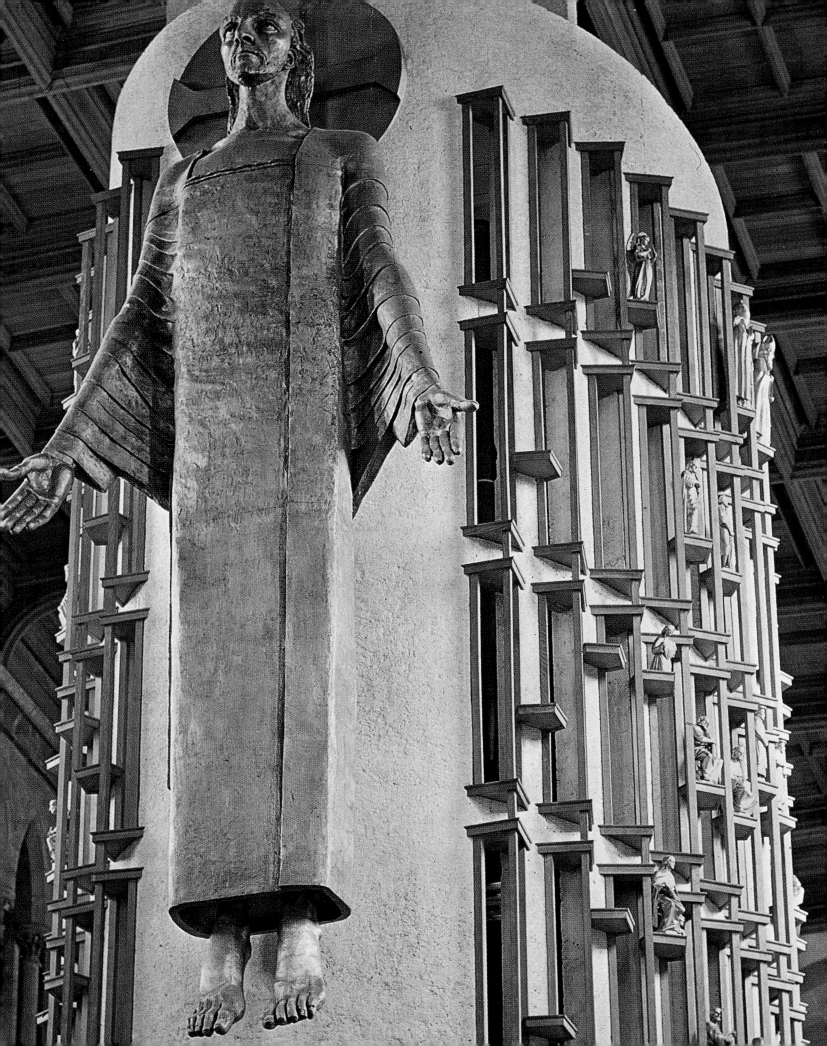

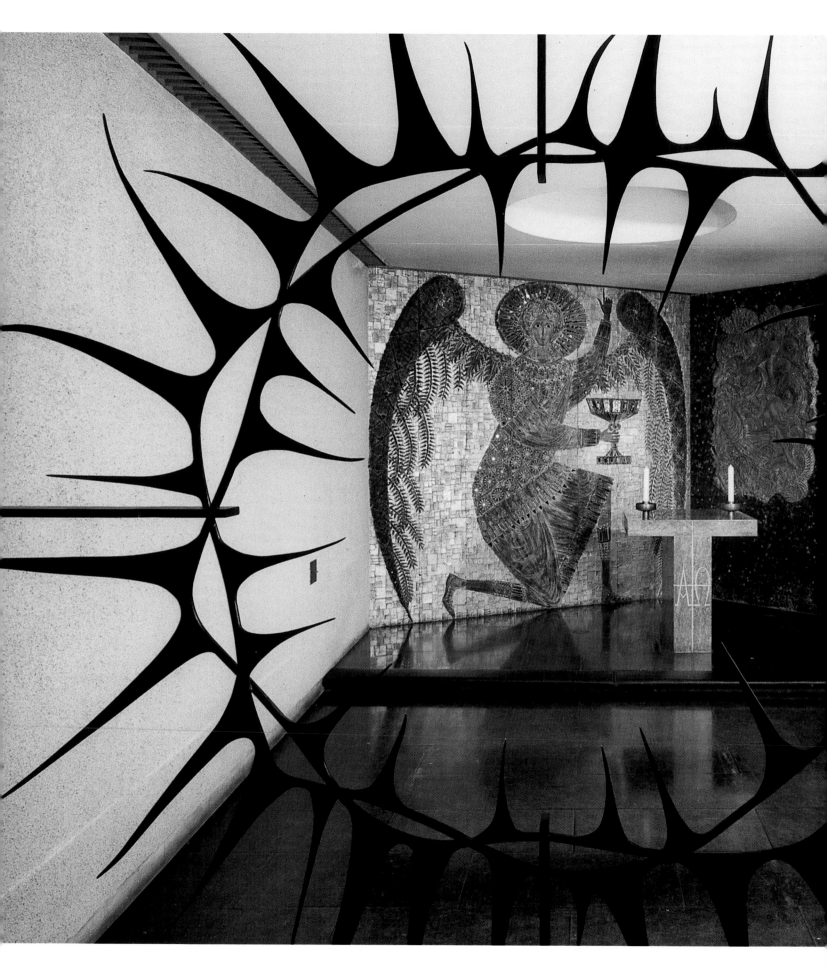

LEFT *Sir Basil Spence's 1962 wrought iron crown of thorns is a gate that opens to Coventry Cathedral's Gethsemane Chapel. The mosaic* Angel of Agony *is by Steven Sykes.*

RIGHT *In Sykes's head of the crucified Christ in Washington National Cathedral's War Memorial Chapel, the brass halo simulates cannon shells and the thorns of cast aluminum suggest barbed wire.*

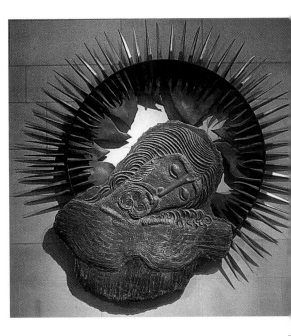

RIGHT *At the site of Thomas à Becket's martyrdom in Canterbury Cathedral, sculptor Giles Blomfield's wrought iron pieces (1986) suggest both crosses and the swords by which Becket was slain in the year 1170.*

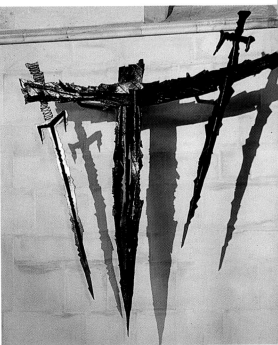

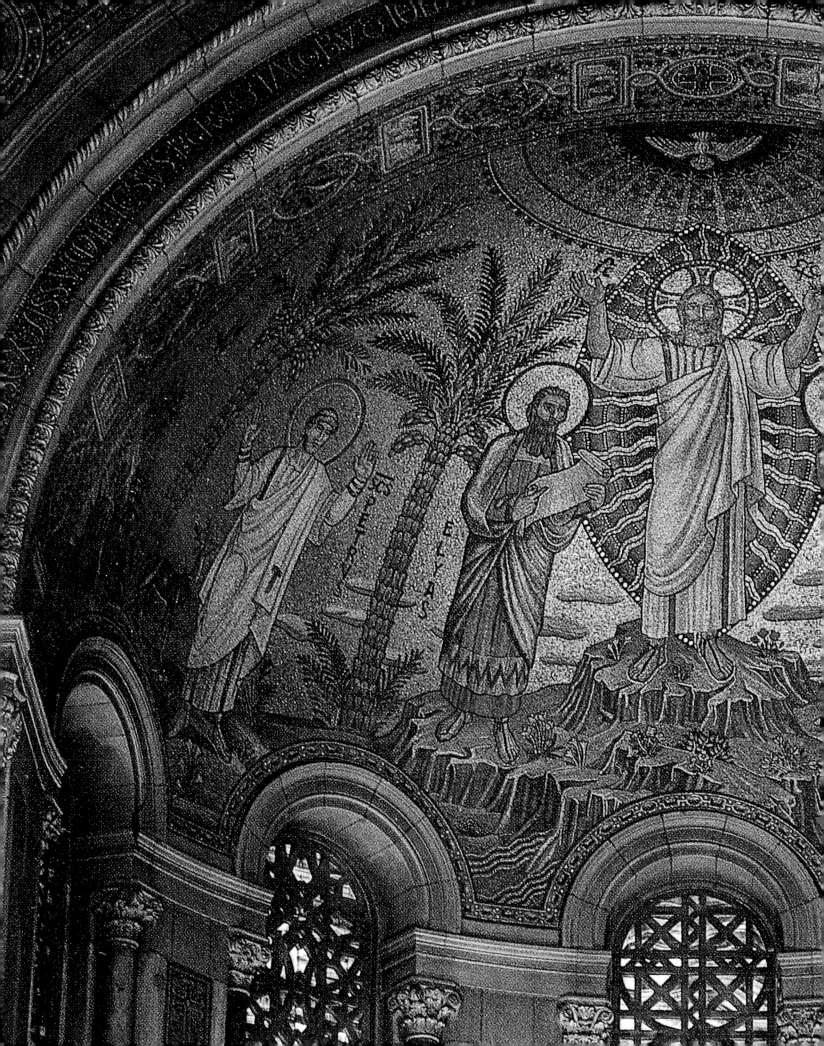

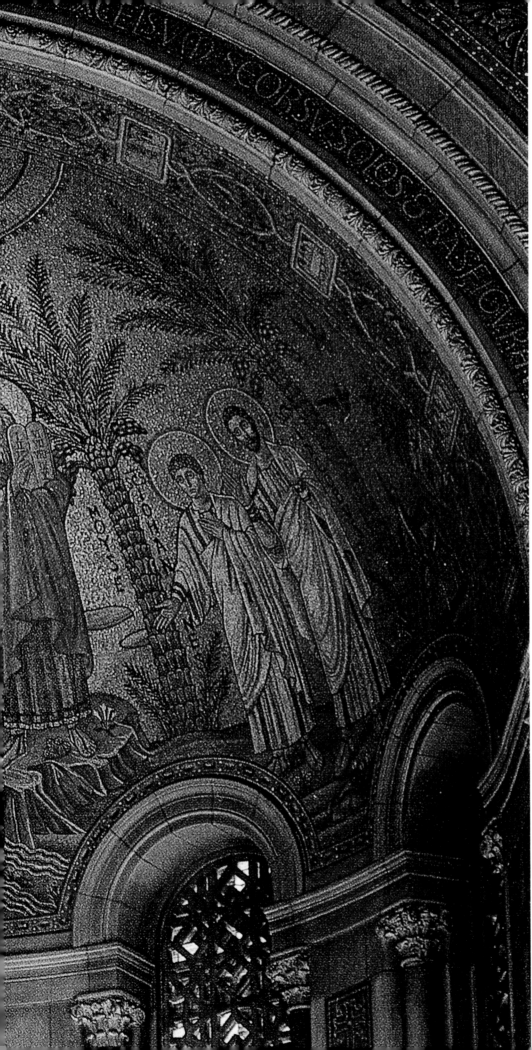

Mosaics

Hildreth Meiere's 1927 Transfiguration of Christ *was not part of the architect's plan and did not find its place in the apse until 1927, eight years after the completion of Saint Bartholomew's Church, Park Avenue and 50th Street, in New York.*

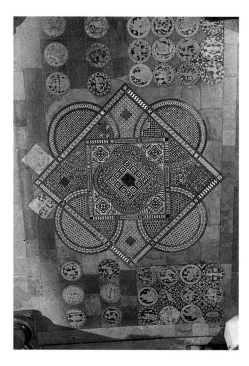

An intricate mosaic floor near Canterbury Cathedral's high altar dates from the late twelfth century.

OPPOSITE *Beyond the high altar, a mosaic floor in gold and brown is all that remains of the original shrine of the martyred Thomas à Becket.*

Mosaics—when defined as paintings or patterns created from *tesserae*, cubes of colored glass, stone, or marble, embedded in plaster—rival the place of paintings in religious art, as can be seen at Canterbury and Westminster, in Victorian excess, and in the restrained coolness of modern mosaics that form shimmering, multi-colored narrative on walls and floors.

In Rome, for instance, the darling of the stained glass world, Edward Coley Burne-Jones, turned to mosaics with great intensity when King Victor Emmanuel permitted the construction of an Anglican church, St Paul's-Within-the-Walls. "I want big things to do and vast spaces," he chortled, "and for common people to say, 'Oh!'—only 'Oh!'" A half-century later, at St Bartholomew's in New York, architect Bertram Grosvenor Goodhue, warned that the drift toward using Byzantine mosaics could result in an interior that "looks more like *Arabian Nights* or the last act of *Parsifal* than any Christian church."

The long, widespread use of mosaics is reflected in several languages—in Middle English *musycke*, in Old French *mosaique*, from Old Italian *mosaico*, from Medieval Latin *musaicum*.

In early mosaics in Constantinople, gold leaf was trapped between layers of transparent glass to produce an overall gold background. Each *tesserae* was embedded at a slightly different angle to its neighbor and together they vibrated in the light like cut diamonds, giving a unique richness of surface and intensity beyond that of any pigment.

The unknown writer or writers of the Old Testament's Book of Exodus report a vision of "the God of Israel: and there was under his feet as it were a paved work of sapphires stone..." Another favored stone, onyx, is thrice mentioned in Exodus.

The historian and art conservator Helen de Borchgrave notes that the Greeks developed mosaics into a sophisticated and elaborate art, more popular than paintings as a form of rnamentation, and that the Romans spread the skill across the empire—from North Africa to the Black Sea, from Asia to Spain—and floor mosaics became so popular in patrician, or noble homes, that Diocletian introduced a price scale for mosaicists. The Byzantine techniques preserved the ideas and achievements of Greek art in the depiction of drapery, faces, and gestures, in the modeling of light and shade and in the principles of foreshortening. In Anglican and Episcopal churches, mosaics flourished as pictures, portraits, or decorative designs made by setting small colored pieces into a surface, as durable, relatively permanent art in a kaleidoscope of colors, on floors, walls, ceilings, altars and reredoses.

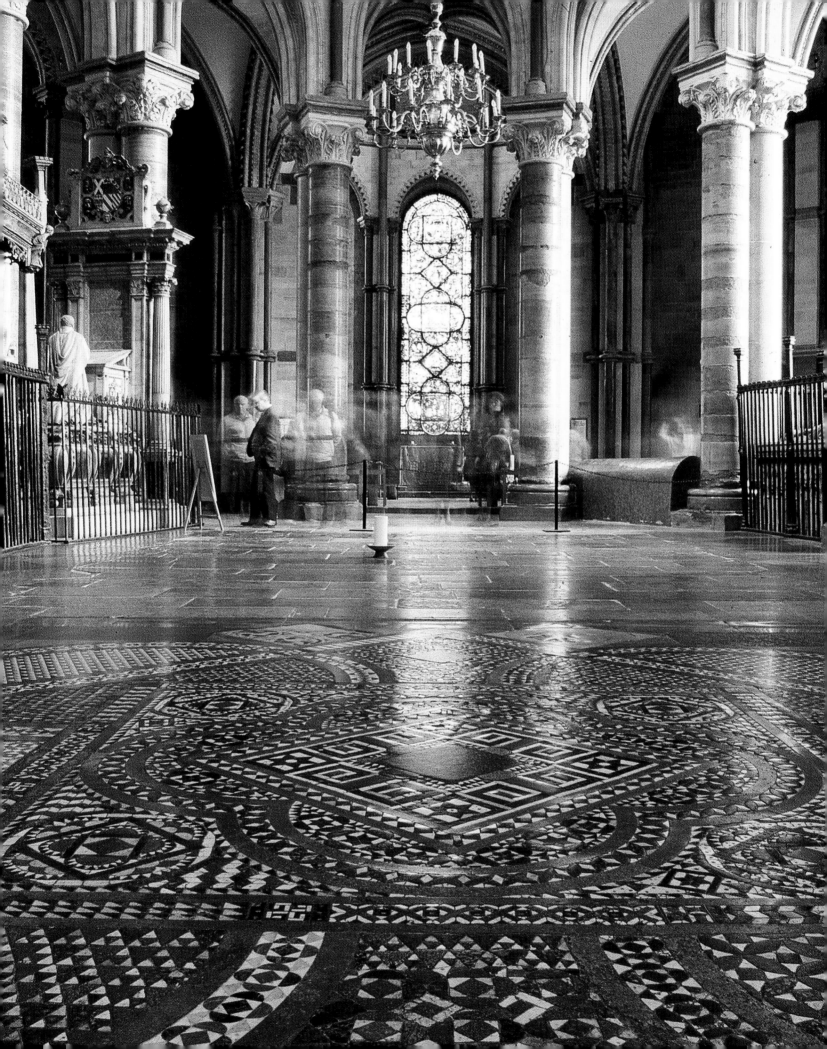

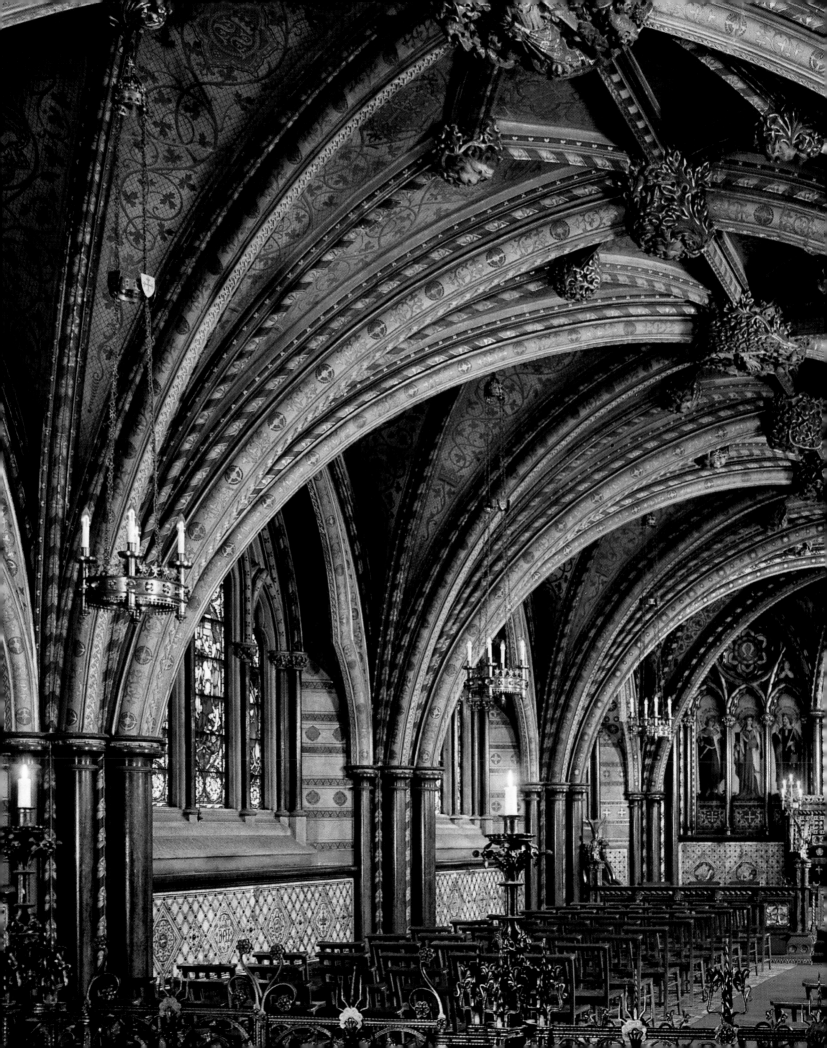

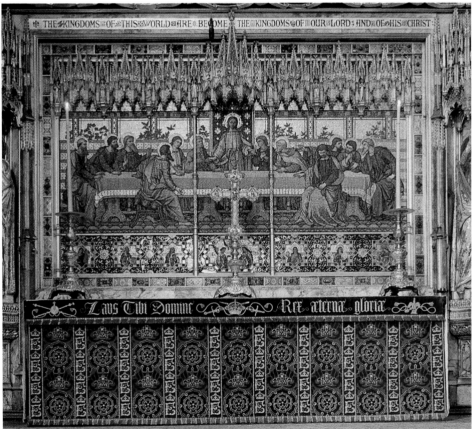

LEFT *At the Palace of Westminster, where Parliament has sat for centuries, the thirteenth-century Chapel of Saint Mary Undercroft* (LEFT), *survived the fire of 1834 and was restored in 1860. Two ecclesiastical builders and designers, E. M. Barry and Augustus Pugin, covered every surface with a tumult of vines, demons, angels, dragons, saints, and martyrs.*

ABOVE *The recessed reredos of the high altar of Westminster Abbey, a mosaic depiction of the Last Supper, stood undamaged in the midst of charred timbers and rubble after the abbey was hit hard in the wartime bombing of 1940.*

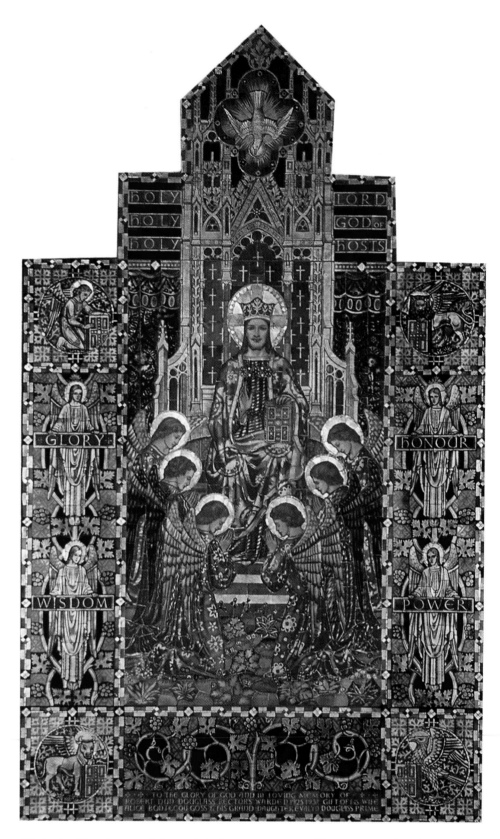

Part of mosaic's enduring appeal is its flexibility and use of variety of materials. The Venetian style of mosaics calls for glass tiles; the Byzantine needs hard-clipped tiles of marble or other stone; while ceramic tile is formed of square or broken pieces. For color, there is a fairly extensive palette in stone and a near-infinite variety available in ceramic and in glass, including Japanese-made Lumi-Tile, that glows under black lights.

In the mid-nineteenth century, it seemed that some saintly giant was striding across the skies above London, strewing bits of stone and glass for mosaics everywhere. The almost oppressive flowering of mosaics did not spare many of the most prominent churches but now, in new churches, is regarded as the exception to standard décor with much prized individuality. Indeed, creativity changes things. It is why the Louvre displays ancient Roman mosaics from the third century and why travelers stop and stare at the ten huge mosaic floor medallions in Washington's recently completed Reagan National Airport.

Christ the King in enameled mosaic is the reredos of the baptistry altar at the Church of Bethesda-by-the-Sea, Palm Beach, Florida.

OPPOSITE *The mosaic reredos of Grace Church on lower Broadway in New York is the work of James Renwick Jr. who went on to design the Smithsonian Institution, Washington, D.C.; Calvary Church, near Gramercy Park in New York; and Saint Patrick's Cathedral, New York.*

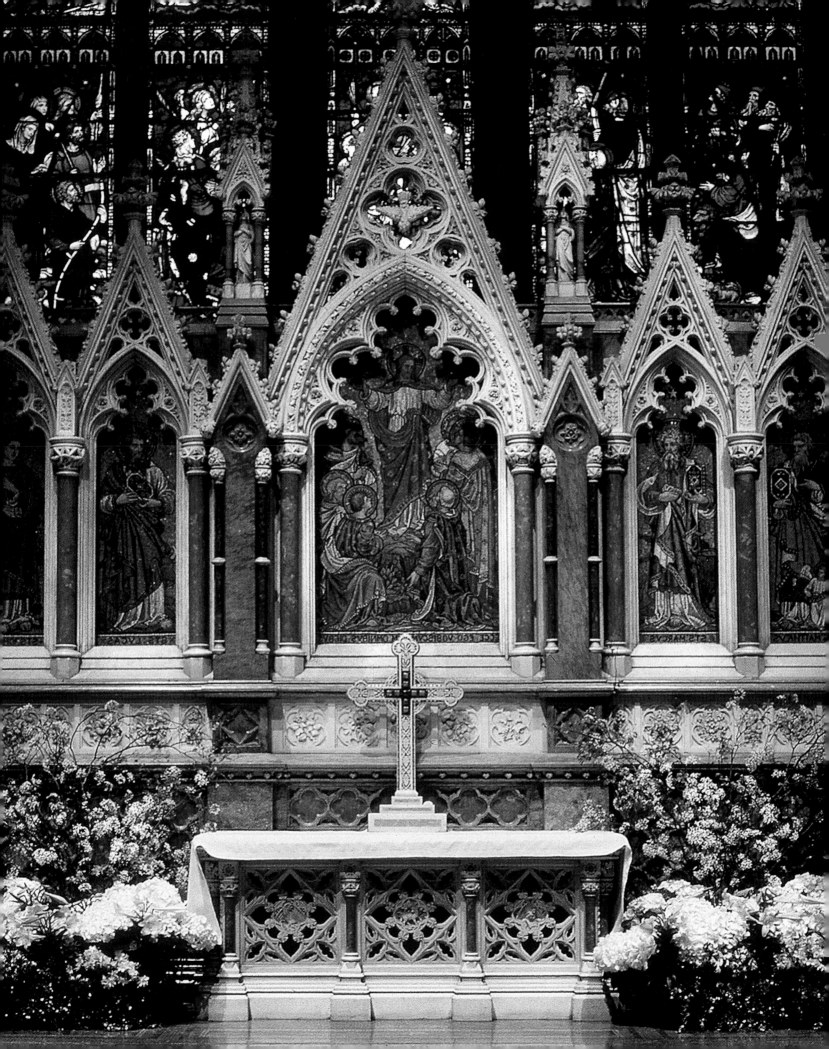

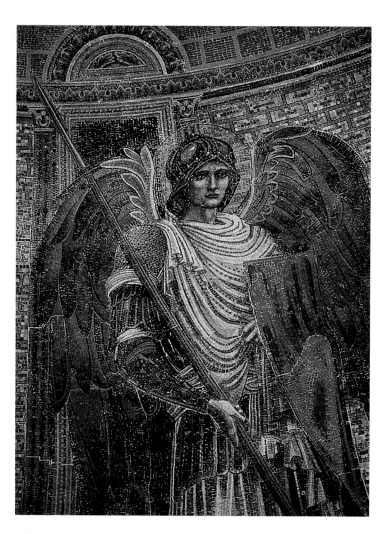

OPPOSITE *Sir Edward Burne-Jones's great sweep of mosaics dominates the Church of Saint Paul's-Within-the-Walls on Via Napoli in Rome. Its planning began in 1870 when King Victor Emmanuel's government gave permission for non-Roman Catholic congregations to build churches within the ancient boundaries of the Eternal City. George Edmund Street was commissioned as architect and Burne-Jones was persuaded to turn at least momentarily from his work with stained glass. He responded with* The Tree of Life *in the highest arch,* Christ the King *flanked by Saint Michael* (LEFT) *and other archangeles, and, lastly,* The Earthly Paradise (BELOW) *of saints and martyrs. After Burne-Jones's death in 1898, the mosaics were brought to completion by another Englishman, Thomas Rooke, and dedicated in 1907.*

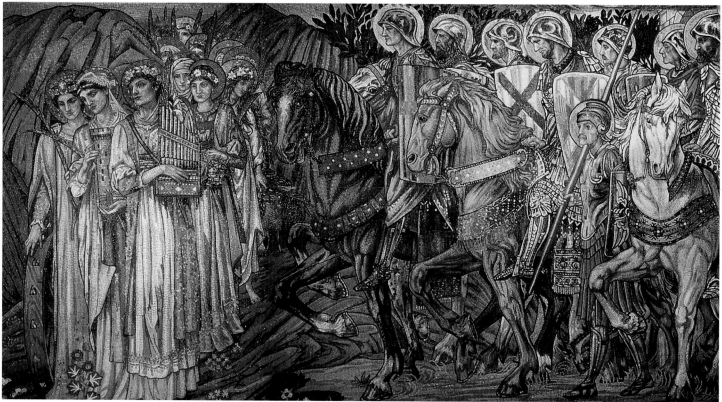

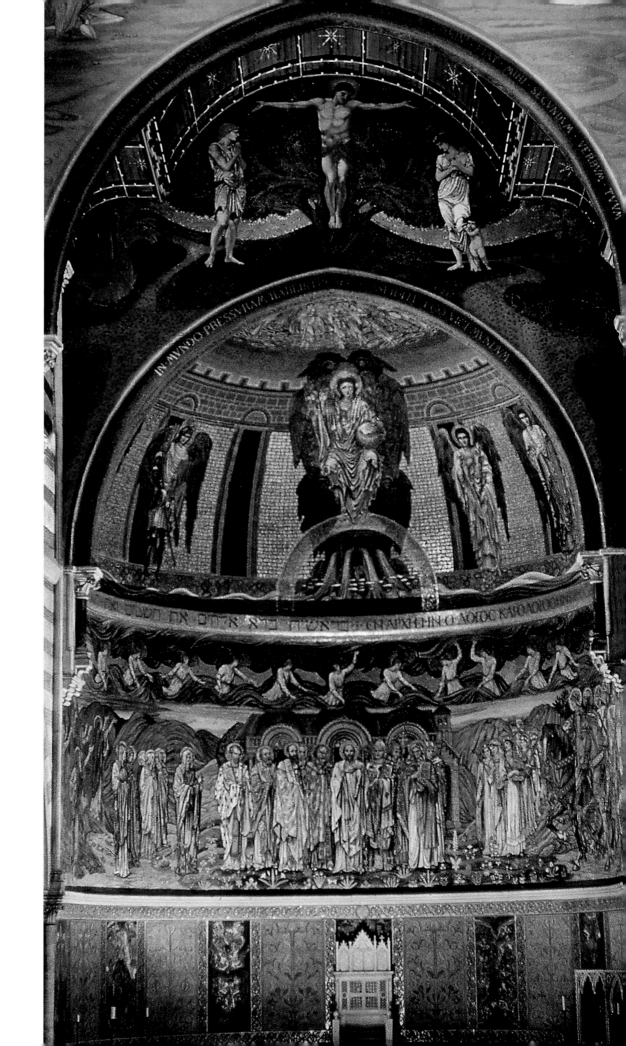

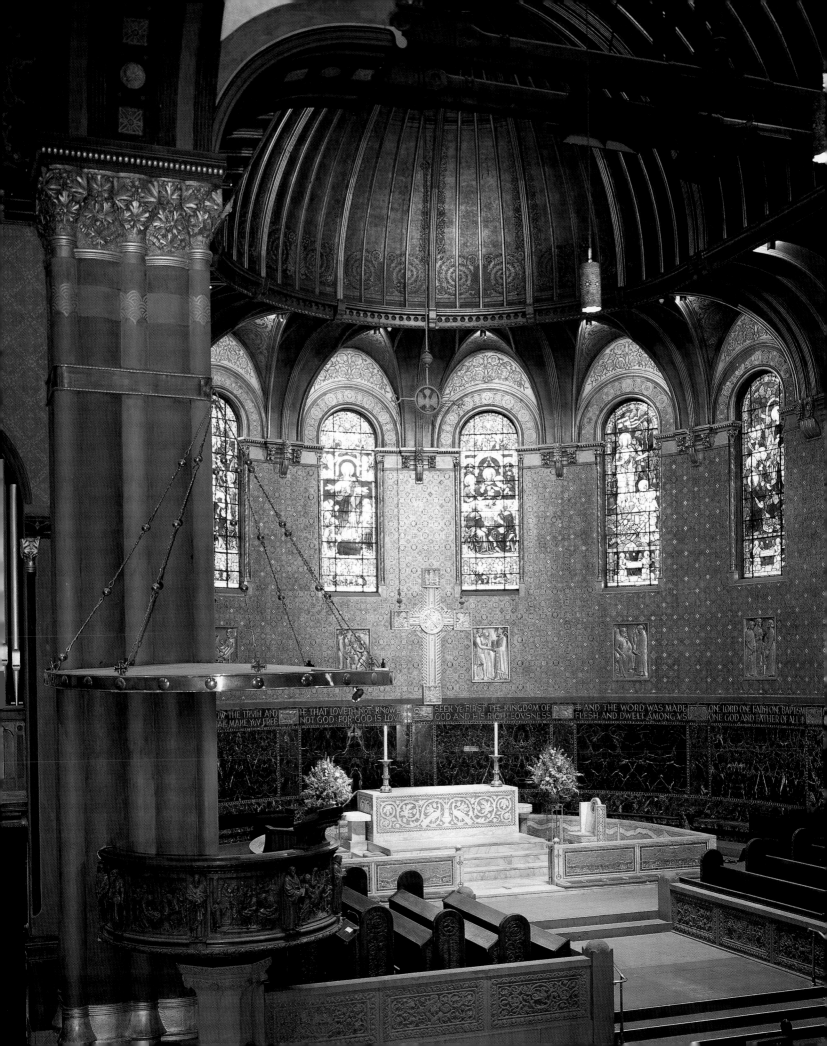

OPPOSITE *In Henry Hobson Richardson's 1877 Trinity Church, Boston, Romanesque mosaics, Victorian glass, and heavy timbers speak compatibly with the newer light marble and spaciousness that characterize the sanctuary 125 years later.*

In the Chapel of the Resurrection at Washington National Cathedral, a mosaic of the risen Christ, robed in white, bears in his hands the cross and banner of victory. The sun of the first Easter morning blazes against the blue sky while, at right, two Roman soldiers sleep and, at left, an angel kneels before the open tomb.

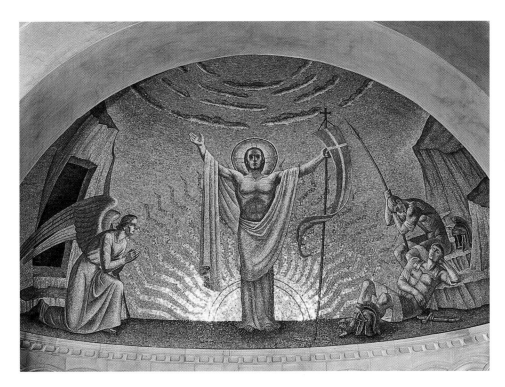

Also at Washington National Cathedral, the crossing, where the north and south transepts bisect the center aisle, four mammoth piers soar 324 feet from their bases to the Gloria in Excelsis tower.
At top right of the picture is the pulpit, with scenes from the history of the English Bible carved from stones of the Bell Harry tower at Canterbury Cathedral. At top left is the lectern, from which the Scriptures are read and U.S. presidents speak at great national services. The floor is inlaid with the Jerusalem cross, the cathedral's special symbol.

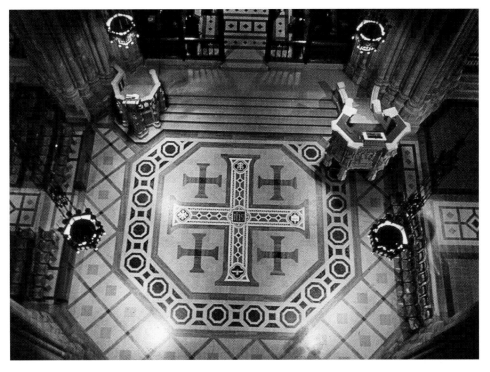

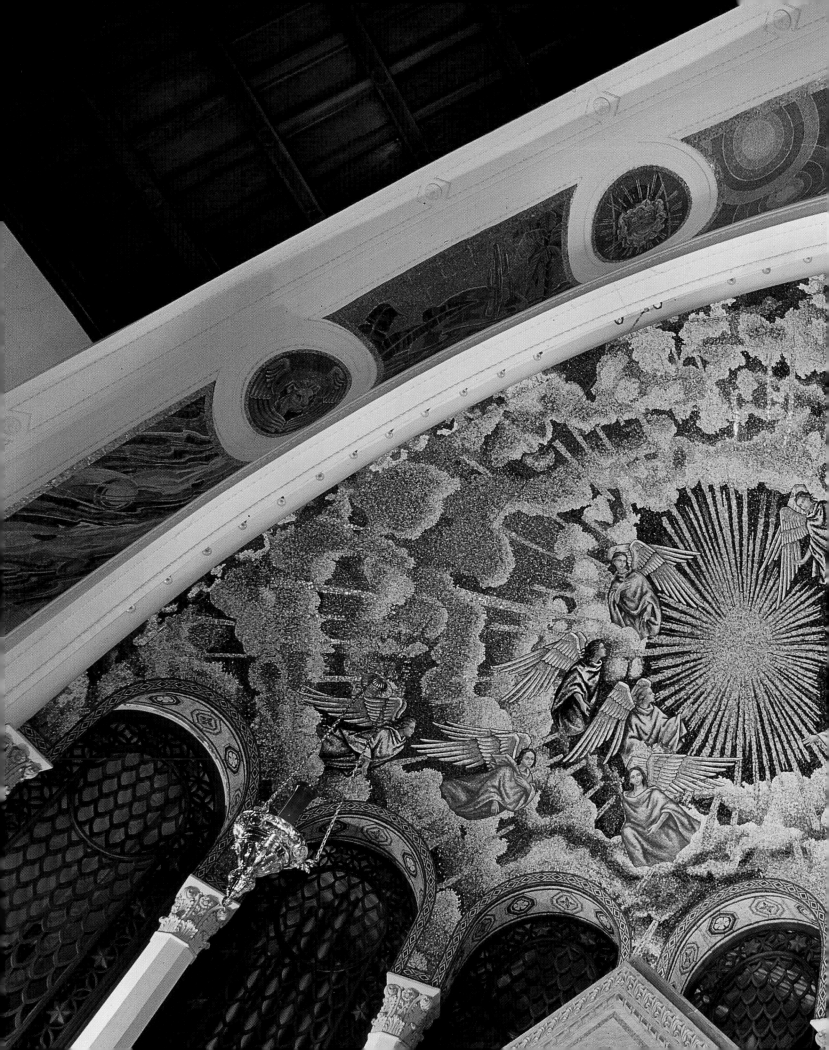

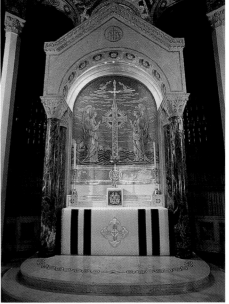

Pillars of the Almighty *sings with color in a sunburst of clouds and angels in intricate mosaics at Trinity Cathedral, Miami, Florida. The reredos of the high altar, also in mosaics, is framed with black columns beneath a marble baldachino.*

Paintings

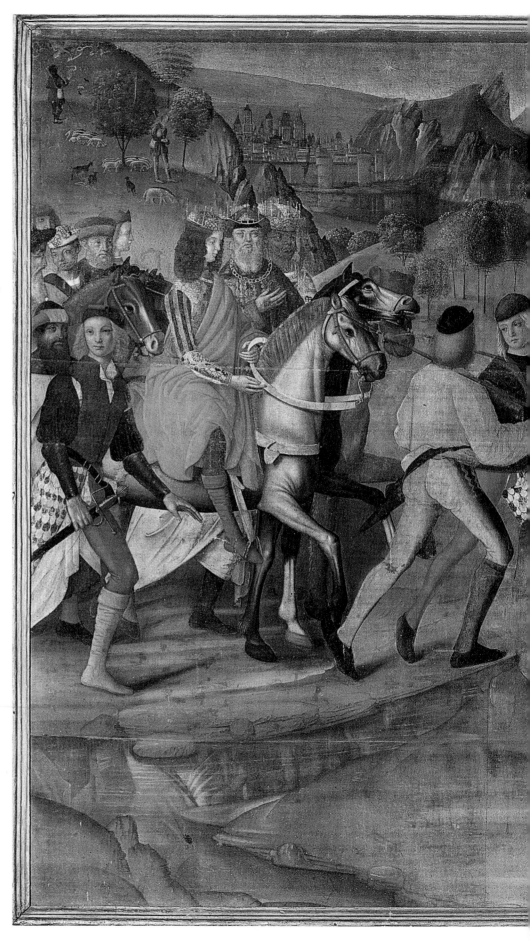

A fifteenth-century Cavalcade of Wise Men and Adoration of the Child Jesus *by Francesco Zaganelli dei Bosio (1470–1531), surmounts a sixteenth-century altar in the chapel of the Church of Saint Barnabas-on-the-Desert, Scottsdale, Arizona. According to a dealer's documentation, written in Florence in 1928, Zaganelli's presentation of the infant Christ, the two adoring angels, and the landscape reflect the strong influence of the School of Ferrara and of Flemish masters. The painting, a gift in 1969 from a winter vacationer, Ronald Byrnes, of Menlo Park, California, is in tempera on an unprimed canvas measuring 6 x 8 feet.*

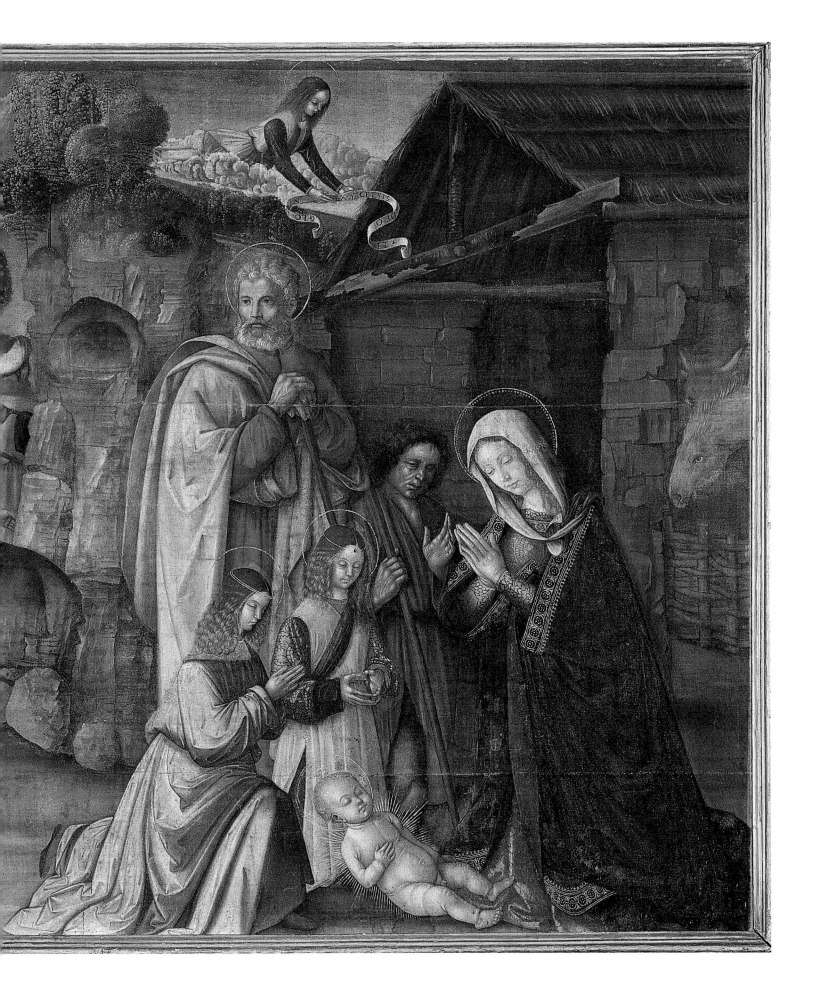

Saint Paul shakes off a viper at Melita (Malta) in a twelfth-century wall painting in Saint Anselm's Chapel of Canterbury Cathedral.

OPPOSITE *In* Saint Peter Receives the High and the Mighty *at Saint Peter's Church, Wenhaston, Suffolk, only the headgear of four applicants for Heaven hints at the importance they enjoyed in the world but could not bring with them to judgment. The seventeenth-century painter is unknown.*

From the moment that paint and brush were first applied to frescoes, canvas, wood, or other hard surfaces, paintings were destined to rank with stained glass as major adornments of Anglican and Episcopal cathedrals and churches. "What was first structural soon attracted ornament," writes Simon Jenkins in his study of England's "thousand best churches."

Although early wall paintings, faded but still clearly visible, are in several English cathedrals, a goodly number, dating from around 1290, are in parish churches. The figures are postured with mannered elegance and sometimes set beneath a rich architectural canopy. More of these exquisite relics from medieval times continue to be discovered beneath the whitewash of numerous parish churches.

As for great painters, the Anglican panoply runs from Canoletto to Wyeth and includes Borthwick, Bermejo, Constable, Feibusch, LaFarge, Rembrandt, Rubens, Spencer, Sutherland, Turner, and West. While the cathedrals at Coventry and Chichester have commissioned art in recent years, the church as a whole enjoys art that it has purchased or inherited. Whatever the case, paintings take on new meaning and authority when they are seen in a church well seasoned with worship and prayer, rather than in the relative sterility of a gallery or museum. Rubens' *The*

Adoration of the Magi at King's College Chapel, Cambridge, may well be the most valuable painting in Anglican hands, having been purchased by a wealthy real estate executive in 1959 for a record price of £275,000. He then gave it to King's in what *The Times* of London was to describe as "a gesture of fabulous generosity." The painting precipitated a long-running quarrel about how to best display it, but cool heads won out and it was placed above the altar.

At a girls school, St Felix, at Southwold, Suffolk, the sale of a Ranieri di Leonardo da Pisa was unsuccessfully protested by 155 students and went to a rock'n roll star for £84,000.

The vestry at All Saints, West Newton, Massachusetts, called in experts to give what it thought would be a modest estimate of the worth of a painting that was so large it could never be fitted into the church. After languishing face-down in the rectory attic and a closet for 86 years, it turned out of be an original *Madonna and Child* by the Florentine Renaissance artist Andrea del Sarto, 1486–1530. It was purchased by three dealers bidding at Sotheby's for more than a million dollars.

On the other hand, some parishes continue to value their paintings even after they've turned out to be copies. Christ Church Cathedral, Cincinnati, Ohio—unfazed when *The Holy*

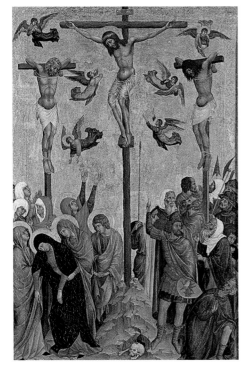

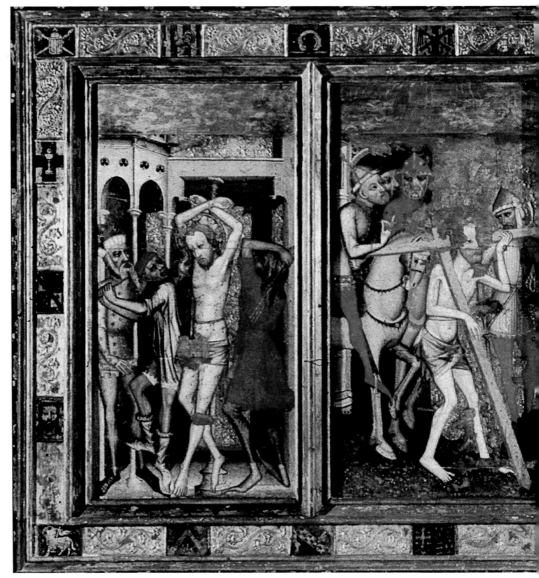

Family, a gift in 1926, failed to be an authentic Rubens—continues to hang their treasure above the main altar during the Christmas and Epiphany seasons. The same is true for a supposed El Greco that has an honored place in the parish library at the affluent St Martin's in Houston, Texas.

Decorated ceilings and vaults, trompe l'oeil, testers, and other valuable paintings, from Britain to New Zealand, await a complete inventory that would finally establish the immense value of Anglicanism's religious art.

ABOVE LEFT The Crucifixion, *by Duccio di Buoninsegna, was the chef d'oeuvre in the private collection of a nineteenth-century Anglican priest, Walter Davenport-Bromley. It was the later part of the collection assembled by Sir Alexander Lindsay and in the exhibition* A Poet in Paradise: Lord Lindsay and Christian Art, *held at the National Gallery of Scotland, 25 August–19 November 2000. The painting is now owned by the Manchester City Art Galleries.*

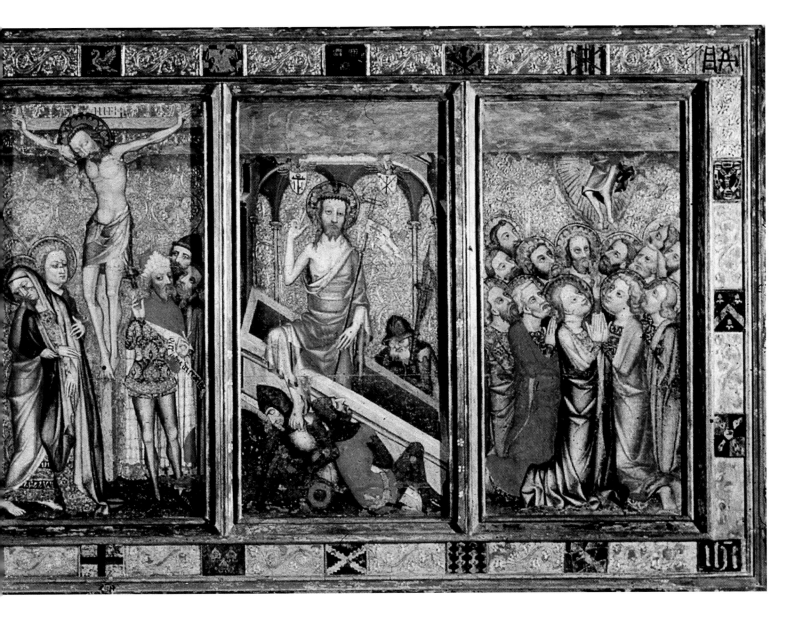

Five scenes, from Jesus' torture to the Ascension, constitute a retable that, although undated, is believed to be the oldest art in Norwich Cathedral.

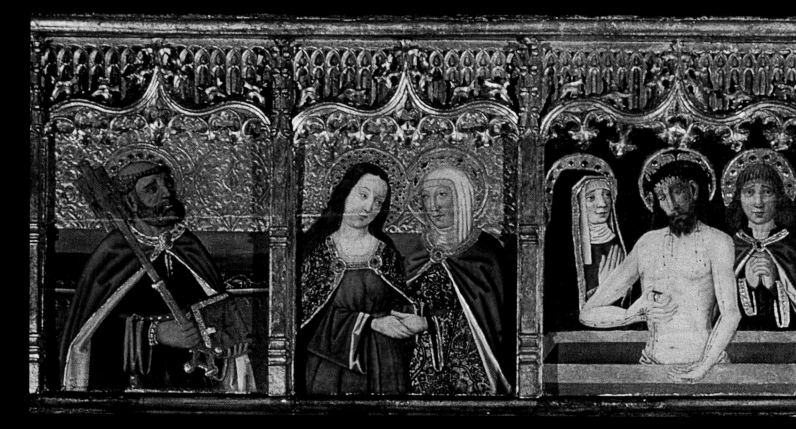

Visitors to the Church of Bethesda-by-the-Sea, Palm Beach, Florida, see a medieval altarpiece, in gold leaf on wood, displayed below the antiphonal organ. The panels depict Peter, Elizabeth and Mary, the Resurrection, two unidentified saints, and John the Baptist.

Madonna and Child *(ca. 1885)*, also in gold leaf, on Bethesda-by-the-Sea's south transept wall, is by Pietro della Vedova *(1831–1898)*.

The Resurrection *(ca. 1480), Christ rising amid soldiers who have fallen asleep, is the central panel of a triptych above the altar of Queen's College Chapel, Cambridge. Believing that it was probably part of a much larger altarpiece, curators attribute it "on stylistic grounds to the unknown master of* The View of Saint Gudule.*"*

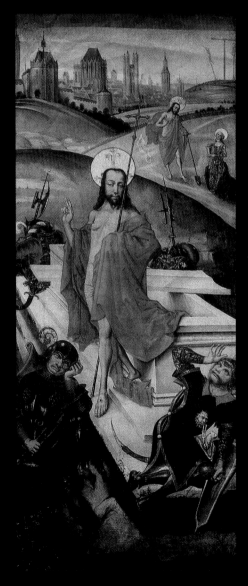

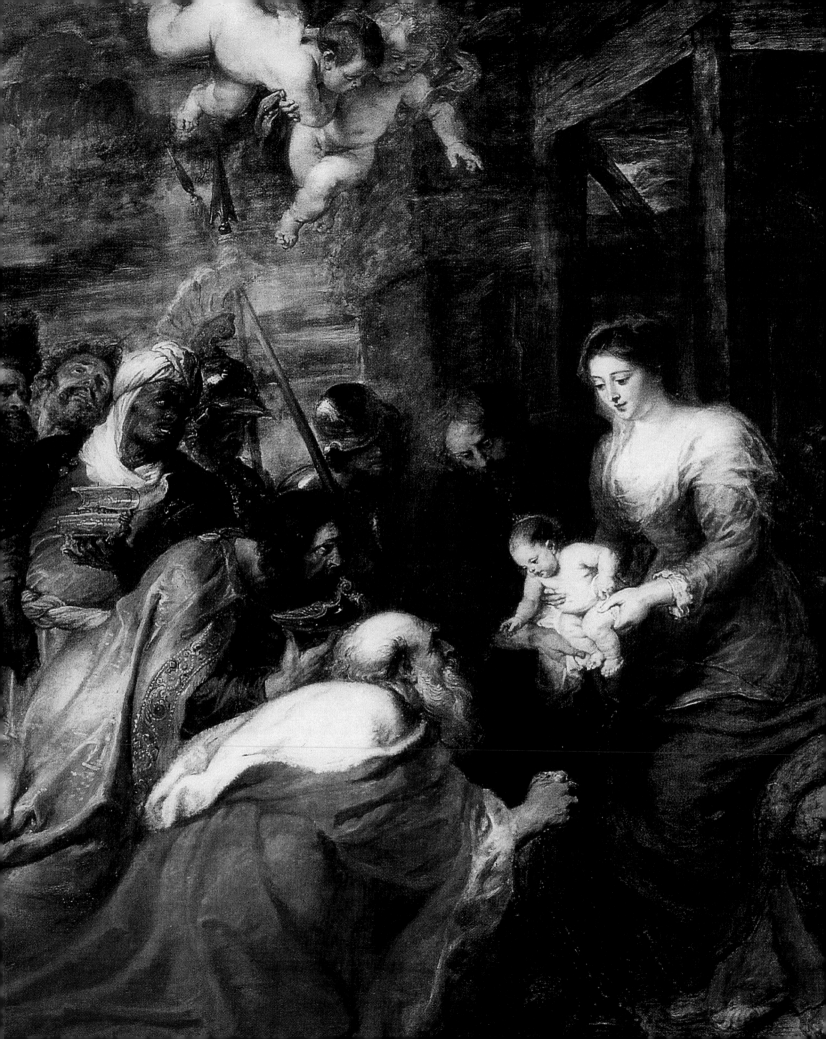

OPPOSITE *Peter Paul Ruben's 1634*
The Adoration of the Magi *is a master-
piece set within a masterpiece, King's
College Chapel, Cambridge, built by King
Henry VI five centuries ago. Painted in eight
days on oak planks, it hung for 155 years
in the convent of the White Nuns in
Louvain before passing into a dealer's hands
during the French Revolution and from
thence going to England. Over the next
170 years it was handed down by the
Lansdowne family to the Grosvenor family
to the second Duke of Westminster, Hugh
Richard Arthur Grosvenor (1879–1953).
At his death, it was placed on public auction
in 1959. The purchaser, Major J. E. Allnatt,
gave it to King's where it was first displayed
on an easel in the antechapel and then fitted
out with two panels as a triptych for the
main altar.*

The massive, nine-foot high Resurrection
*(ca. 1578), by Paolo Cagliari, known as
Veronese hangs in
the chapel of the Chelsea and Westminster
Hospital, London. One of six paintings
commissioned for a church in Venice, it was
brought to England in 1767 by a wealthy
traveler of the day, Sir James Wright. In
1950, the hospital chaplain, Christopher
Hildyard, wandered down Bond Street in
search of something to hang over the altar.
He found the Veronese painting at
Colnaghi's and persuaded the hospital
trustees to agree that if he secured £2,000
by public subscription they would raise the
rest. Restoration disclosed a whole range of
colors in the tradition of Titian and Bellini
and details not previously seen.*

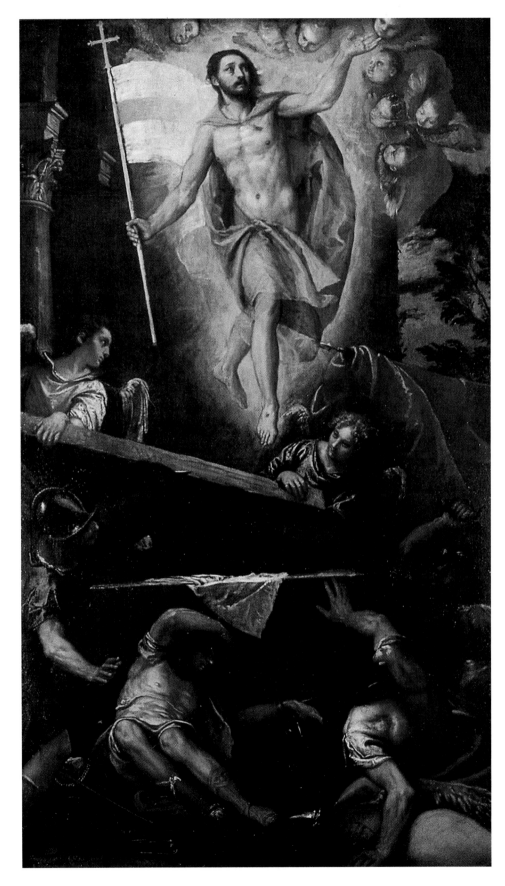

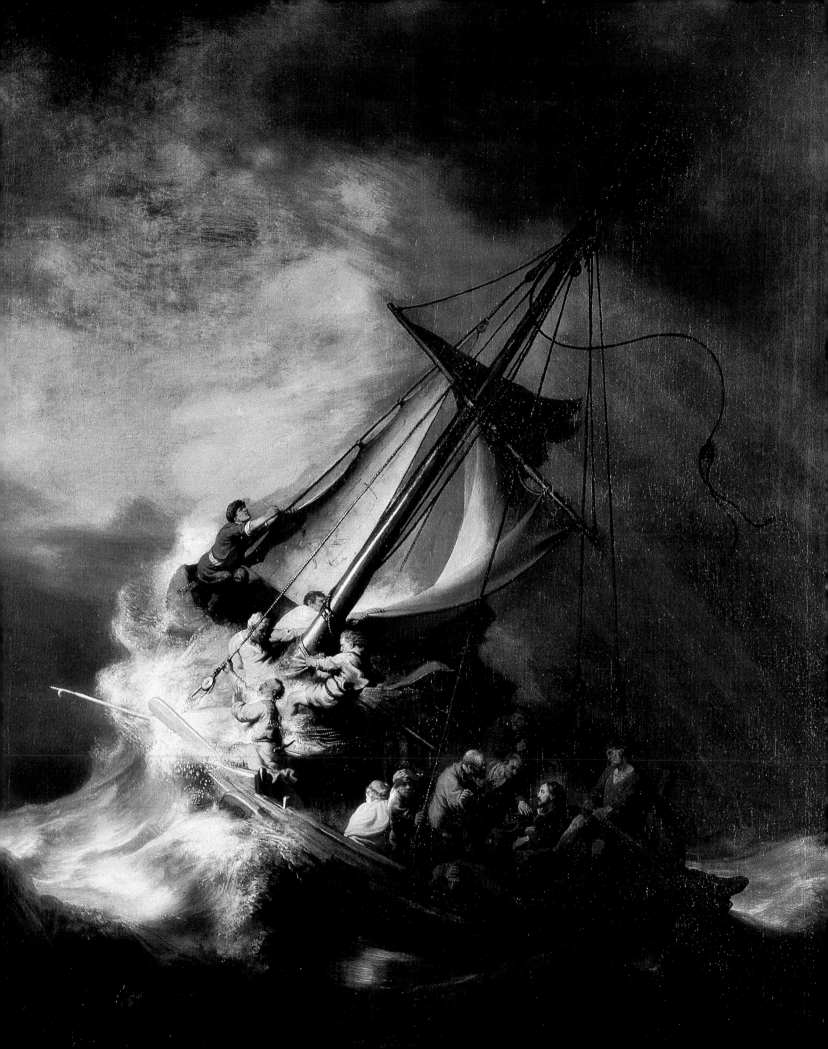

John Constable's 1821 The Risen Christ *hung at Saint Michael's Church, Manningtree, Essex, until the parish closed in 1965 and it was purchased by All Saints, Feering, Essex. Failing to sell at auction, it was taken over by the Constable Trust to be placed in Dedham Vale near the birthplaces of Constable and Thomas Gainsborough, his neighbor at Sudbury, Suffolk.*

BELOW *Benjamin West's 1786* Saint Paul Saved from the Sea *is above the altar at the Royal Naval College at Greenwich.*

OPPOSITE *One of Anglicanism's greatest private collectors of art was Boston's Isabella Stewart Gardner (1840–1924) and her greatest religious acquisition was Rembrandt van Rijn's 1633* Storm on the Sea of Galilee. *It celebrates Christ's calm and his reassurance of his disciples but, ironically, the painting's later history is anything but calm. It was torn from its frame at the Isabella Stewart Gardner Museum in Boston in a theft in 1990; despite a $5 million reward and "absolute blanket amnesty," the painting has never been recovered. The museum continues to exhibit Lorenzetti's* Saint Elizabeth of Hungary, *ca. 1348; Botticelli's* Madonna of the Eucharist, *ca. 1485; and Bellini's* Christ Carying the Cross, *ca. 1516.*

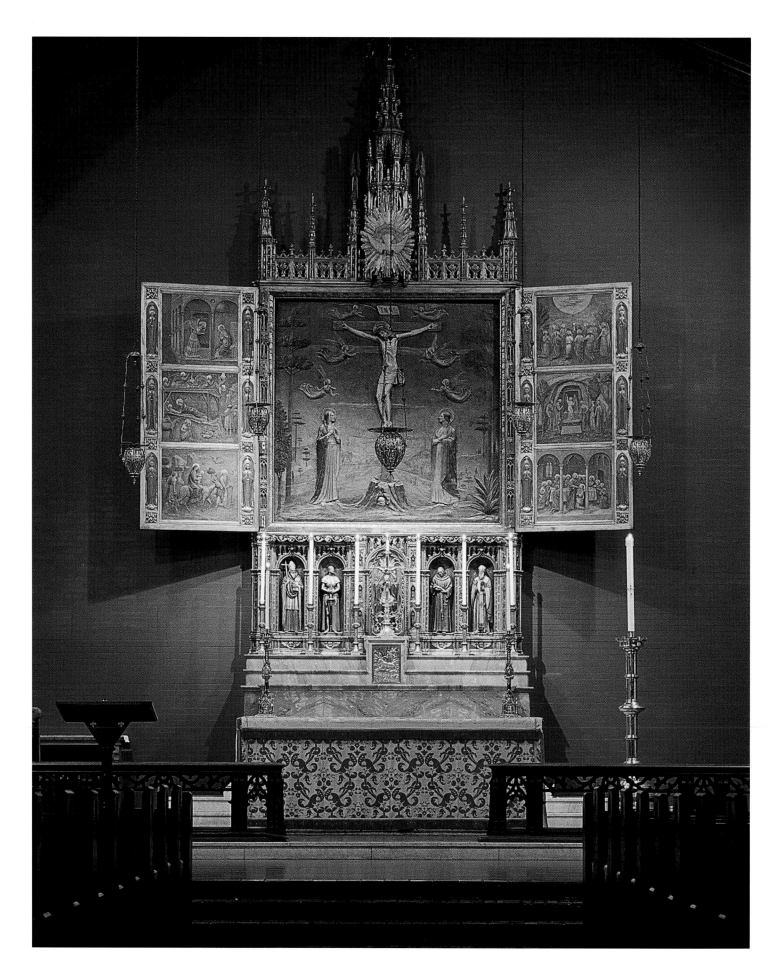

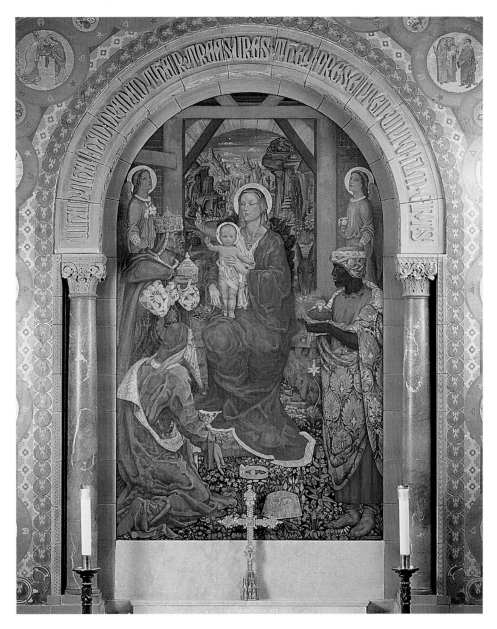

At Binham Priory in East Anglia, sixteenth-century reformers sought to expurge an image of Christ, the Man of Sorrows, *with text from the first English Bible but, as historian Simon Schama was to write: "The lost souls sent wandering by obliterators have returned, peeping through the letters of the Gospel like prisoners on the other side of a barred window, trapped but not disposed of."*

OPPOSITE *A vigil light burns before the high altar of All Saints Cathedral, Milwaukee, Wisconsin; the altar was designed by Eugene W. Mason of New York in 1922. The dove of the Holy Spirit keeps vigil in a sunburst at the triptych's top, with side pieces copied from Fra Angelico and Giotto. Beneath the square, nine-foot Crucifixion, the Virgin Mary is centered between saints representing Milwaukee's ethnic groups: Thomas à Becket for Britain; Joan of Arc, France; Francis, Italy; and Demetrius, Greece. Mason's work replaced a Victorian altar relocated to Saint Mathias's Church, Waukesha, Wisconsin.*

Ethel Parsons Paullin's 1919 Adoration of the Magi *is above the altar in the chapel of Saint Bartholomew's Church in New York.*

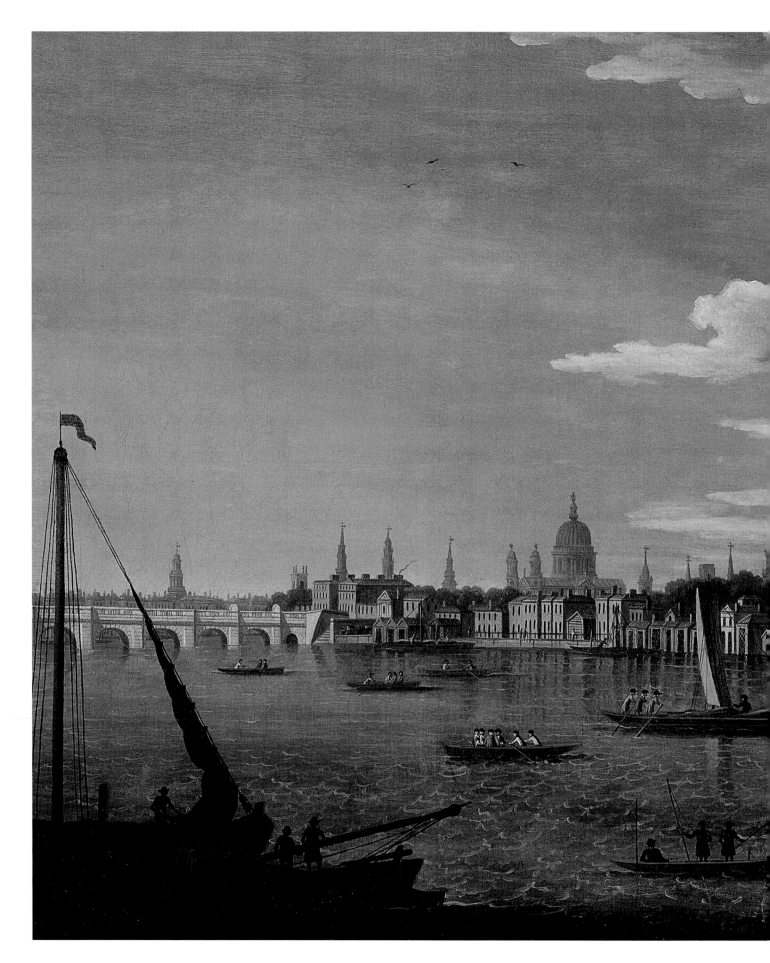

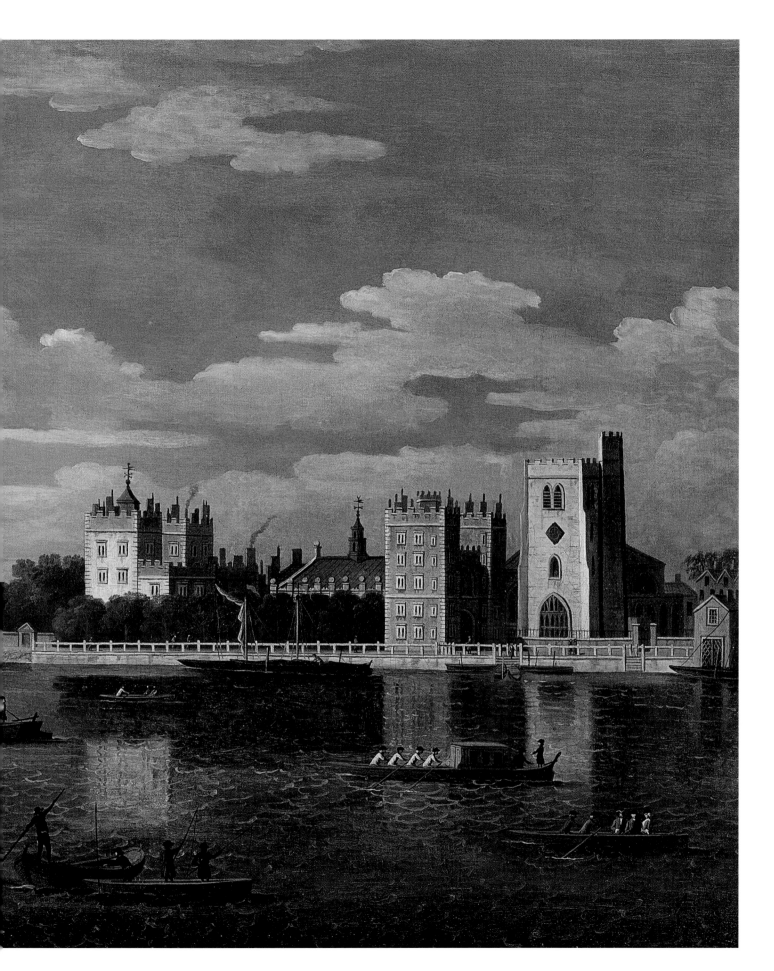

PREVIOUS PAGES *Samuel Scott's sweeping view of the Thames in 1750,* Saint Paul's and Lambeth Palace, *encompasses Westminster Bridge (left), the cathedral's dome, Lollards' Tower (right) on the grounds of the palace, and the now redundant Church of Saint Mary's-at-Lambeth. The painting hangs in the Victoria Art Gallery in Bath.*

Priceless collections of sacred art and glass have long flourished in the drawing rooms and private chapels of English country houses. (LEFT), *Hatfield House glories in its windows and* (RIGHT), *Luton Hoo prizes Sebastiano Ricci's* Presentation in the Temple *and* The Flight Into Egypt, *both painted in 1715.*

OPPOSITE, *besides the nativity scene the dukes of Devonshire at Chatsworth also claims Veronese's 1560* Mystic Marriage of Saint Catherine. *The paintings were included in* The Treasure Houses of Britain, *an exhibition held at Washington's National Gallery 3 November 1985 to 16 March 1986.*

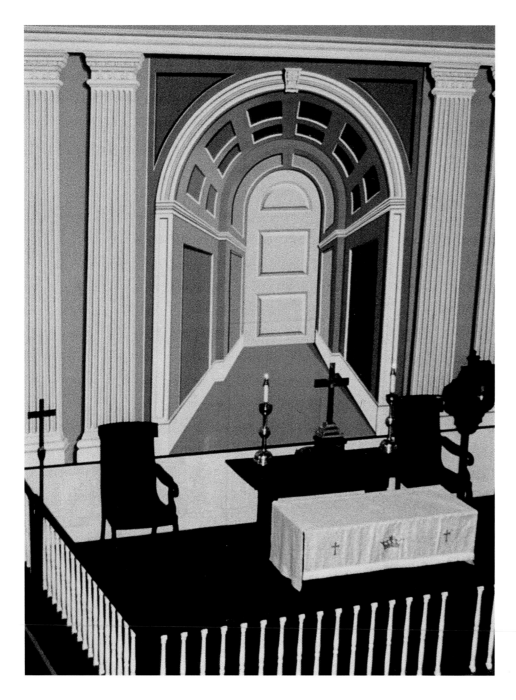

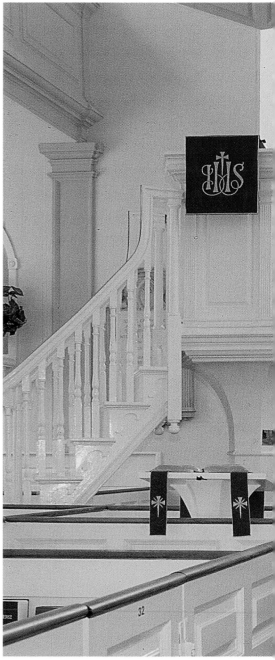

Trompe l'oeil in oil, fooling the eye with
an illusion of depth, greets visitors to Saint
James Church, Accomac, Virginia. this paint-
ing technique was popular in Greek Revival
homes and churches between 1820 and
1860. Accomac's reredos was rendered by
a traveling artist from Maryland's Eastern
Shore, Jean G. Potts.

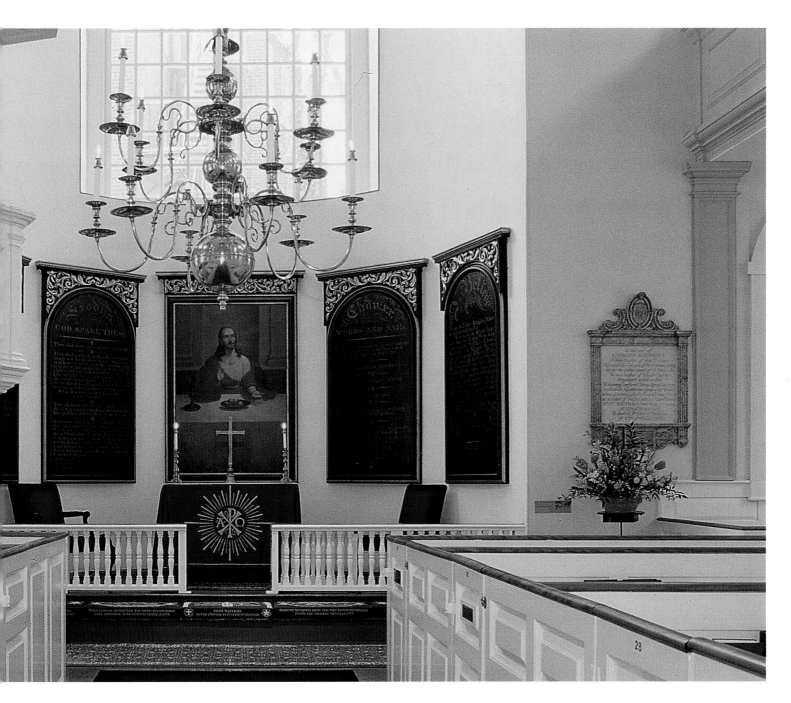

Boston's Old North Church, famous for Paul Revere's warning by lantern from its belfry in 1775, added J. Hu's painting of a red-robed Christ Presiding at the Last Supper *about 1885. The church retained panels of the Apostles' Creed, the Ten Commandments, and the Lord's Prayer, similar to those found in many colonial churches.*

In Ely Cathedral, built between 1083 and 1189, the embellishment of the wooden ceiling of the long nave, seventy-two feet above floor level, was undertaken in 1855 by a gifted amateur, Henry Styleman le Strange. When he died, with the job only half done, an old friend, Thomas Parry, finished it and the eastern bays in 1858.

OPPOSITE In a similar project, the entire ceiling of the nave of St Mary's, Huntingfield, Suffolk, was decorated by the Vicar's wife, lying on scaffolding for most of the decade of the 1850s. "Oh my stars!" said the dean when he saw the completed job.

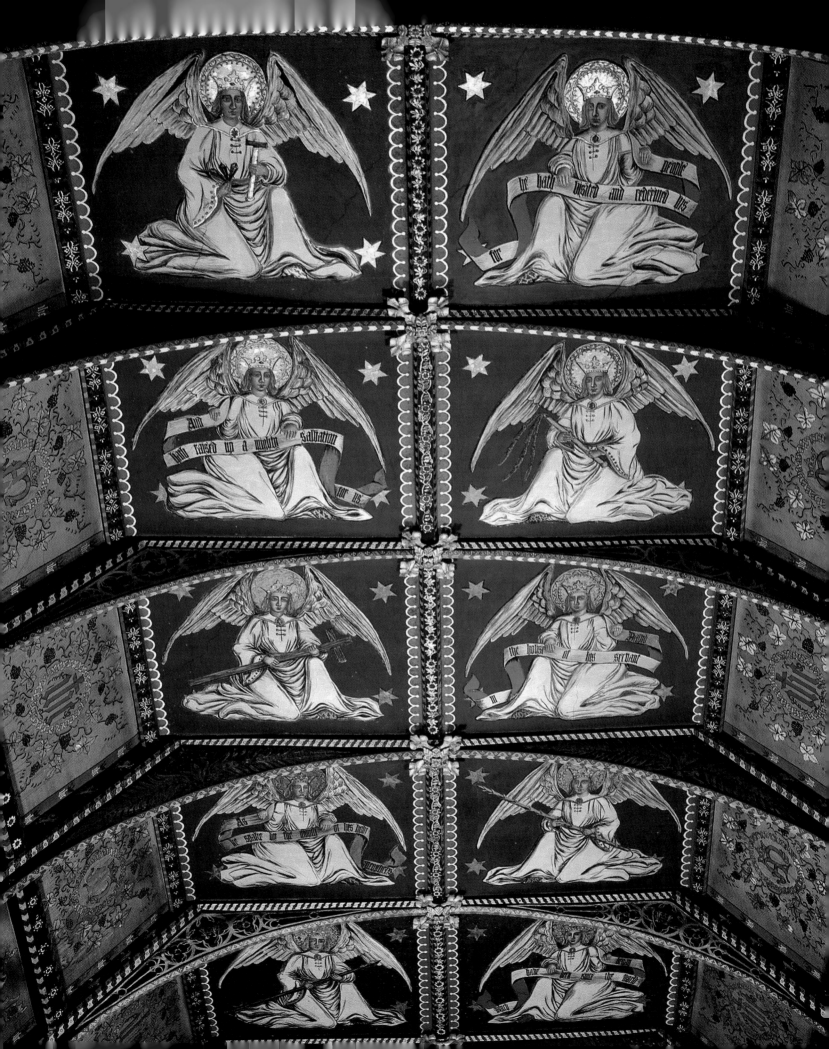

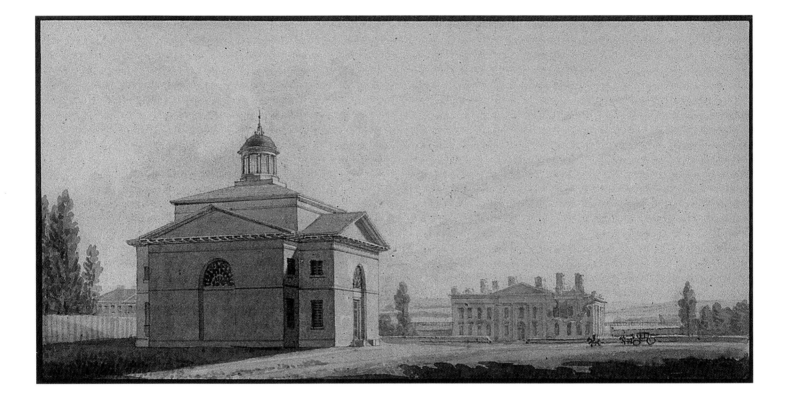

An early nineteenth-century drawing shows the proximity of the White House (on the right) to Saint John's Church, Lafayette Square—to which every U. S. president since James Madison has come, usually on Inauguration Day, to be seated in pew 54. The four-story British Legation was later built in back of the squarish church building and in time became its parish house.

A pair of royal portraits, modeled in softly colored paper-mâché, honors the colonial benefactors of Christ Church, Shrewsbury, New Jersey, founded in 1703. Some historians identify them as William and Mary, others say they are George II and Queen Anne or George III and Charlotte. Generations of parishioners have been observed by the hawk-nosed monarch and his demure, dark-haired bride from their ovals in square wooden frames attached to the rear wall of the church, but they themselves remain mute personages of mystery— not only as to their correct identity but also as to who painted them and where, and when they were put in place.

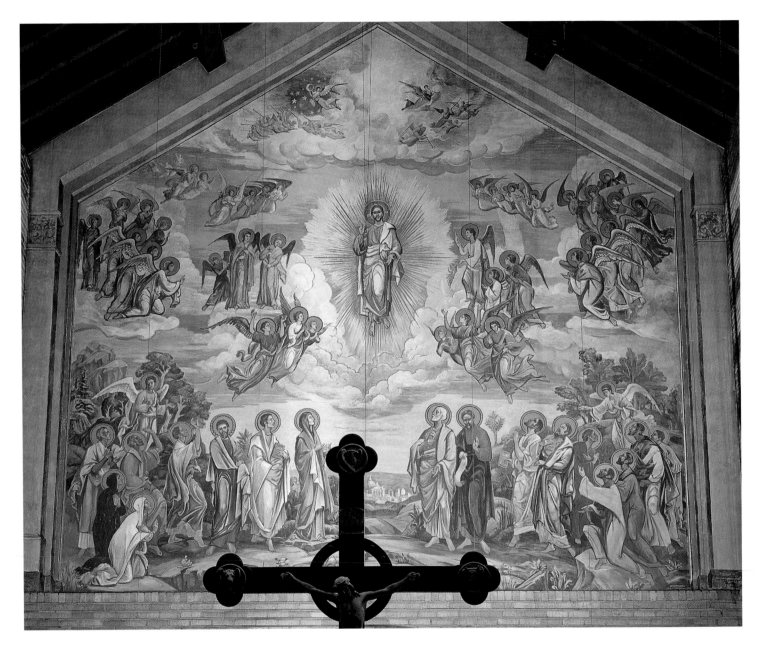

The Ascension, *above the high altar at Saint Mark's, Portland, Oregon, was achieved over a seven-year period by a priest/artist, Father Bernard Geiser, who came from Denver, Colorado, to execute the project. Completed in 1937, forty years later it was at the heart of an unusual court rul-* *ing that allowed the congregation to retain the building when it withdrew from the Episcopal Church over Prayer Book changes and female ordinations. The church is now the procathedral of the Diocese of the West of the Anglican Church of America.*

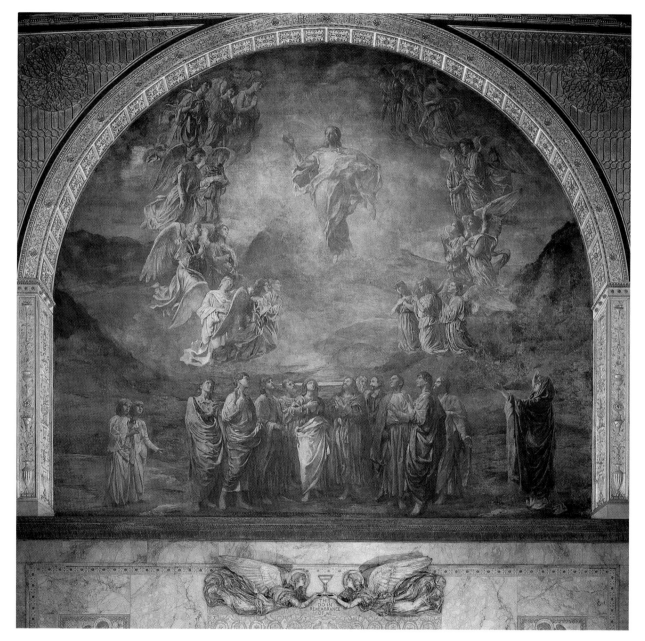

The Rhinelander altarpiece at the Church of the Ascension on Fifth Avenue and 10th Street in New York was painted by John La Farge in 1886. The angels were sculpted by Augustus Saint-Gaudens.

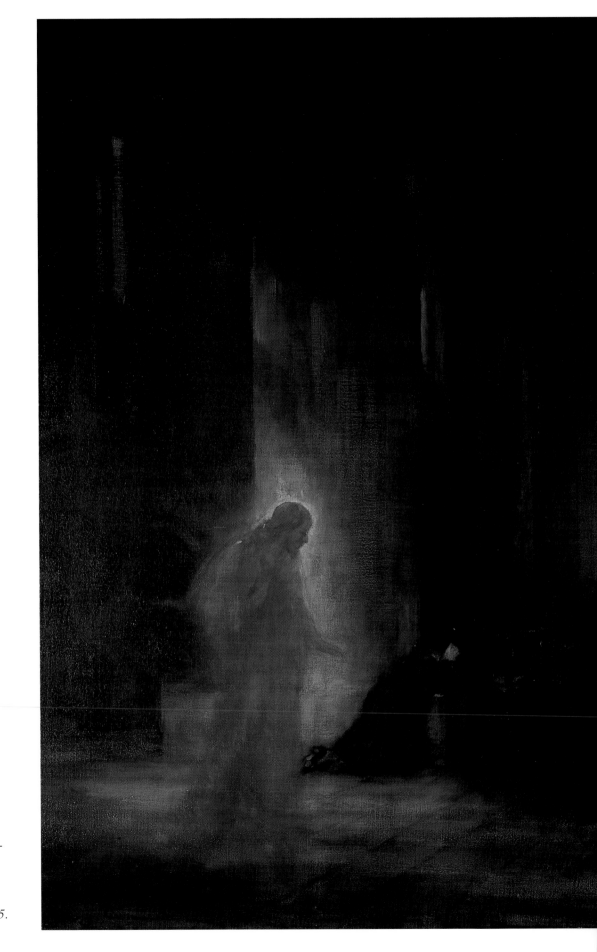

The Presence, *Alfred Edward Borthwick's painting in Saint Mary's Cathedral, Edinburgh, connotes the dual presence of Christ: in the Eucharist at a brightly illuminated altar; and with the humble in the back of the church. Completed in 1910, the painting was awaiting color reproduction in Germany when war broke out; in 1920 it turned up in copyright litigation in the United States. Borthwick, a member of the family residing at Borthwick Castle in the Midlothian area of Scotland, presented it to Saint Mary's in 1945.*

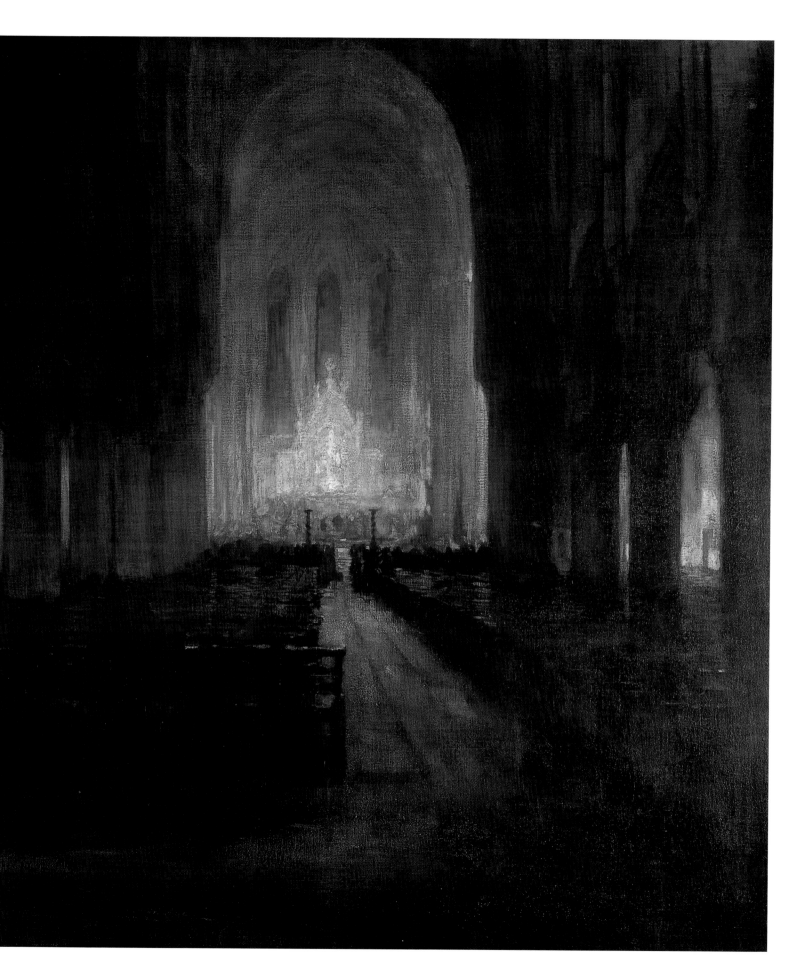

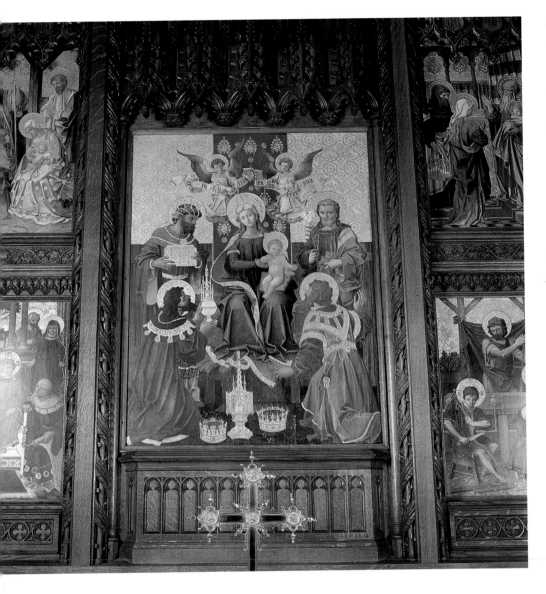

At *Saint Paul's School, Concord, New Hampshire, founded in 1886, Henry Vaughn's reredos, with paintings executed by Clayton & Bell, was dedicated eight years later as the focal point of daily worship.*

OPPOSITE At *Saint Clement's Church, Philadelphia, completed in 1858, the roof of the sanctuary was raised ten feet in 1908 to accommodate the towering oak triptych and English red stone altar designed by Horace Wells Sellers. The concept of Christ the King in eucharistic vestments and reigning from the cross was a new concept, painted by Frederick Wilson seventeen years before the Feast of Christ the King was instituted. Angels kneeling on each side are bordered by statues of Michael, Clement, Alban, Augustine of Canterbury, Gabriel, Catherine of Alexandria, Athanasius, and Columba. When the street behind the altar was to be widened in 1929, months of planning resulted in successfully moving the sanctuary and nave forty feet to the west.*

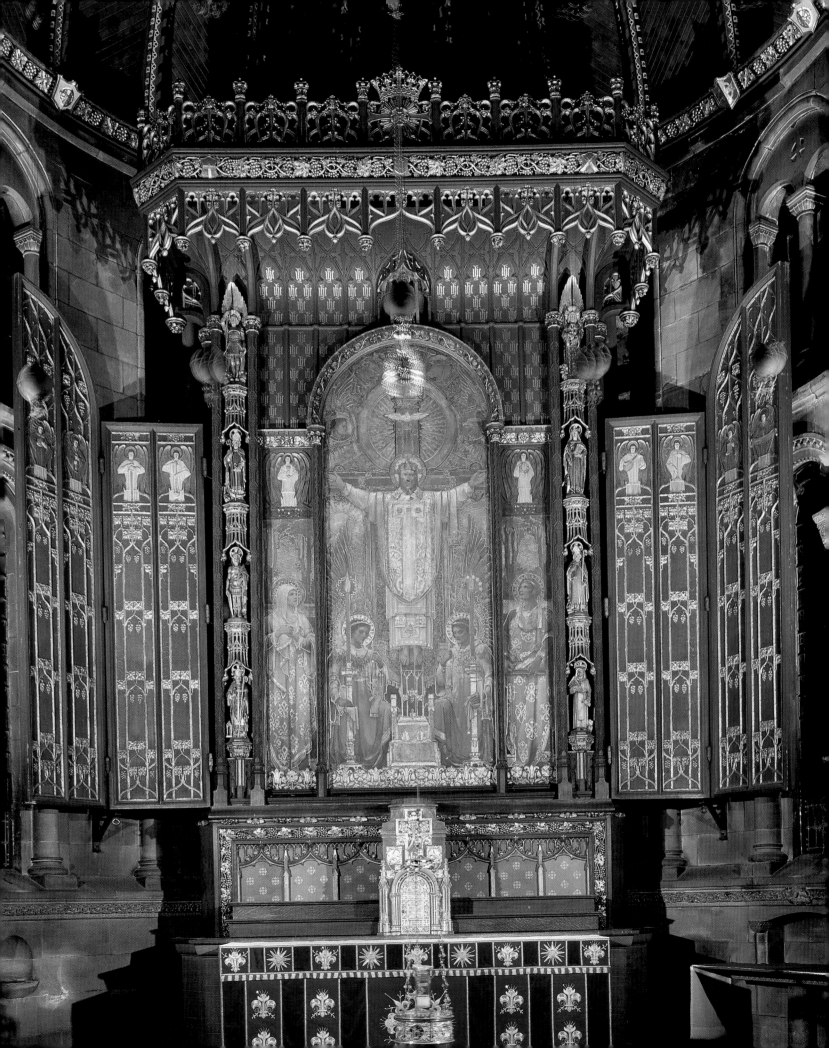

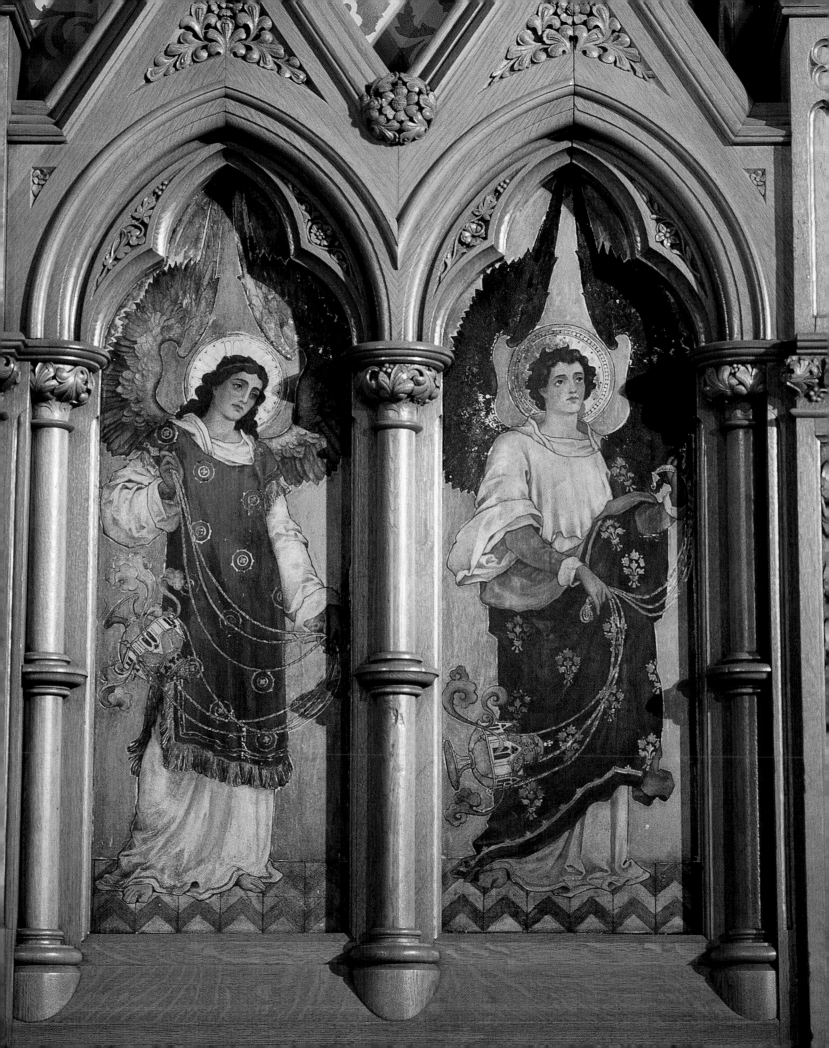

OPPOSITE *Angels at Saint James Cathedral, Chicago, gracefully swing thuribles in the reredos; these figures were part of a restoration that returned the reredos to its appearance in 1888.*

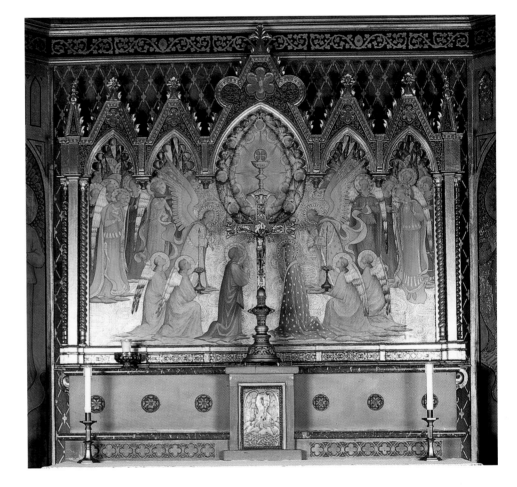

RIGHT *The reredos of the motherhouse of the Eastern Province of the Community of Saint Mary at Peekskill, New York, still glows nearly a hundred years after it was painted by Sister Mary Veronica, CSM, as do her angels (bottom) at The House of the Redeemer in New York City.*

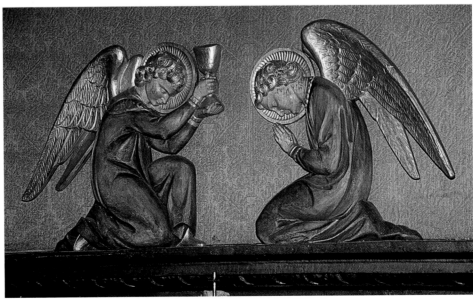

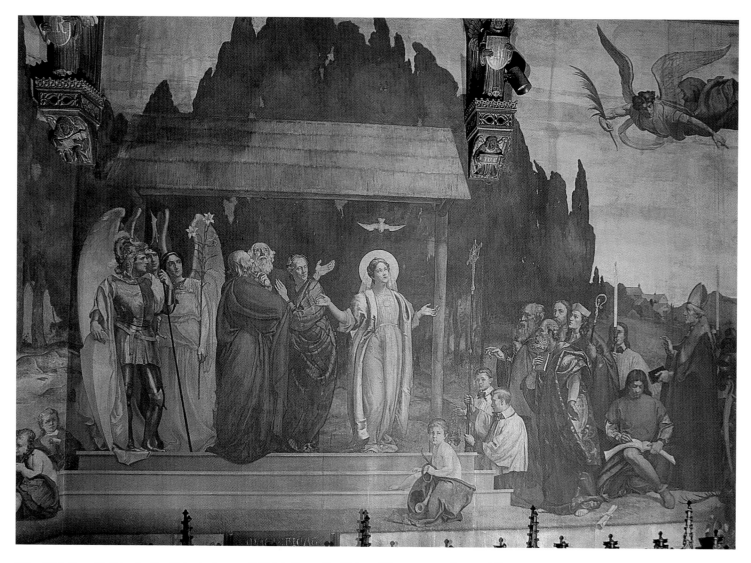

The Epiphany *in the Lady Chapel of*
New York's Church of Saint Mary the
Virgin is one in a series of paintings com-
missioned in 1904 and completed three
years later by a prominent Manhattan
artist, Elliott Daingerfield, who was also
a parishioner.

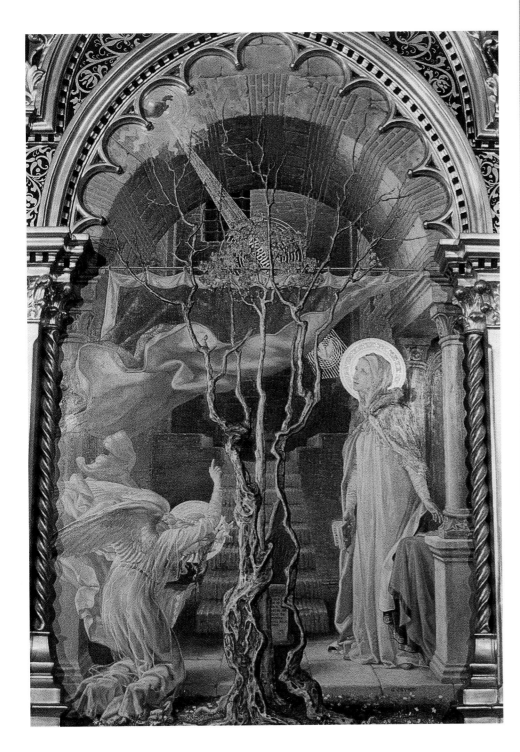

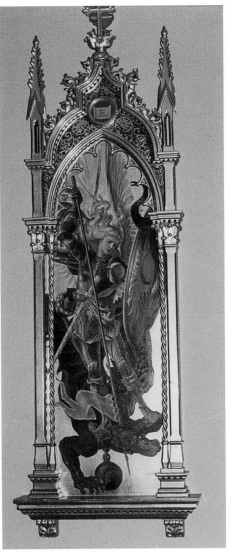

Two mid-nineteenth-century paintings by Sienese artist Guiseppe Catani Chiti were acquired by Saint Mark's, the Church of England parish in Florence, shortly after its present building was acquired in 1877. The Annunciation and St. Michael now decorate the nave of the church, formerly the stable of a grand palazzo that legend says was once the home of Machiavelli.

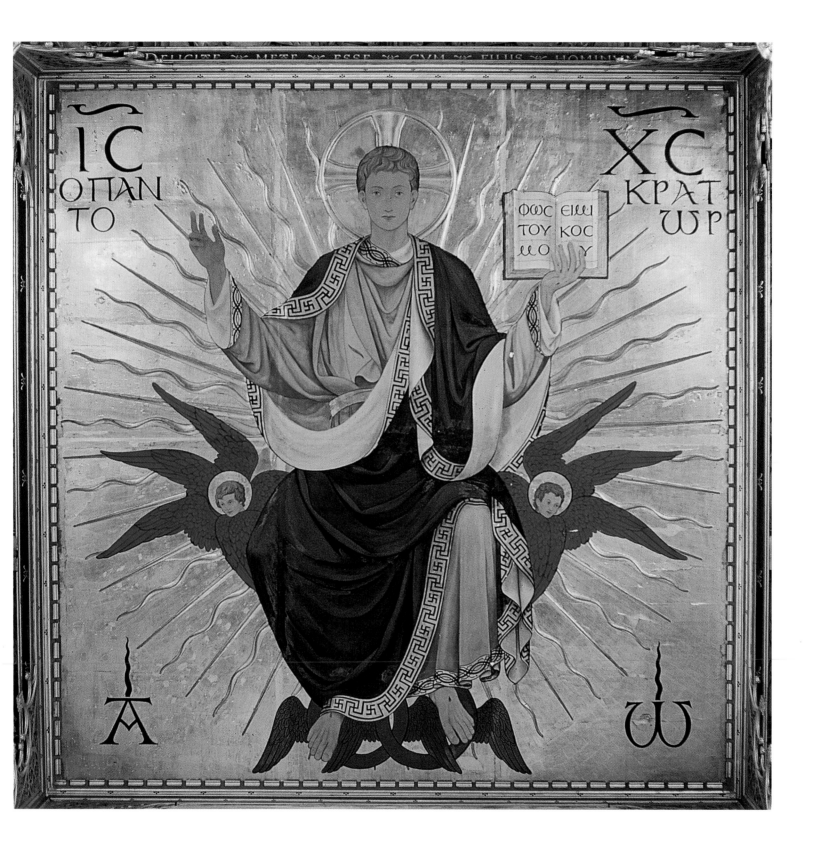

OPPOSITE *Sir Ninian Comper's portrait of Christ is hung as a tester so that the Savior may be clearly seen by the celebrant of the Mass in elevating the consecrated bread and wine. Communicants at the altar rail may also behold the figure as they receive the Sacrament. The painting is one of Sir Ninian's major accomplishments in furnishing Saint Cyprian's, Clarence Gate, London SW 1, in 1902 and 1903.*

Tabor Sears painted the risen Christ, flanked by sleeping soldiers and the women at the empty tomb, as the reredos for the Chapel of the Resurrection at Saint Thomas, Fifth Avenue, in New York. It was given by Margaret C. Hurlbut at Easter, 1929.

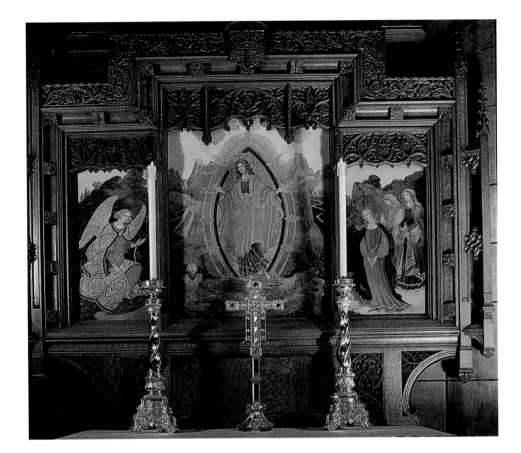

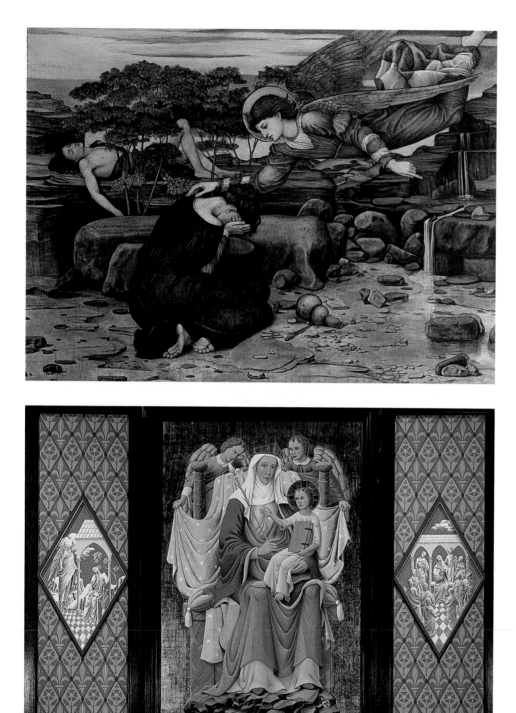

A mother's grief is dramatically reflected in John Rodham Spencer Stanhope's 1875 Hagar in the Wilderness, *the first of his embellishments in the chapel of Marlborough College at Marlborough in Wiltshire.*

OPPOSITE *At Saint Mark's, Portland, Oregon, Father Bernard Geiser painted* The Annunication *in a side chapel, while two women artists, members of the parish, completed the triptych.*

A triptych of Our Lady of Walsingham *by Davis d'Ambly was blessed and dedicated at Saint Paul's Church, K Street NW, Washington, D. C., on All Saints' Day 2000. The side panels are "powdered" with lilies and roses. It is the centerpiece of the Lady Chapel at that parish.*

·ALMAREDEMPTORIS·MATER·

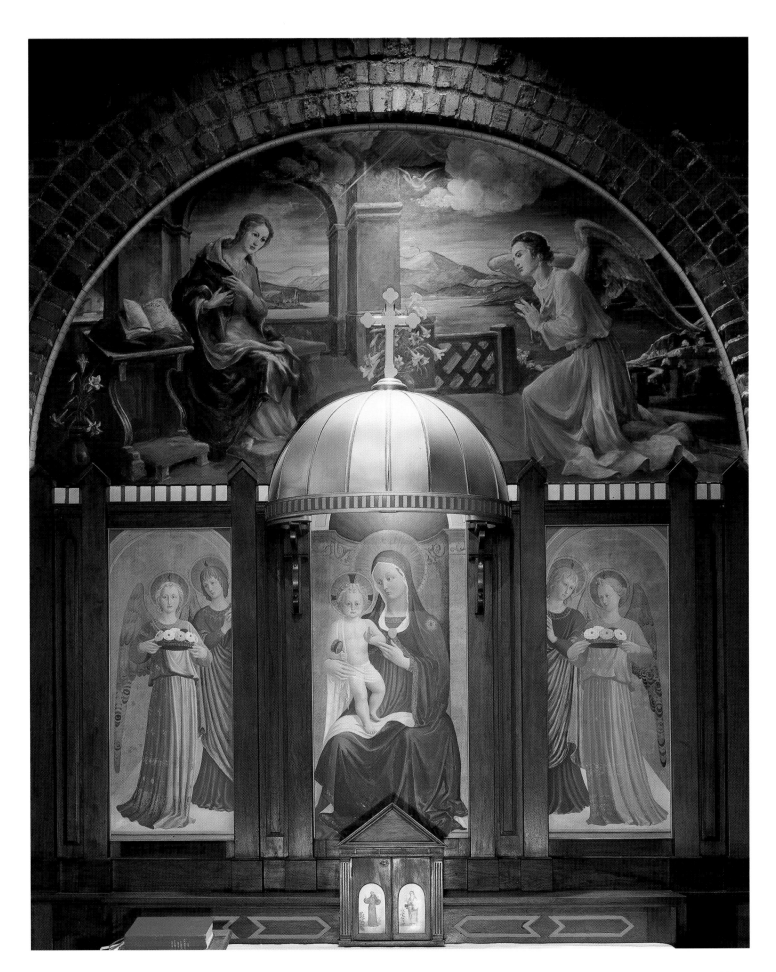

Two angels surround the portal at St. Mary's Convent, Peekskill, New York.

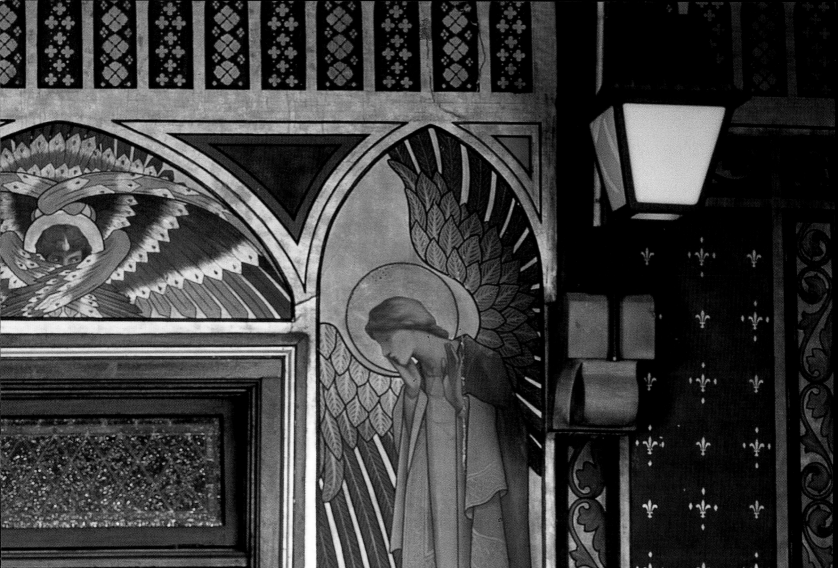

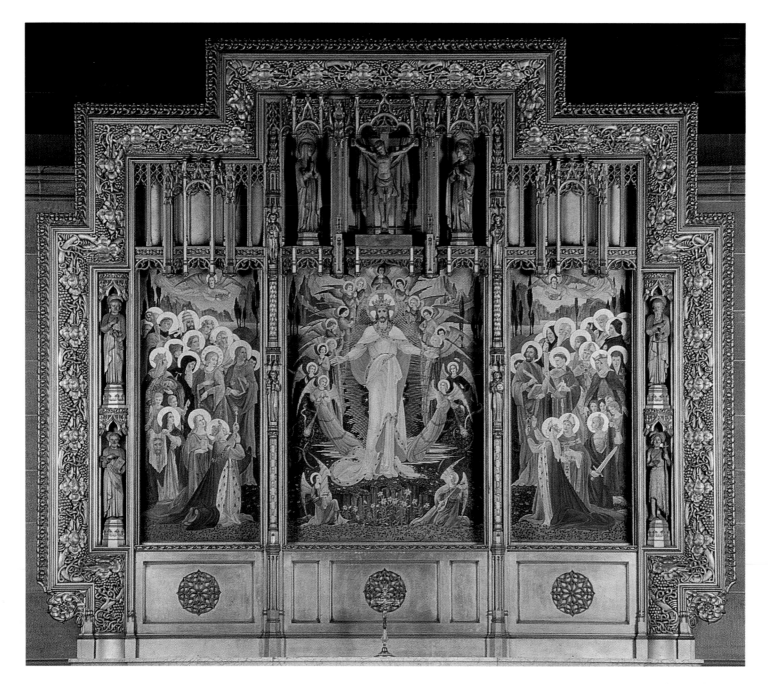

ABOVE AND OPPOSITE Paradise *is the theme of the three panels of a side altar, framed with elaborate wood carvings, in the nave of the Cathedral Church of Saint John the Divine in New York.*

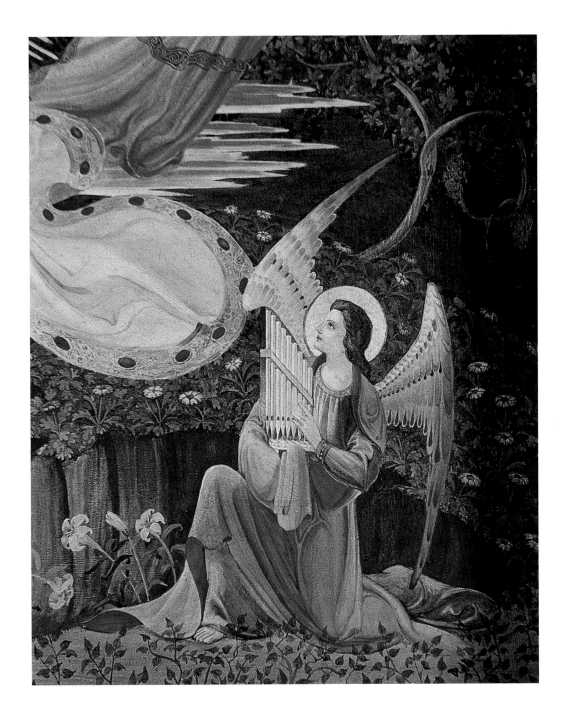

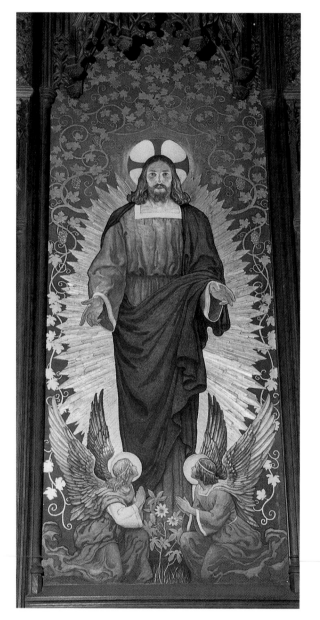

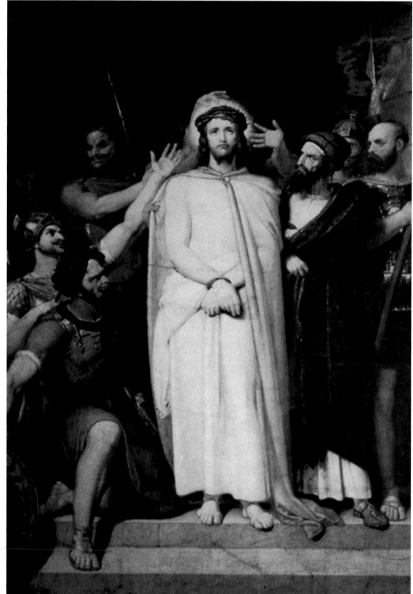

N. C. Wyeth's triptych of Christ, painted in the 1930s for the Holy Spirit Chapel in Washington National Cathedral, is considered a "crowning glory" of his venture into biblical paintings.

The round, columned portico and conical steeple of All Souls, Langham Place, London W1, near the old BBC headquarters, has been a distinctive presence since 1822; and Richard Westall's Ecce Homo depicting Christ's appearance before Pilate, is even more distinctive— the only bright spot of creativity among the church's restrained, post–World War II furnishings. Acquired early in the life of the parish, it was cut into thirteen pieces by a crazed man in 1859 and was bricked up to escape further damage after the blitzkrieg of 1940.

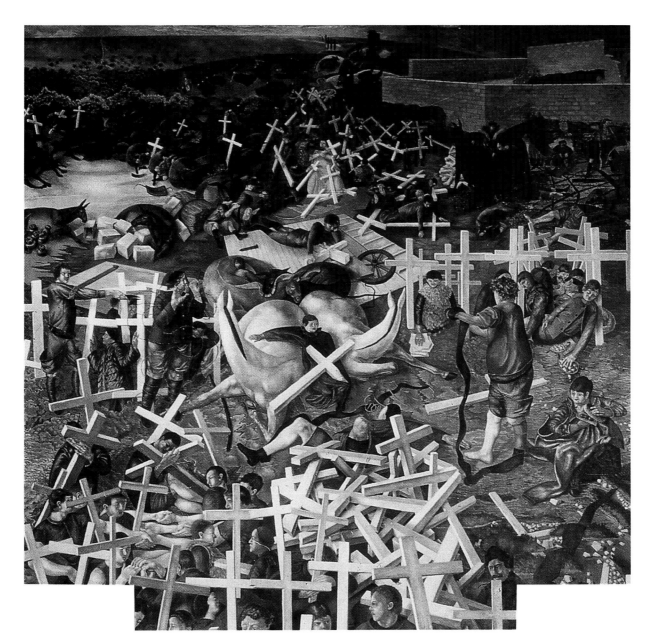

A cascade of crosses from a World War I battlefield startles viewers of Stanley Spencer's Resurrection of the Soldiers *above the altar of Sandham Memorial Chapel, Burghclere, Hampshire. Painted in 1928 as part of a series that also covers the side walls, Spencer's sepia-toned murals symbolize the random waste of life in the 1914–1918 conflict, in which he served. A similar theme is explored in Spencer's painting of parishoners climbing out of their graves on Judgment Day, in the churchyard of Holy Trinity, Cookham-on-Thames,, his native village in Berkshire.*

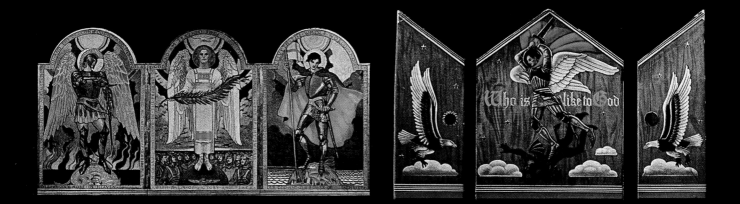

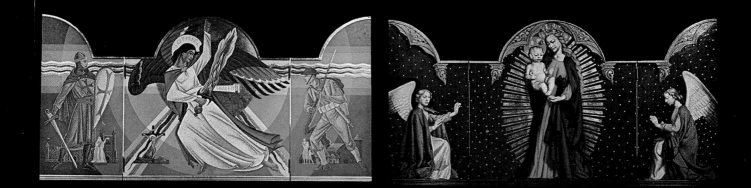

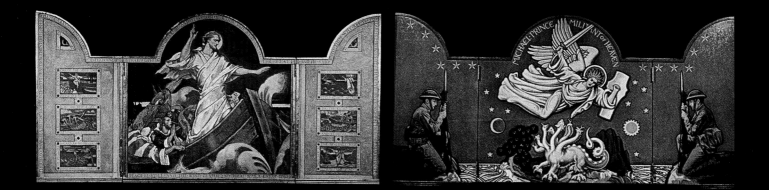

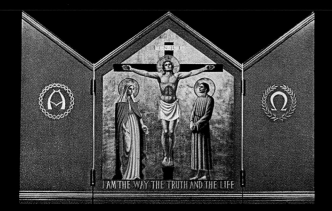
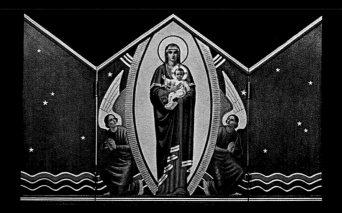

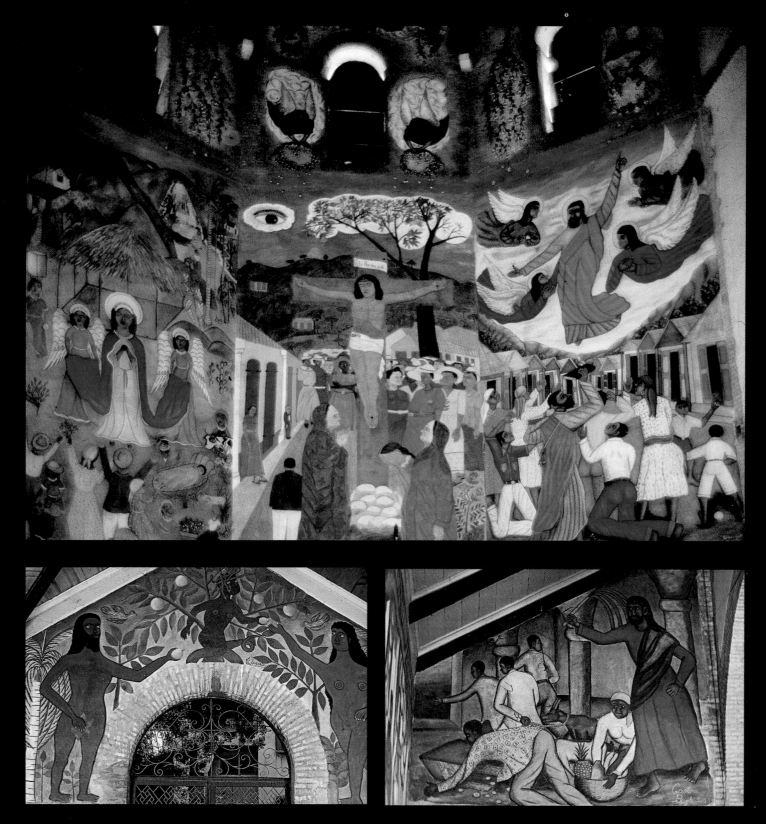

OPPOSITE *A New York City group known as the Citizens Committee for the Army and Navy organized scores of artists to provide altarpieces for World War II bases and ships.*

ABOVE *In the late 1940s, native artists painted the reredos at the Holy Trinity Cathedral, Port-au-Prince, Haiti. Adam and Eve find places on an archway (LEFT) and, up near the eves (RIGHT), Jesus drives the money changers from the temple.*

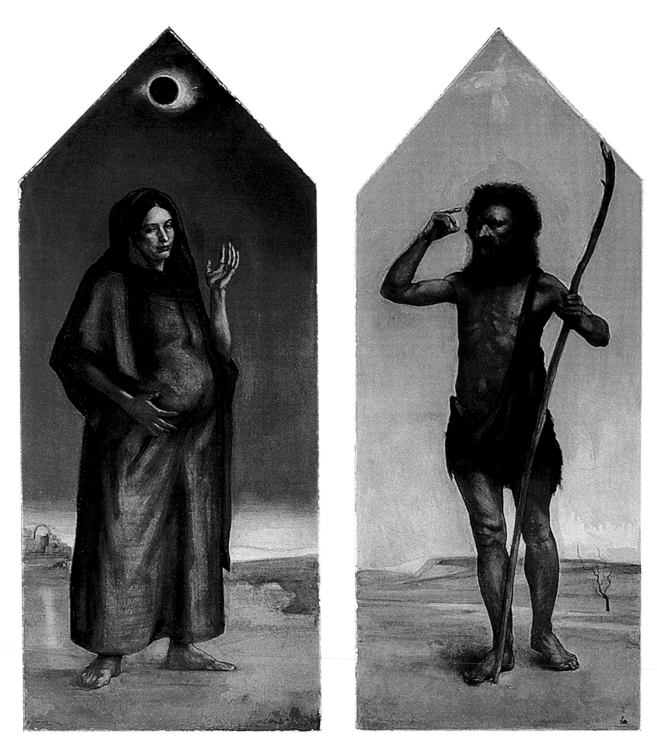

"We're called Saint Mary's, why don't you paint Mary expecting?" asked Father J. Fulton Hodge, vicar of Beaver Creek, North Carolina, of a young artist, Ben Long, who had offered in 1973 to execute murals for the floundering mission church there.

The result is Mary, Great With Child (LEFT) and John the Baptist that, with an altarpiece of the Crucifixion, draw hundreds of visitors annually. The mountain girl who volunteered to pose as Mary has never been located.

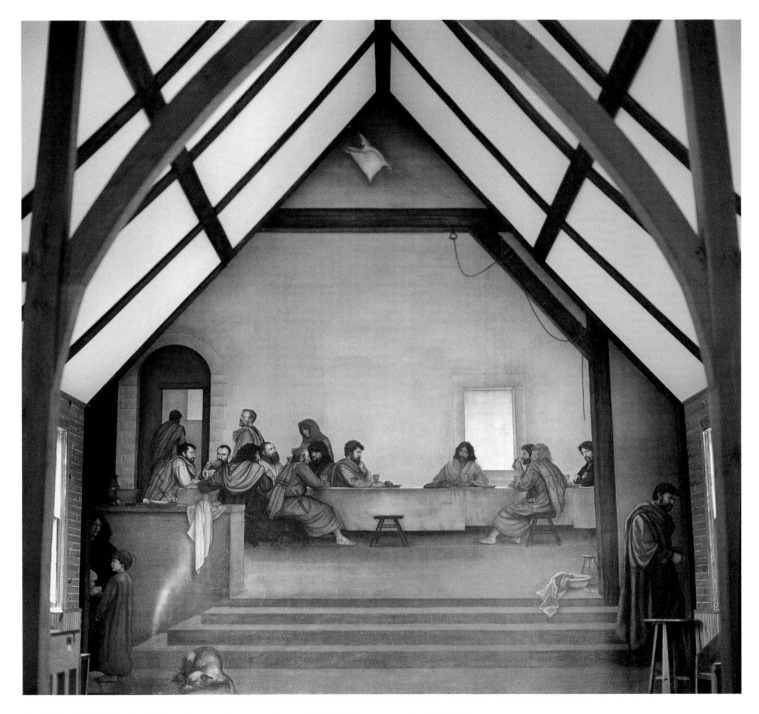

In Father Hodge's other falling-down mission, the Church of the Holy Communion, Glendale Springs, North Carolina, Ben Long painted a spare version of the Last Supper that also attracts many visitors and has revitalized the congregation's life. Note the bowl and napkin that Jesus used in the foot washing (far right) and, nearby, a figure, possibly Judas, who is slipping away.

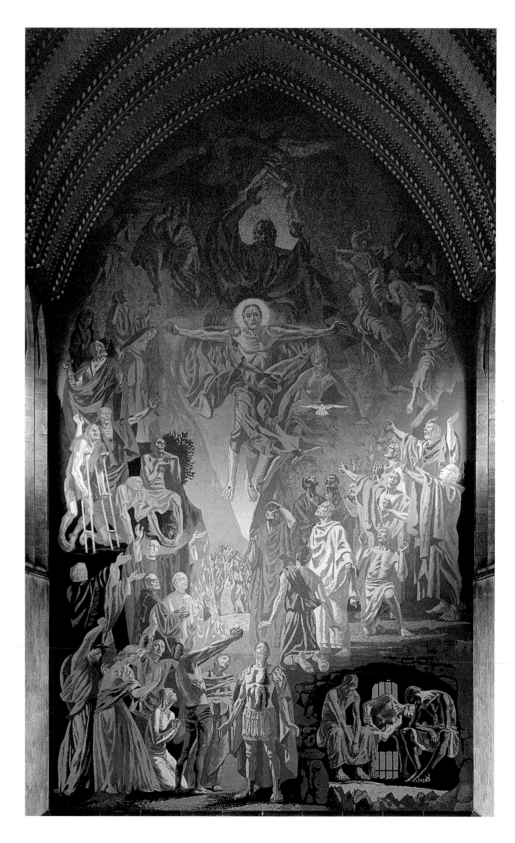

In the postwar rebuilding of Saint Alban's, Holborn, London EC 1, Hans Feibusch was commissioned to paint
The Trinity in Glory *that reaches to the ceiling on the wall behind the high altar.*

OPPOSITE *Christ's burial in the tomb of Joseph of Aramathea is depicted in the Washington National Cathedral's Chapel of his name.*

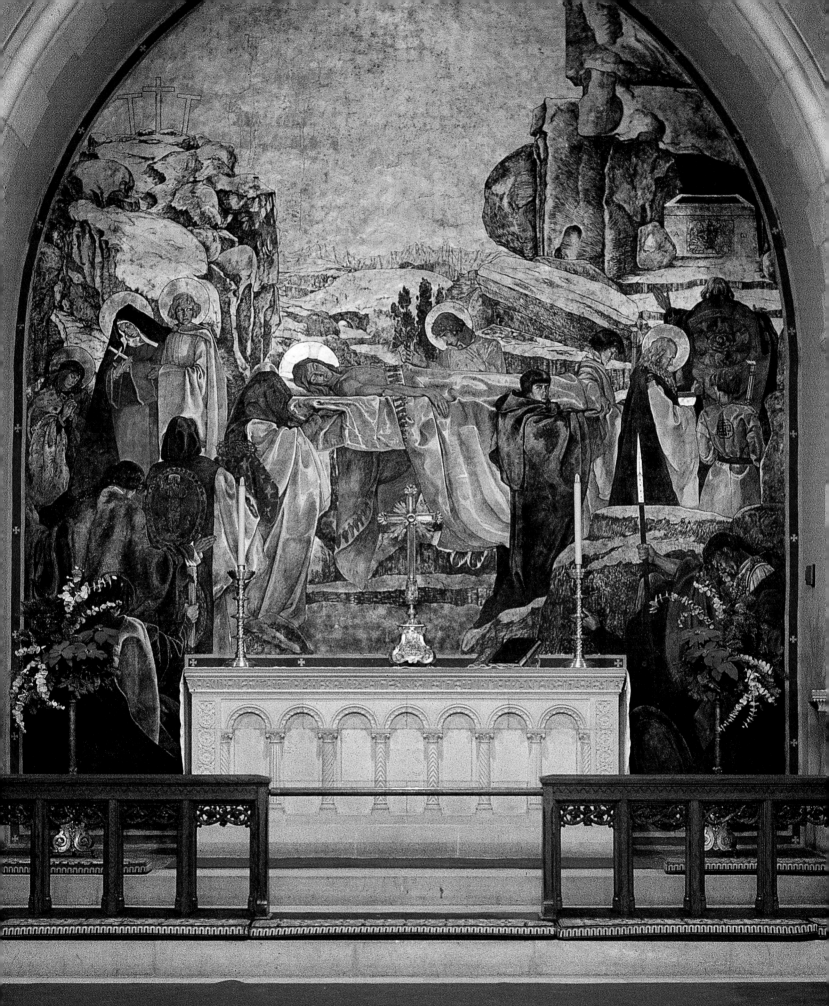

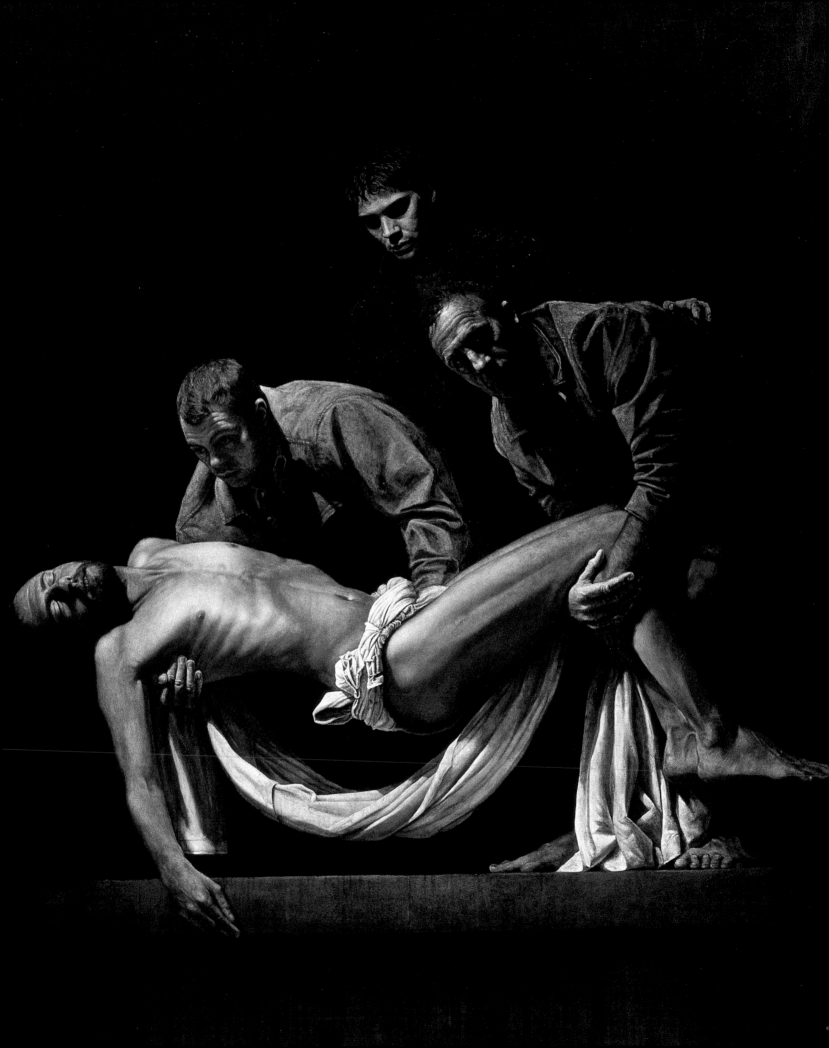

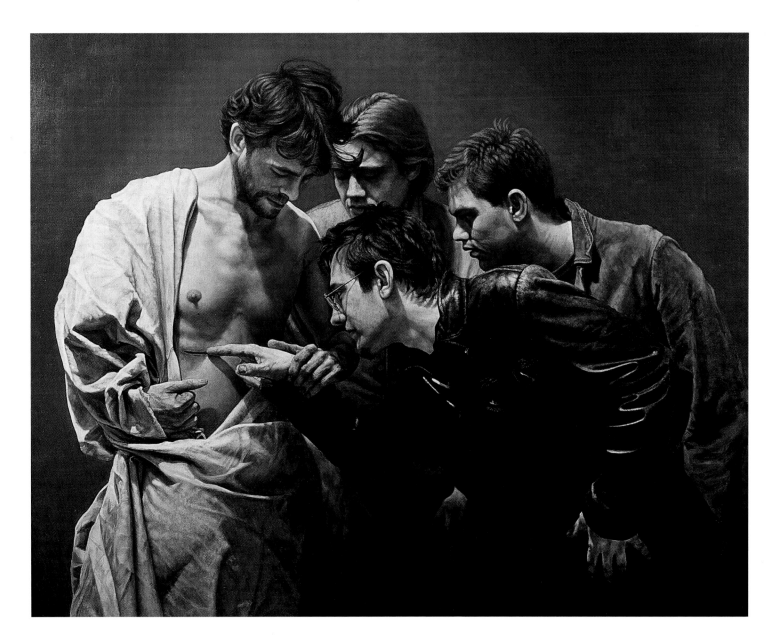

OPPOSITE *Artist John Gregory's modern interpretation of Caravaggio's "Entombment" now hangs on the main wall of the nave of the Bangor Cathedral in North Wales. It is entitled "Why?".*

In Still Doubting, John Granville Gregory emulates the realistic style of Caravaggio to portray a leather-jacketed Saint Thomas who would not believe that Christ was crucified and risen until he could actually touch the wounds. Trained as a commercial pilot, Gregory turned to painting after losing his *hearing at age twenty-four in 1991. The picture hangs in Saint Philip's Church, Alderley Edge, Cheshire. Continuing to work with oils on a large canvas, Gregory produced* Entombment (LEFT) *in 1999, again using contemporary figures.*

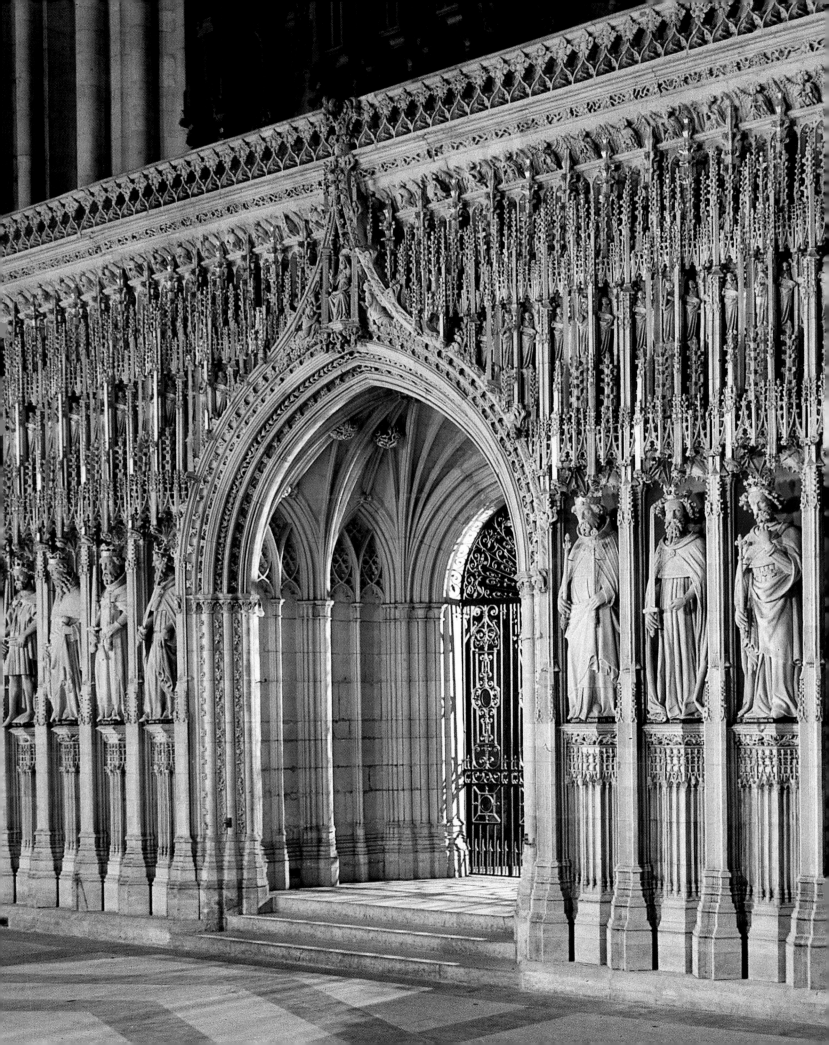

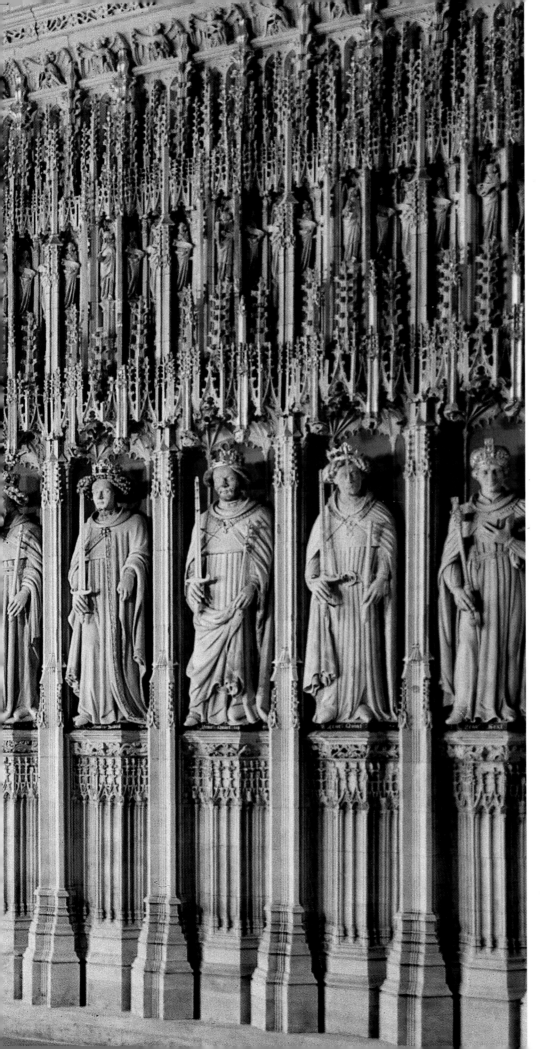

Stone

Kings of England march across York Minster's pulpitum *that was constructed in the Middle Ages to reserve the choir for members of the monastic community. It also serves as a buttress between the two eastern piers of the tower, helping to support its great weight as well as the weight of the majestically situated organ.*

Saint Augustine's chair and footrest, a patriarchal throne made of Petworth marble with an incised cross in the back and front panels, is situated in Canterbury Cathedral's corona, sometimes called Becket's Crown, and since 1978 the Chapel of Saints and Martyrs of Our Own Time.

OPPOSITE *For enthronements of archbishops of Canterbury as successors to the first archbishop, Saint Augustine, his chair is placed in front of the high altar looking down the length of the choir and nave. Some historians trace it to 1210 or 1220, but its style is considered curious for that period and it may be a copy of a much older throne destroyed in the great fire of 1174. "There is no soft cushion in the chair of Saint Augustine," say observers of the ancient office's many responsibilities.*

Stone, the most enduring of all fabrics, chosen for Solomon's Temple, the Ten Commandments, the tablets on which the first Christians wrote their names and engraved holy symbols, the substance of the earliest Christian relics, the choice for marvelous columns and capitals, sweeping arches, roof bosses, uncounted pavements, wondrous screens, baptismal fonts, altars and tabernacles, towering reredoses, sedilias, shrines, tombs, sarcophagi, memorials, *pulpitums* that divide the choir from the nave, and exalted figures of Christ, His angels, and His saints. Beginning with the ancient chair in which St Augustine and his successors, who, as Archbishops of Canterbury, have been enthroned, stone provides the most venerable furnishings.

In any quarry, the first job is to free large chunks of stone to be cut into the required shapes. Even a common rock pile ceases to be a rock pile the moment an artist contemplates it, bearing within the image that the artist contemplates. Unless a marked departure is planned, stone he chooses must blend with work already accomplished and have some compatibility with work to come.

Many artists have carved wood but those who have attempted to cut stone are far fewer. Modern sculptors reach for protective goggles, diamond-edge power saws, pneumatic chisels and high-speed engraving tools, to name a few. The resources at hand today make us even more admiring of sculptors working much more simply with mallets and chisels.

Just as it is easier to carve lime wood than ash, so, too, each type of stone has its own "grain" and other characteristics. Certain kinds have always been preferred for carving ornate capitals; others are better for constructing walls. Still others better weather the elements. The master builder, therefore, has to have a good eye for stone and a knowledge of how it will age once it is cut. Whether he favors the qualities of local stone or decides in favor of distant quarries, transportation of tons of stone to the work site, adds to the complexity of construction.

Photographs of moving of sixteen granite columns from a quarry in Vinalhaven, Maine, down the Hudson, and across Manhattan island, to the Cathedral of St John the Divine, in 1907, offers a new appreciation of what it took to build the pyramids.

Carrara marble is the favored stone for altars but sculptors and builders have used slabs of alabaster, or French and Italian marble, as well as marble from Algeria, Bedford, Caen, Carlisle, Carthage, Chilmark near Salisbury, Exeter, Jerusalem, Purbeck, Sienna, Sicily, the states of Georgia,

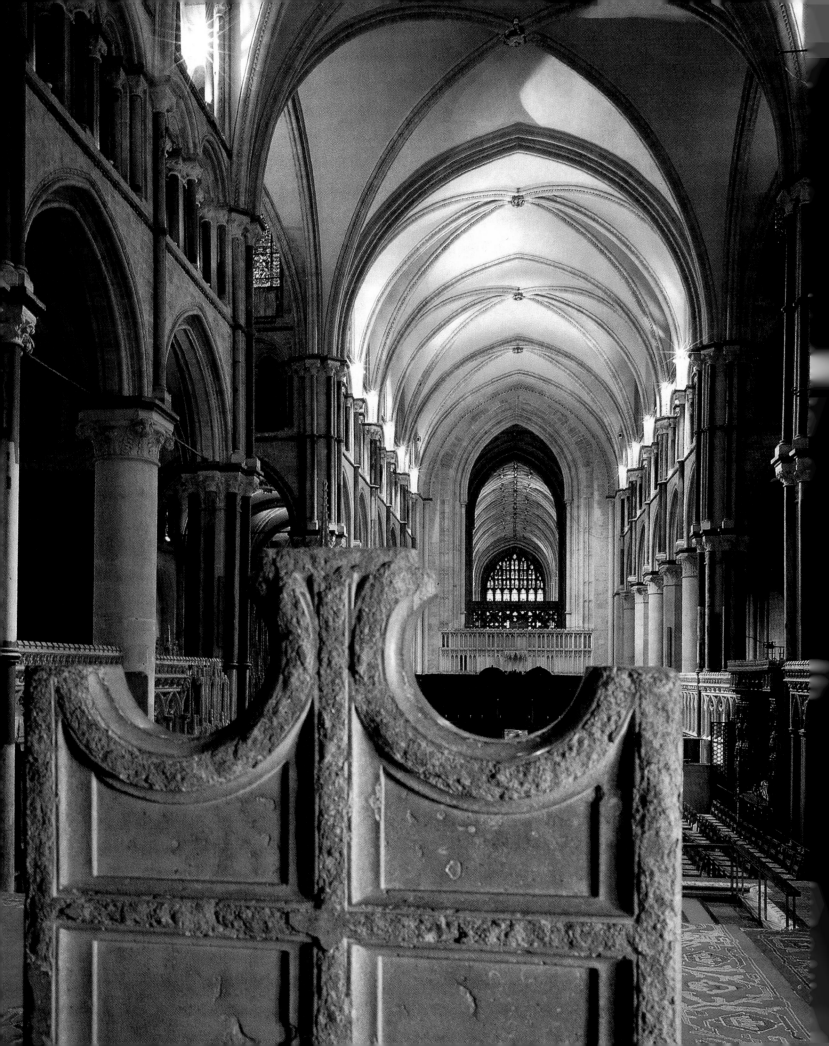

The Green Man, or Hawthorn, originated in pre-Christian seasonal rites, looks down from the cloister of Norwich Cathedral. Placed in the midst of foliate bosses, his face is partially masked by fronds and hawthorn leaves. A similar likeness is carved in a capital in the chapter house of Southwell Minister, Nottinghamshire.

OPPOSITE *Lichfield Cathedral's serene and perfectly balanced high altar is entirely of English stone enriched with inlaid marble of various colors quarried in the area. Emerging in the 1860s in a blend of High Church theology and aesthetic order, the altar was designed by Sir George Gilbert Scott who limited its height to avoid obscuring the Lady Chapel's sixteenth-century Flemish glass. Scott used Minton tiles in the floor of the sanctuary and choir. Alabaster statues of saints and martyrs, designed by C. E. Kempe and carved by Farmer & Brindley, were added in 1902.*

Minnesota, Montana, and Tennessee; and Roman travertine. The richly veined marbles range over a varied spectrum that includes palest apricot and gold to purest white, to shining black onyx and pink granite.

Stone from hallowed, historic places reassure Episcopalians of the continuity of faith and their links with the past and successors to the Apostles. Besides stone from the Holy Land, witness the shipments to America for Washington's Canterbury pulpit and Glastonbury throne. Other churches in the US and the Commonwealth value stone from Westminster Abbey and St Paul's Cathedral, from Winchester, York and Durham, Normandy, Rheims, Rouen, and Ypres, Belgium. In 1888, the Rt Rev Walter Hare, I Bishop of South Dakota, brought home from the third Lambeth Conference a stone cross from the walls of St Augustine's Abbey, Canterbury, and one of polished jasper from the pavement of Canterbury Cathedral.

In *The Stone Carvers*, a documentary on Washington National Cathedral, folklorist Marjorie Hunt pays an expansive tribute in asserting that "from the Gothic cathedrals of Europe to the Beaux-Arts skyscraper of New York, stone carvers have brought enduring beauty...creative works of art that bear the touch of human hearts and hands."

In the words of the muralist Ernest Peixotto, "a great reredos, a gigantic work of art, rears itself aloft, piling its niches, its sculpted figures and its pinnacles, from the altar to the topmost curve of the main vaults of a church—one of the great accomplishments in ecclesiastical art."

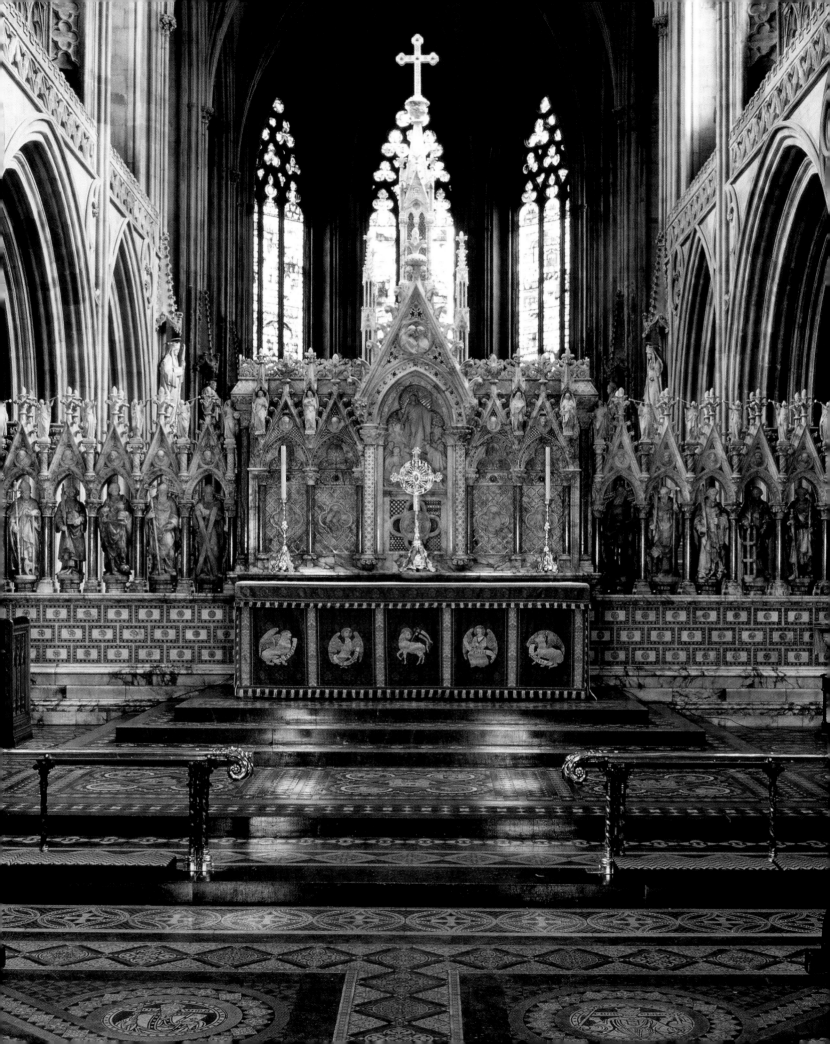

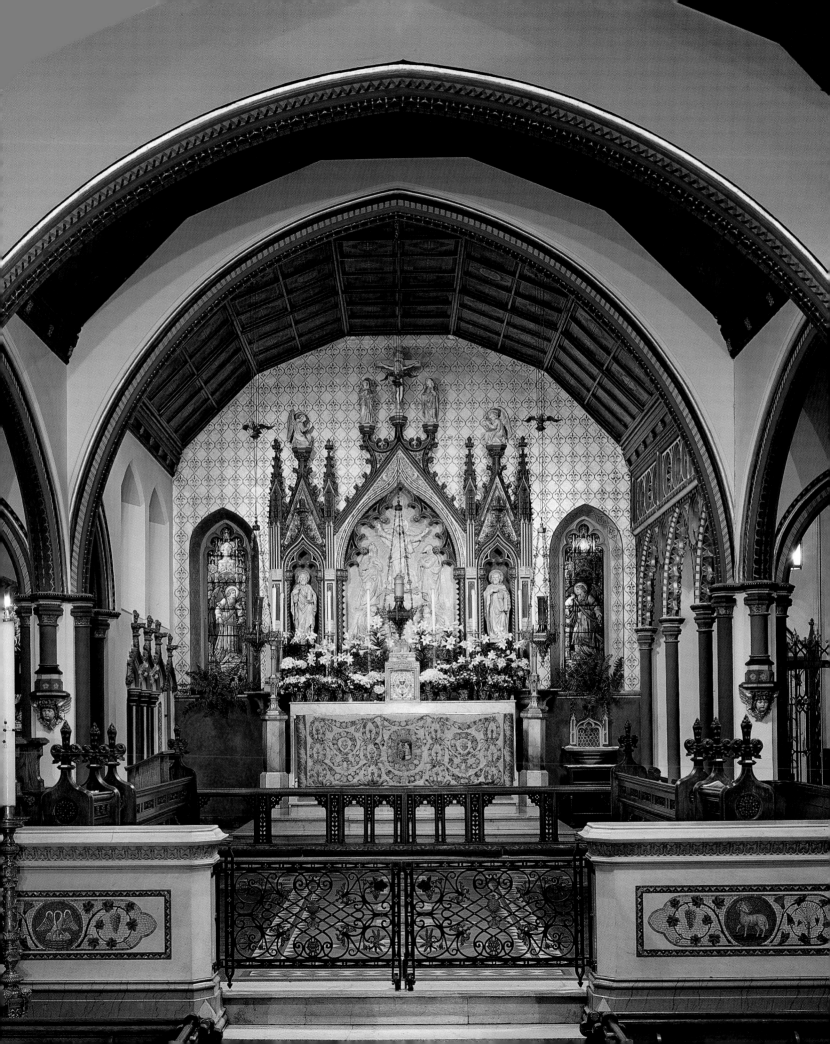

OPPOSITE *Low-ceilinged but nonetheless grand and golden, New York's Church of the Transfiguration ("The Little Church Around the Corner"), founded in 1848, centers its corporate life on a richly polycromed reredos, an enduring statement of the Cambridge-Camden Society that sought to revive historically authentic Anglican worship.*

The gilding of a heavily carved canopy and white marble figures distinguish the reredos of Saint George's Chapel, completed in 1528 at the gates of Windsor Castle. It is here that most monarchs and their spouses lie in state; and here, more recently, Prince Edward was married, Prince William was confirmed, and Princess Margaret's ashes were interred.

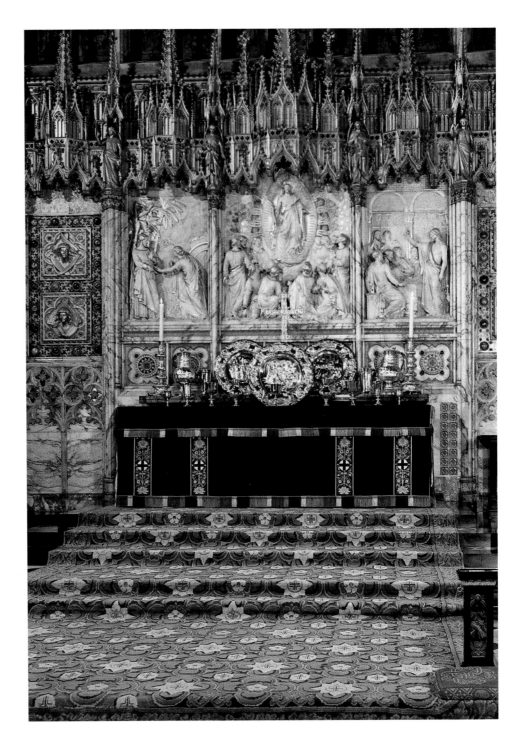

Chicago's premier Anglo-Catholic parish, the Church of the Ascension, built in 1881 on North LaSalle Street, is a symphony in gold and blue stenciling around a white marble altar (ABOVE) designed by John Stout in 1894. Its alabaster angel (ABOVE LEFT) was carved in London and the tabernacle's mosaic door (LEFT) was crafted in Venice—both replicas of the high altar of Saint Mary's Church in Cologne, Germany.

OPPOSITE The General Theological Seminary, the Harvard of the Episcopal Church, which occupies an entire city block on Manhattan's West Side, has at its heart the Chapel of the Good Shepherd, designed in 1888 by J. Massey Rhind. Three years later, Rhind added alabaster statues of the Good Shepherd, flanked by Moses, John the Baptist, Matthew, Mark, Luke, John, Peter, and Paul.

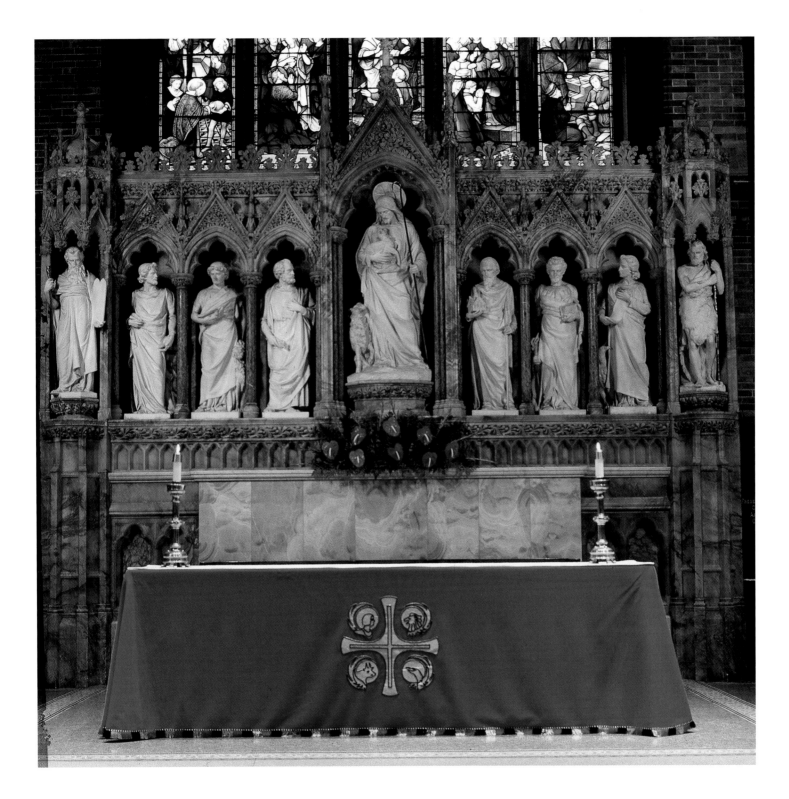

165 ❧

OPPOSITE *Beginning with the twelve apostles, nearly sixty figures are granted niches in five banks above the altar of New College, one of Oxford's most beautiful chapels, founded in 1538.*

Saint John and the Blessed Mother behold the crucifixion in the marble and stone reredos given to Trinity Church, Wall Street, New York, in 1875 by John Jacob Astor Jr. in memory of his father.

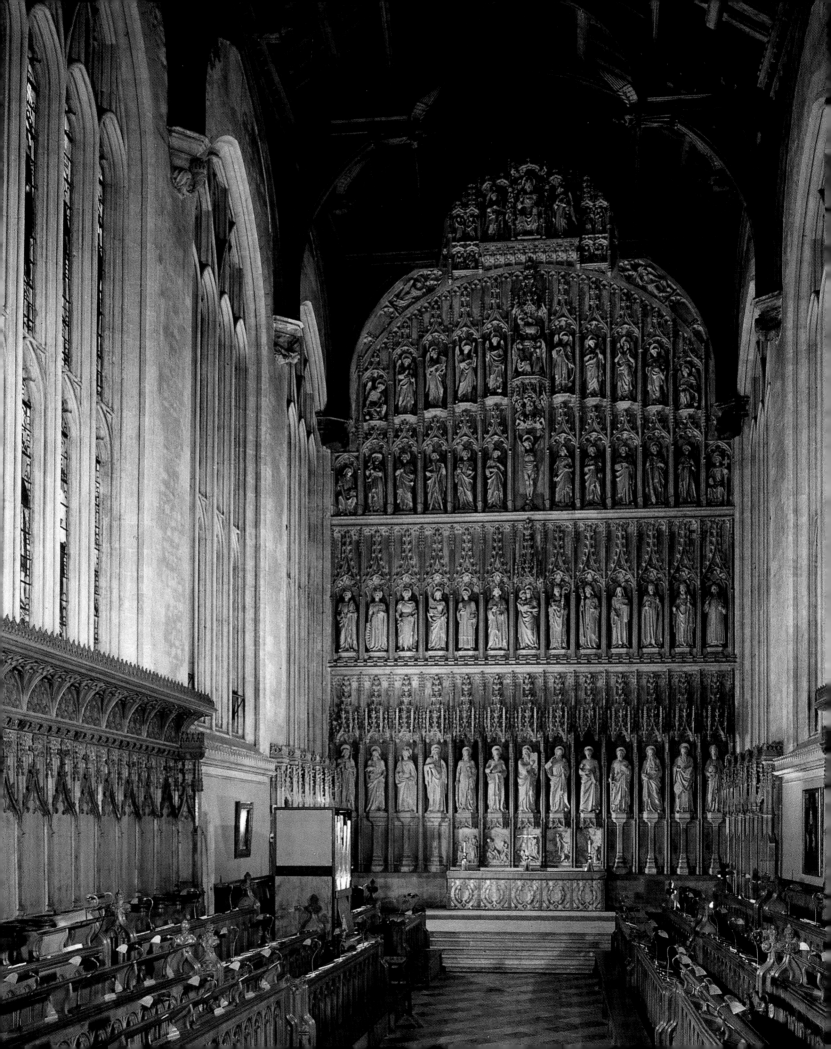

RIGHT *In Worcester Cathedral's decidedly Victorian altar, Sir George Gilbert Scott's alabaster figures are barefoot with realistically wrinkled garments, each of them holding symbolic objects. Christ the King raises his hand in blessing as does Saint Mark at his right.*

LEFT *Just off Park Avenue in the East Seventies in New York, Mary Magdalene's meeting with the risen Lord outside the Holy Sepulchre was carved by unknown hands as the reredos of the small but tenacious Anglo-Catholic Church of the Resurrection, founded in 1862.*

Frederick Temple's tomb in Canterbury Cathedral incorporates the primatial cross given during his archiepiscopate, 1872–1902.

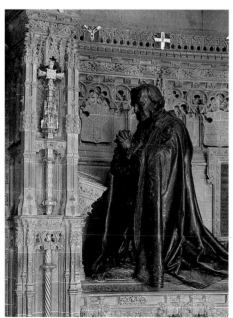

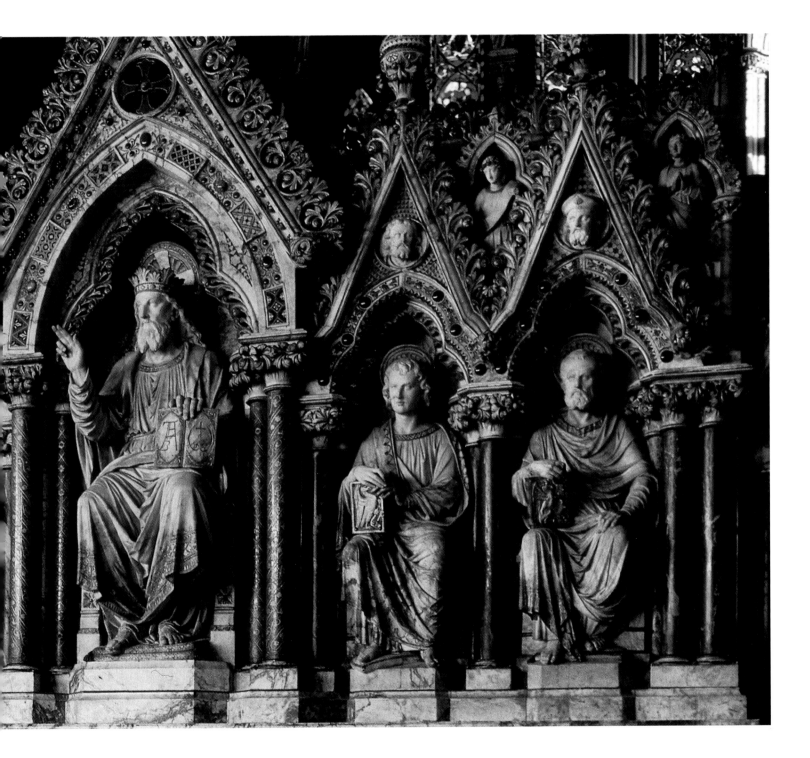

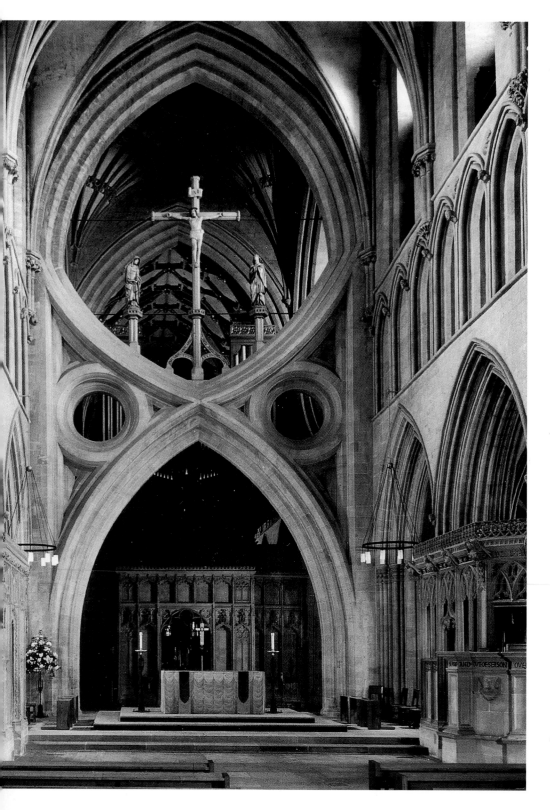

Wells Cathedral's central inverted arch, an architectural feature that saved the tower from collapse in the 1330s, curves gently around a Calvary that in 1920 replaced a much earlier grouping.

OPPOSITE *A splendid wall of statuary rises above the altar of Saint Thomas Church on Fifth Avenue in New York, its sixty life-sized personages radiating outward from the cross in an army of the exalted. They soar to the height of a seven-story building, framing, at the top, a trinity of shimmering, deep blue lancets, flecked with red, reminiscent of Chartres. Lee Lawrie's figures in Ohio-quarried Dunville stone stood each day on West 53rd Street, awaiting placement throughout a ten-month period during World War I. The 40 x 80 foot screen of saints, prophets, and statesmen, a detailed panorama of Christian history, is both vibrant and frozen in time. "Thou art the King of Glory, O Christ," reads a passage from the "Te Deum Laudamus" deeply carved above the ample altar. "Thou didst open the Kingdom of Heaven to all believers."*

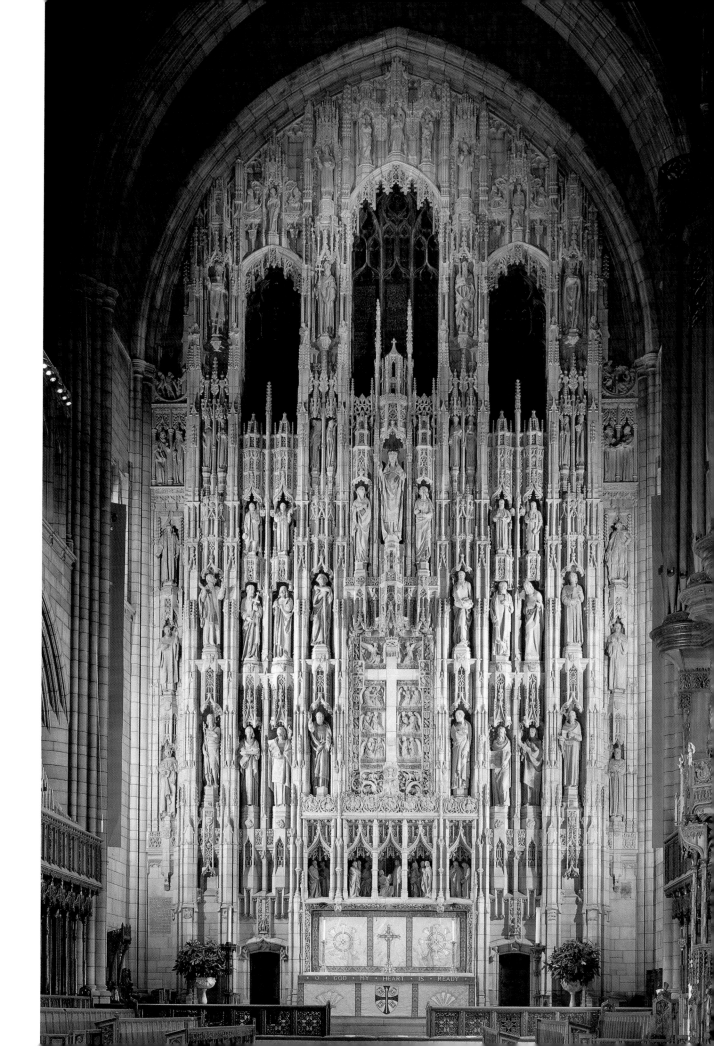

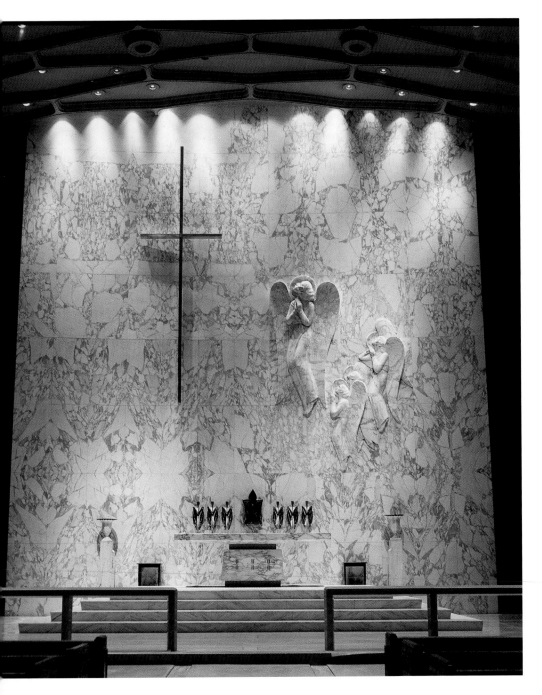

A trio of angels approaches a slim gold cross on a giant field of white marble, an understatement of simplicity, above the altar of the Church of Saint Michael and All Angels in Dallas, Texas. As brightly lighted as a stage set, it picks up shades of red and blue, during morning worship, from stained glass windows on opposite walls of the sanctuary.

OPPOSITE *Manifold problems were overcome in the choice of stone and space in adding the* Majestus *to statuary carved twenty years earlier for the high altar of Washington National Cathedral. It was designed by Walter Hancock and carved by Roger Morigi from fifteen tons of Texas limestone.*

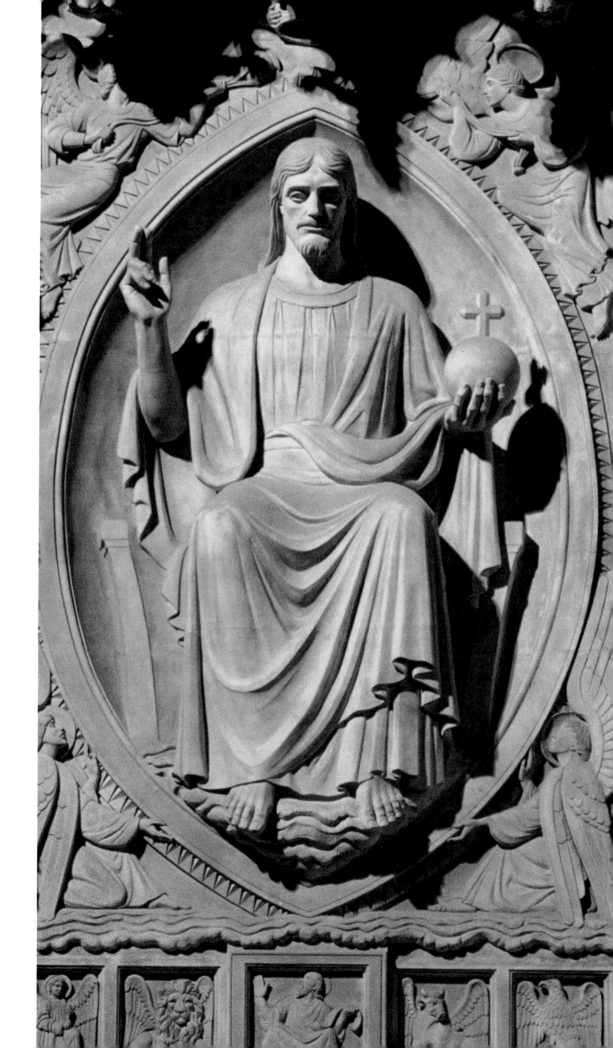

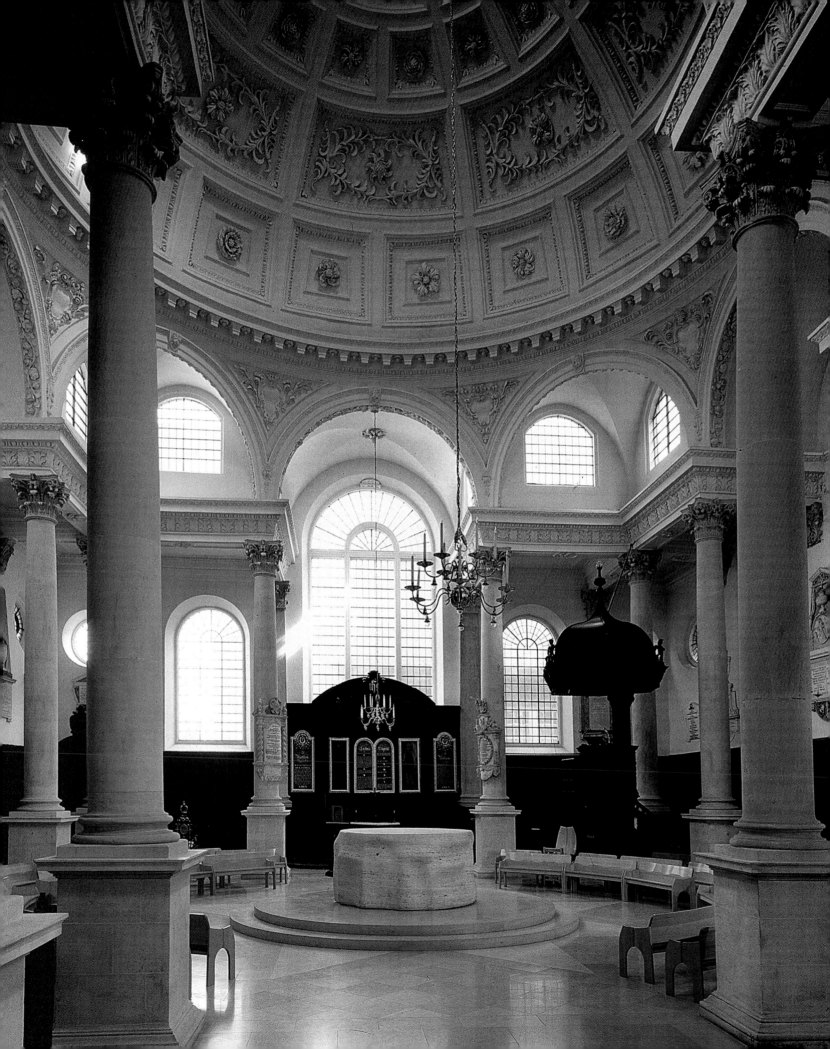

RIGHT *Chipping away ten to twelve hours a day for six weeks, Henry Moore sculpted his* Madonna and Child *from a two-ton block of brown Hornton stone. It was placed in 1934 in Saint Matthew's Church, Northampton, in the English Midlands. Although Moore's massive work was increasingly accepted over the next twenty-eight years, the circular travertine marble altar (*OPPOSITE*), designed for a Christopher Wren church, Saint Stephen's, Walbrook, in London, was condemned by a consistory court on grounds that it was not a table in the biblical and theological sense required by canon law.*

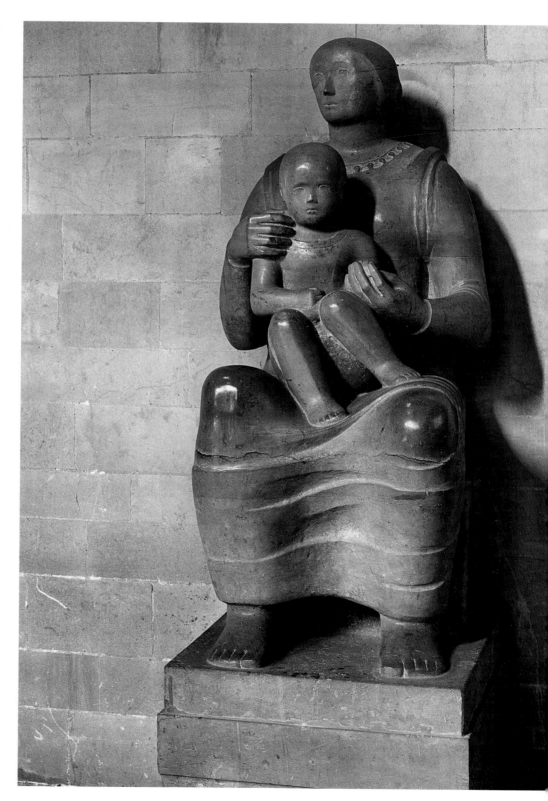

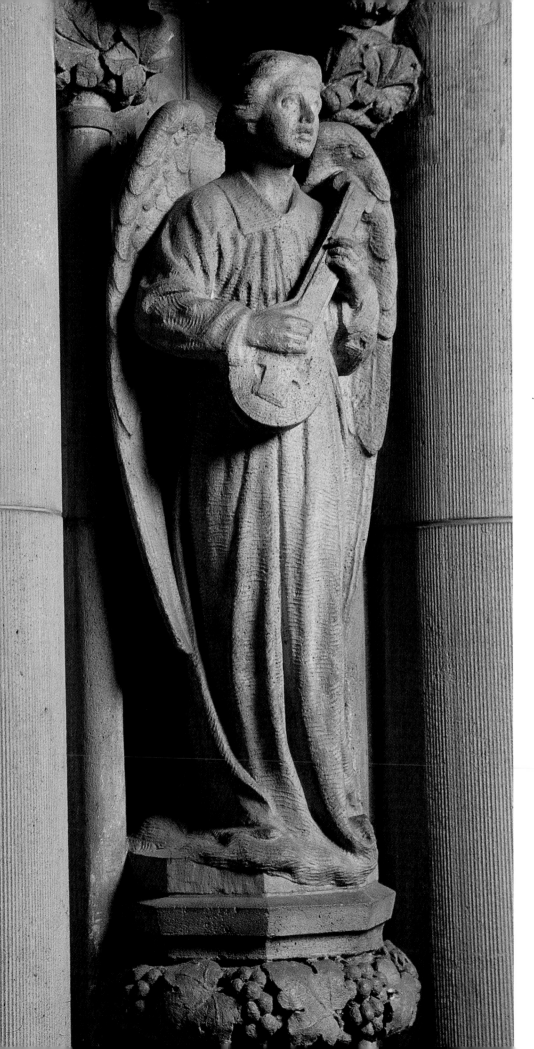

Two gentle angels hold ancient musical instruments as members of a band of twenty-six forming a heavenly choir at the entrance to Saint Saviour's Chapel in the ambulatory of New York's Cathedral Church of Saint John the Divine. The band of angels was completed in 1904 and stood alone for a prolonged time while walls of the cathedral rose on either side. The sculptor, Gutson Borglum, came under fire for casting female angels, whereas archangels and other angelic hosts were traditionally male. Hardly deterred, Borglum went on to work on a much larger scale—the Confederacy memorial on Stone Mountain in Georgia and the heads of four American presidents on Mount Rushmore in North Dakota.

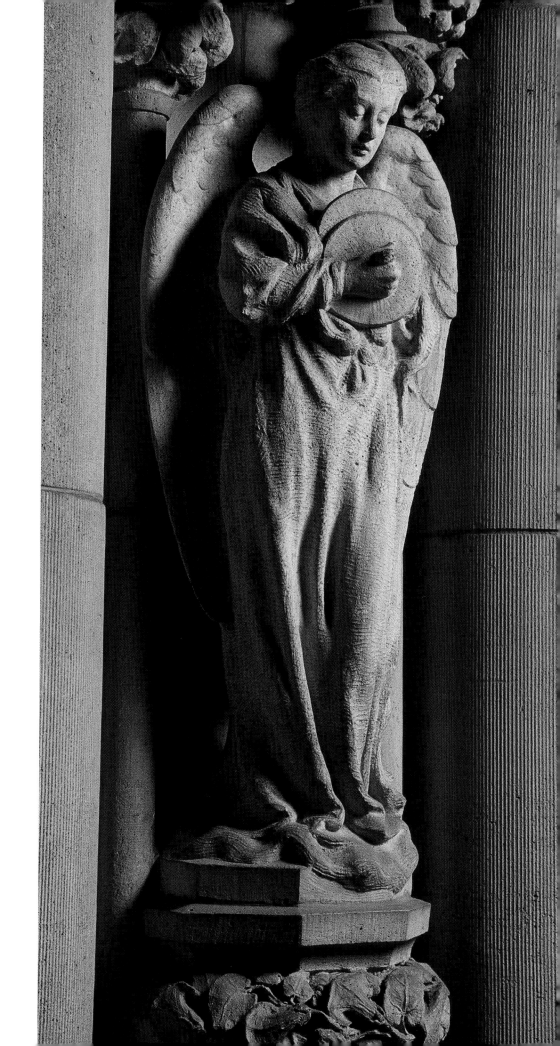

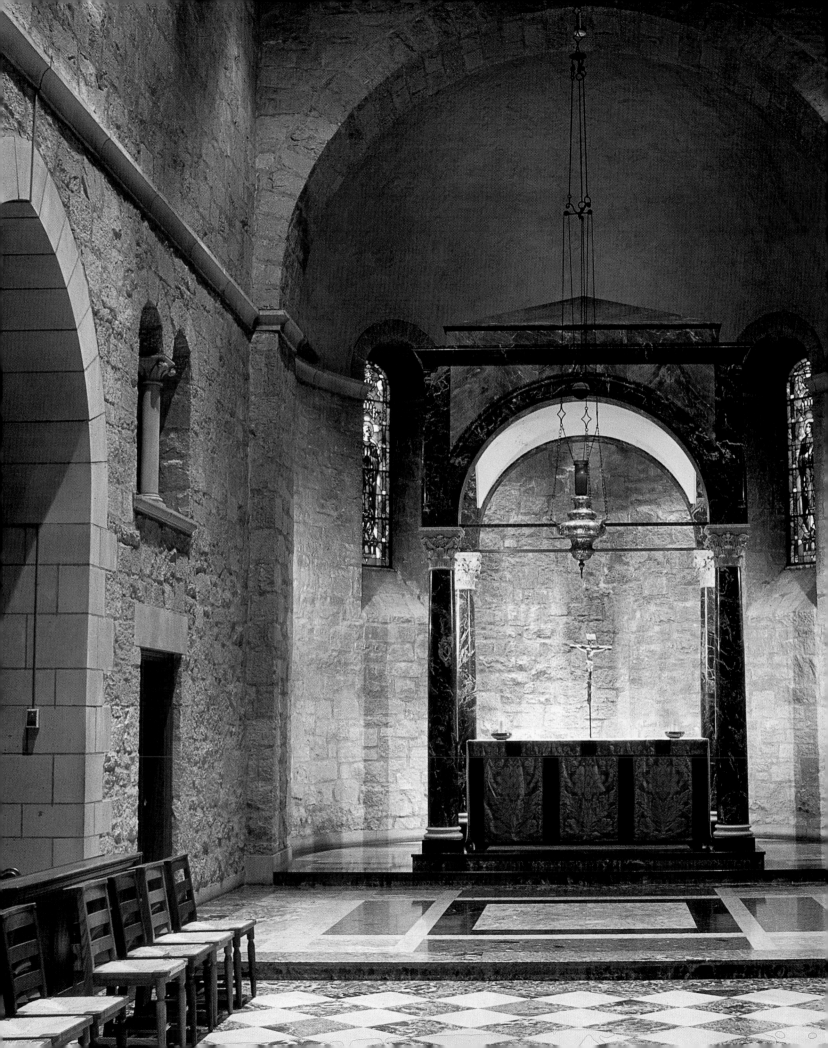

Ralph Adam Cram's restrained design of the chapel of the American community of the Oxford-founded Society of Saint John the Evangelist on Memorial Drive in Cambridge, Massachusetts, combines rough stone walls with the polished marble of the altar and baldachino.

Robert Bliss imaginatively used four pieces of ruggedly carved white marble hung from the ceiling to form the figure of Christ Crucified at All Saints, Parma, Ohio. Shadows on each side form the crosses of the two thieves also put to death on Calvary.

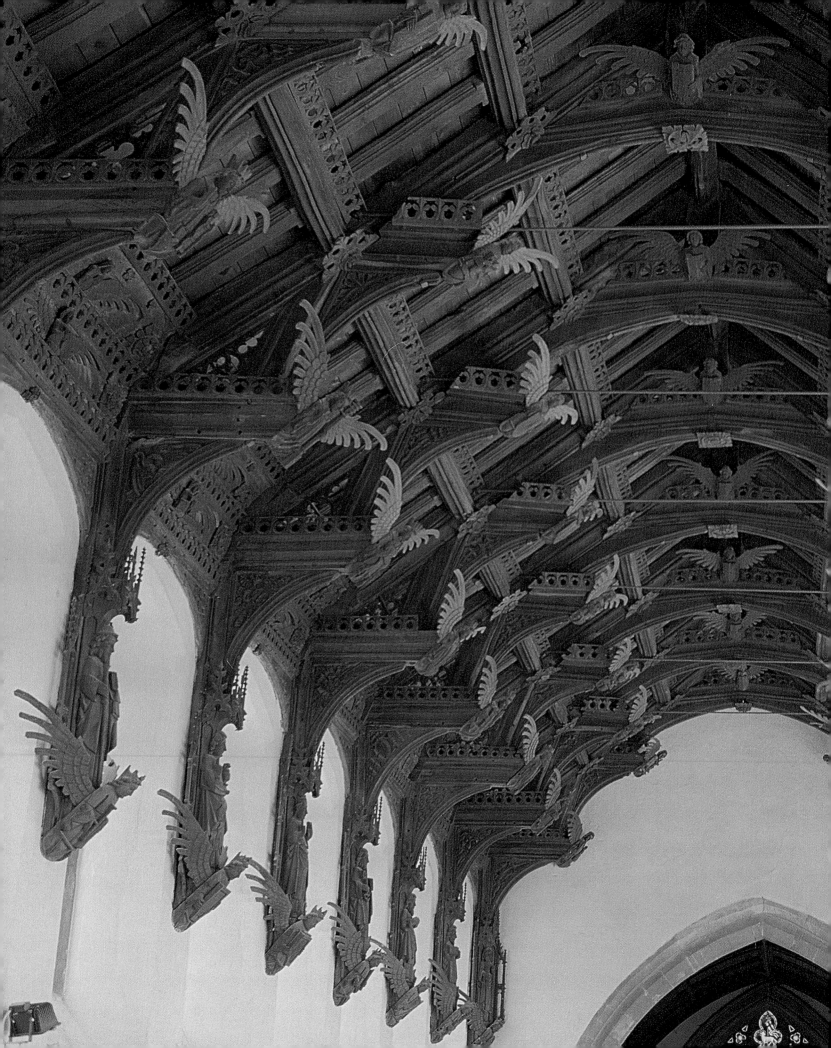

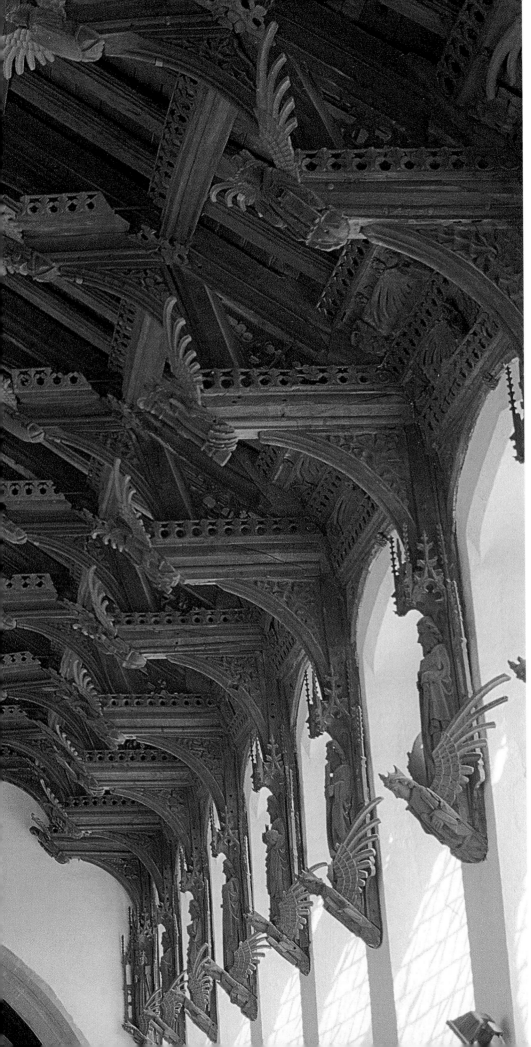

Wood

"Angels we have heard on high…" begins a traditional French carol, a favorite of the congregation that worships beneath these winged figures, ca. 1400, in the nave of Saint Wendreda's Church, March, Cambridgeshire. Similar decoration is seen in churches in Norfolk and Suffolk and in Ely and Carlisle cathedrals.

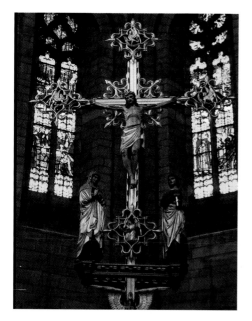

Cape Town, South Africa's Cathedral of Saint George, built in 1901, and its rood, added in 1930, have witnessed historic and turbulent times, including the archiepiscopate, 1986–1996, of the Nobel peace medalist Desmond Tutu.

OPPOSITE *The crucified Christ is crowned with thorns, absent in most other representations before the fifteenth century, in a chapel of Grace Cathedral, San Francisco. The oak altarpiece, carved by Flemish artists in 1499 for Hambye Abbey in Manche, France, was hidden by villagers during the French Revolution, then sold to the Marquis of Fressange. From him it passed to the private collection of the conservator of the Louvre; to a Parisian merchant; and to the Crocker family of San Francisco, whose mansion once stood on the site later occupied by the cathedral and who presented it to the chapel. The Indiana limestone canopy was added in 1930.*

There was a time when wood-carving and painting were the chief ways in which an artist could praise God. Although long ago transcended by modern tools and mass production, it is woodcarvings—crosses, statues, offering plates, candlesticks, tabernacles—that, along with larger pieces—beams and roods, altars, altar rails, reredos, bishop's thrones and canopies, misericords, triptychs, pulpits, organ cases, and pew and carved pew-ends—are authentic, individualistic artifacts that in their making and in their being are timbered tokens of praise. In the world of religious art, wood became a common denominator in its everyday availability to all peoples.

Theologically, the deepest significance of wood always pertains to Christ's secular occupation as a carpenter of Nazareth and to the cross that He carried to Calvary. In the words of a nineteenth-century hymn, still sung today, "Faithful cross! Above all other, one and only noble tree! None in foliage, none in blossom, none in fruit, thy peer may be: sweetest wood, and sweetest iron, sweetest weight is hung on thee."

Historically, we look to wood as the artistic depository of some of the greatest Anglican treasures in the furnishing and ornamentation, from top to bottom, of cathedrals, churches, and chapels. Fire was its frequent enemy, joined later by the rebellious "choppers of the Reformation" who,

in misguided hatred of images, destroyed as much representational art as their hands and hoods could reach.

As for wooden structures, the arrival of Benedictine monks from the Continent in the tenth century led to widespread rebuilding in stone. Consequently, churches of wood don't dot the English countryside as they do in the U. S., in New England and the Atlantic coast, mid-America, and areas as far as the west coast. They are likely to be protected as a historic landmark.

Although much was lost to the Reformation's willful wrecking, much was spared that, in having survived, is highly valued today. As sacramental worship centered on the altar was momentarily replaced by preaching, pulpits were given center stage. Many churches were stripped of their altars. Almost all were given new Jacobian pulpits, lecterns, and pews with new respect for at least slight comfort for listeners. References to the "holy table" replaced "altar" in the lingo of liturgy and many such tables still exist. Talents that once adorned roods and altars were often replaced with representations of clergy, officials, lords of the manor, and their heraldry.

In medieval times, builders usually felled trees while churches were under construction. The trees were left to lie for six months or a year because seasoning made them more stable when cut and lightened their

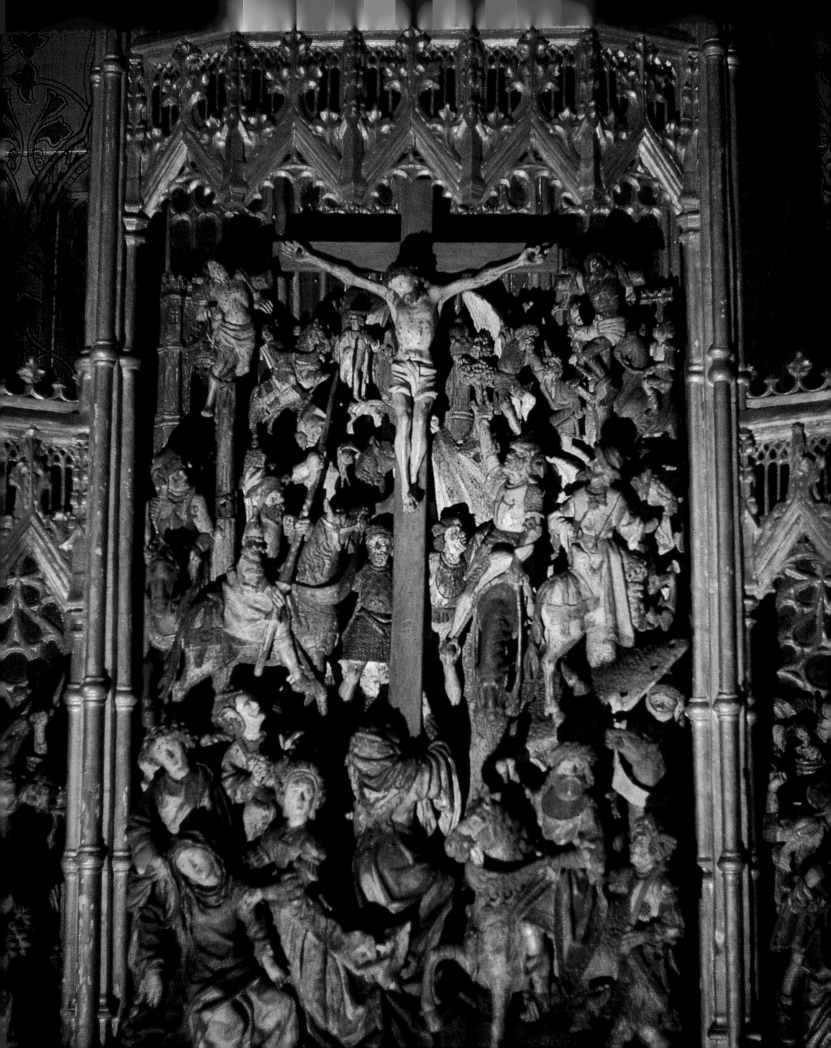

The altar screen at Saint Peter's Church, Cheshire, Connecticut—rare in New England churches—was added during liturgical renewal in the 1960s by Morgan Porteus, later Bishop of Connecticut, to provide a small chapel behind the screen for weekday services. The screen and the entire interior were painted white to relieve darkness in the church building, which dates from 1840. An Advent wreath hangs above the freestanding altar that is used on Sundays.

OPPOSITE *In 1766, Pierre Charles L'Enfant, best known for his layout of the city of Washington, D. C., designed the French baroque reredos of the serenely cool Saint Paul's Chapel, the oldest public building in continuous use on the island of Manhattan. Clouds of glory enshrine the Hebrew letters for God in a triangle of the Trinity and are also carved into an elaborate cartouche with the Ten Commandments. Here George Washington came to pray on his Inauguration Day in 1789 and here crews from nearby Ground Zero ate and slept for weeks after the destruction of the World Trade Center 11 September 2001.*

weight. Large pieces like suspended crosses and statues on the central beam would be hoisted and then secured with wooden "tree nails" or trunnels. The holes for the wooden pegs were precisely misaligned so that when the peg was driven in, it would pull the joint tight.

Woodcarvers beheld blocks of wood in the same way as those working in stone—the mass from which delicately imaged figures would emerge. The woodworker positioned the grain with a sure eye, an ability more or less lost in the machine age. Oak was a favorite for structural work, pine for arches and ceilings, windlasses, and general purposes. Drawings were made on the shop floor and carpenters worked with ruler and dividers to transfer those measurements to the work at hand.

Once in a while, genius emerged—England's Grinling Gibbons in the 1670s, Germany's Alois Lang of Oberammergau, in the early twentieth century.

Regard for the use of wood down the ages was well voiced by the Rt Rev'd Chilton Knudsen, Bishop of Maine, on coming upon a small oratory in the woods surrounding St Jude's Chapel at Seal Harbor, Maine. She paused for meditation and later wrote that it was "as though the very wood of the structure had been soaked in prayers—many prayers over many years."

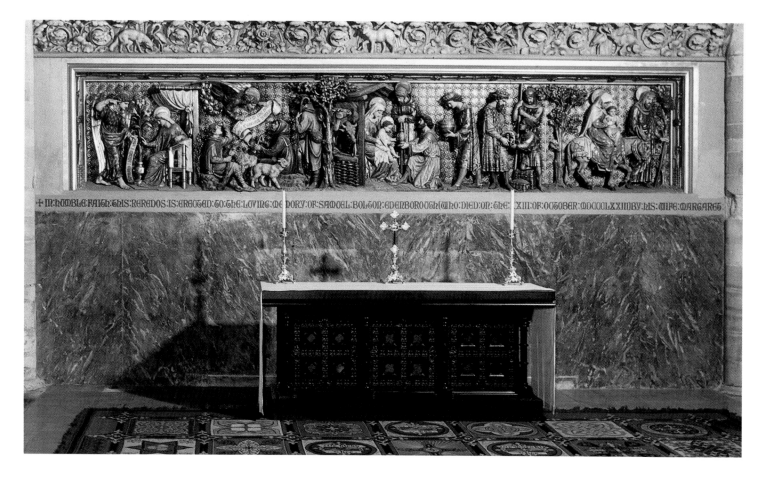

A frieze of the life of Christ is inset in the
wall above an altar at Waltham Abbey in
Essex, a modern addition to a one-time
monastic house founded in 1177. Near
at hand is the tomb of the last Saxon king,
Harold II.

OPPOSITE *The high altar of Saint Paul's
Cathedral, London EC4, destroyed in
World War II, was rebuilt with a baldachino
and carved columns crafted from pencil
sketches of what the original architect, Sir
Christopher Wren, had envisioned. It recalls
Bernini's Italian baroque style at the Vatican
and is crowned with a statue of* Our Lord
in Triumph. *The altar is a slab of Italian
marble weighing nearly four tons. The
stained glass window beyond the high altar
is in the American Memorial Chapel.*

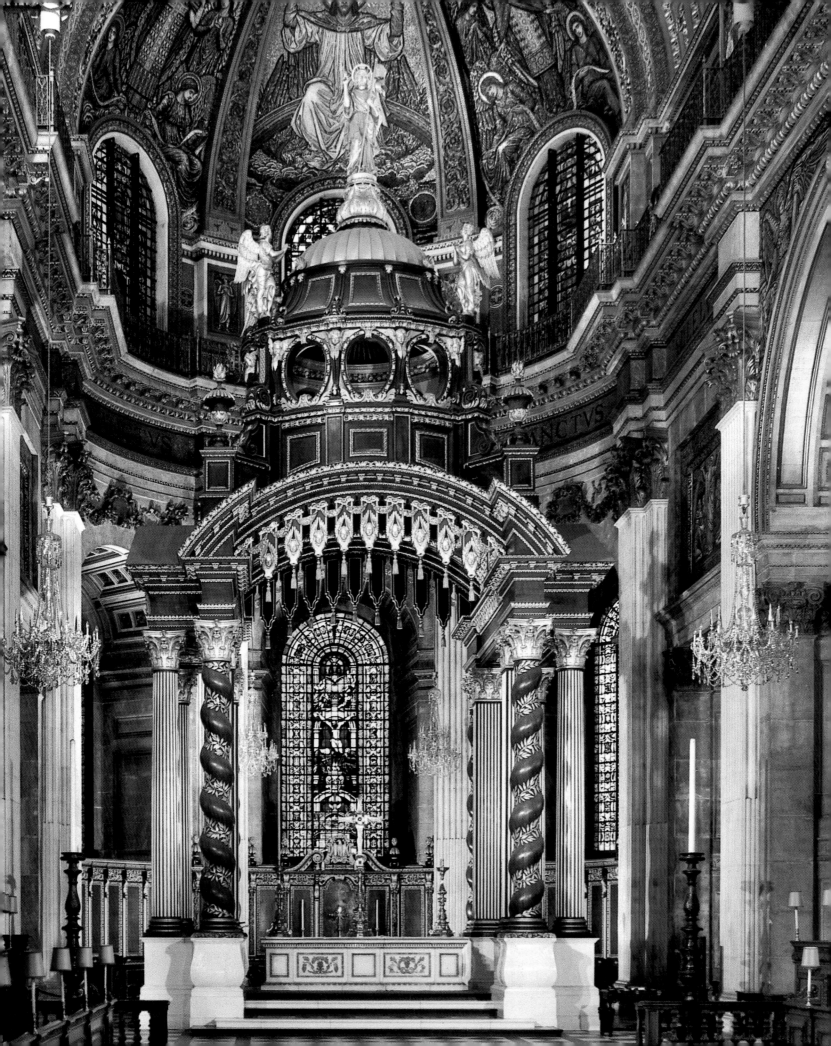

Wood-carver Ernest Pelligrini of Boston
dismisses pious sentimentality for reverend
confrontation in portraying the Visitation of
Mary and Elizabeth before the birth of the
infant Jesus. It is uppermost in the ornate
reredos that he furnished for Saint Mary's
Chapel in Washington National Cathedral.

The Maundy Thursday Foot-Washing *is
one of eighteen wood-carvings,* The King's
Highway: Events in the Life of Christ.
*Designed by the ecclesiastical artist Robby
Robbins, they were dedicated in 1975 at
Christ Church, Middletown, New Jersey.*

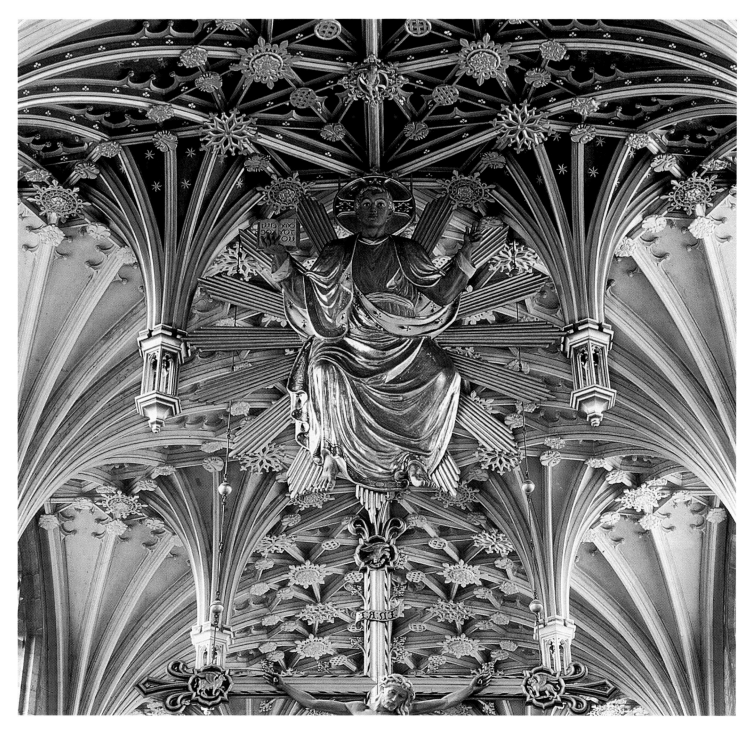

Sir Ninian Comper's most unusual achievement, Christ in Majesty, *is above the nave of Saint Mary's Church, Wellingborough, in the English Midlands. It is based on the* Christ Pantocrator *in the apse of the Capella Palatina in Palermo, Sicily: "as much Italian as English and English as Italian," Sir Ninian said. Saint Mary's was his favorite church and he worked on it almost continuously from 1908 into the 1950s.*

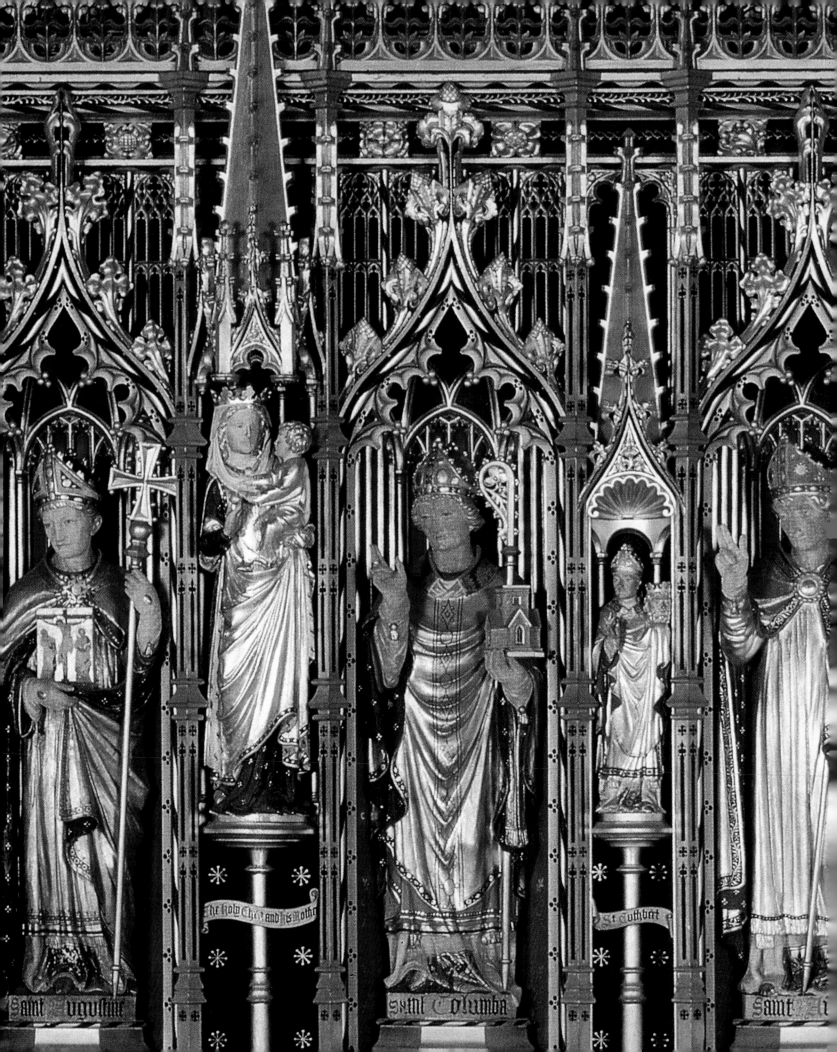

Saint Augustine The Holy Child and his Mother Saint Columba St Cuthbert Saint

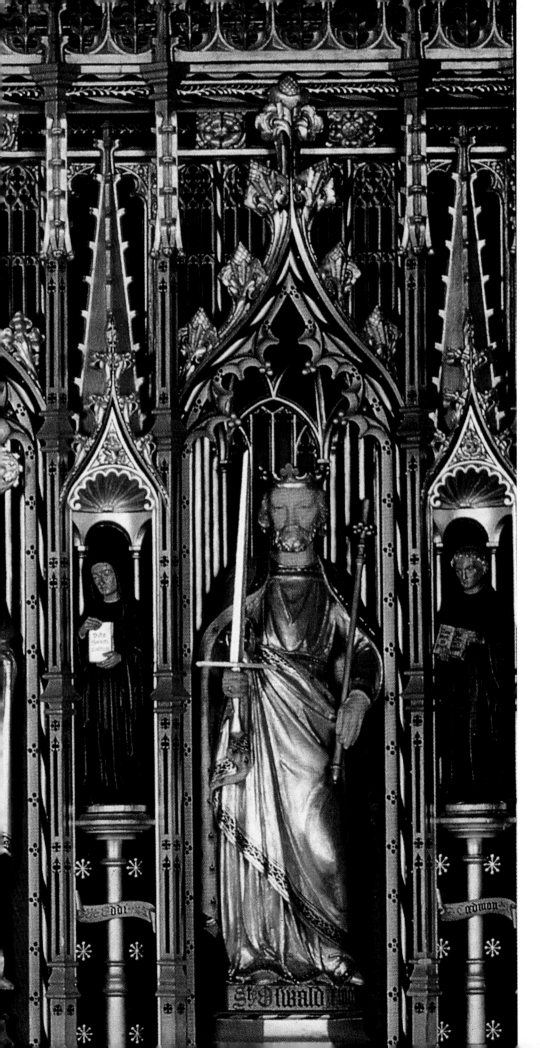

More of Sir Ninian Comper's work is seen in a partial view of the black and gold reredos of saints, kings, and Ango-Saxon worthies at Ripon Cathedral in North Yorkshire. From left to right are Saint Augustine, Saint Mary, St Columba, Saint Cuthbert, St Aidan, Eddi, Saint Oswald, and Caedmon.

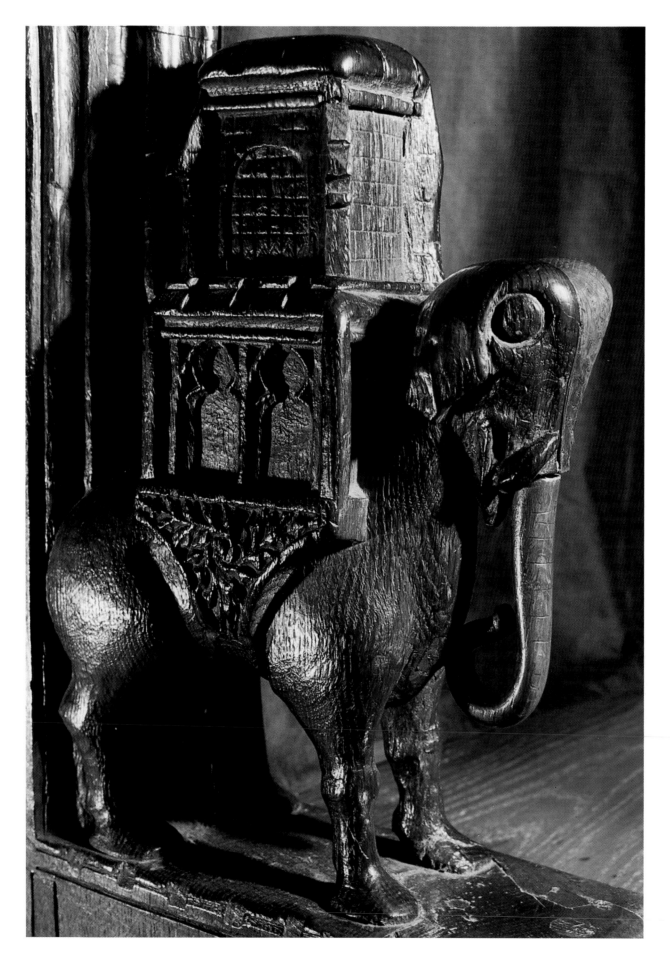

OPPOSITE *This hand-carved choir bench-end of the Elephant and Castle dominates part of the choir in Chester Cathedral.*

RIGHT *The* Crowned Madonna and Child *is in Nairobi Cathedral, Kenya.*

The starkness of the crucified Christ is the emphasis in the austere sanctuary of Saint James, Capitol Hill, in Washington, D. C. Carved in prewar days in Oberammergau, Germany, it was for years a familiar sight on the facade of the church before being moved inside when the parish was given a modernistic iron facade figure of Christ the King.

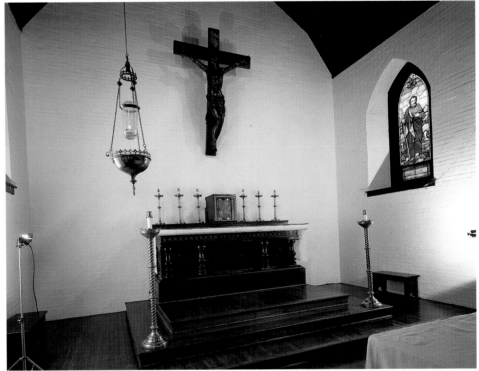

OPPOSITE *This massive reredos was moved to Christ Church, in a suburban area of Manchester, when the Church of Saint Edward, King and Martyr, was demolished in 1984. The reredos was designed by a prominent architect of the 1870s, G. F. Bodley.*

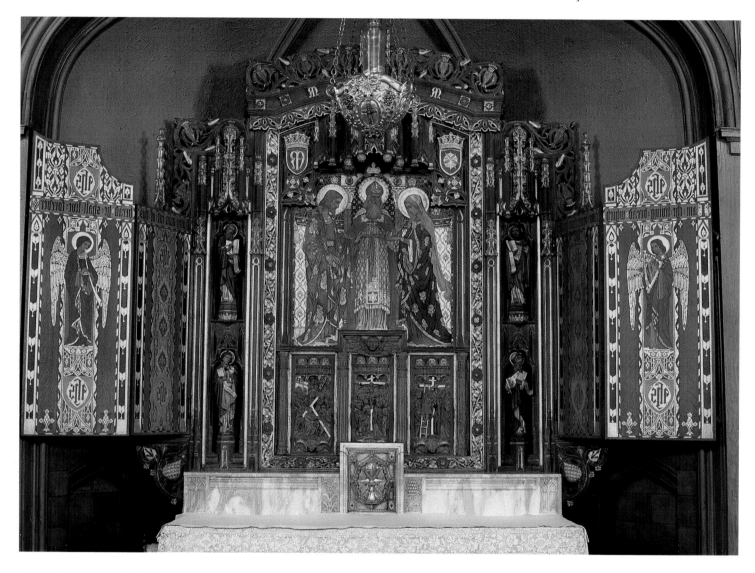

At New York's Church of the Transfiguration ("The Little Church Around the Corner"), what was originally a schoolroom in the 1850s was set aside as the Bride's Chapel in 1926. The lower central portion of the polychromed rereodos is inset with three rare carvings of black oak brought from a dismantled Scottish monastery. The painting is The Betrothal of the Blessed Virgin and Saint Joseph.

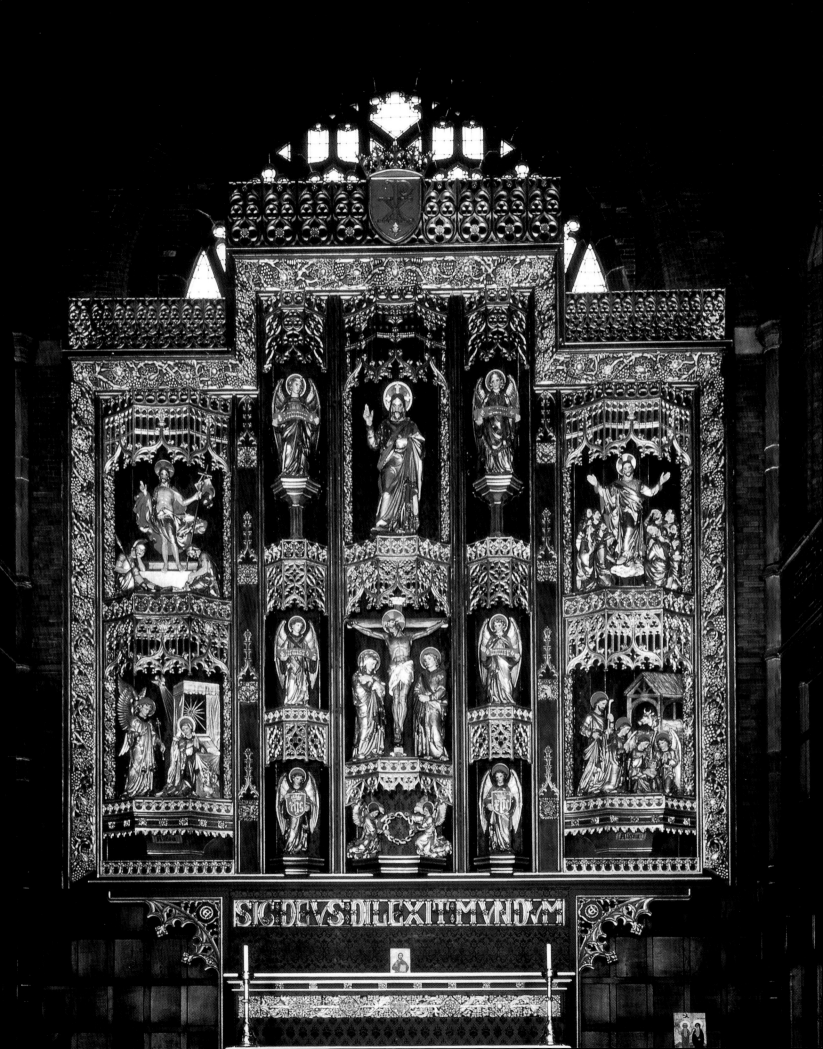

SIC DEVS DILEXIT MVNDVM

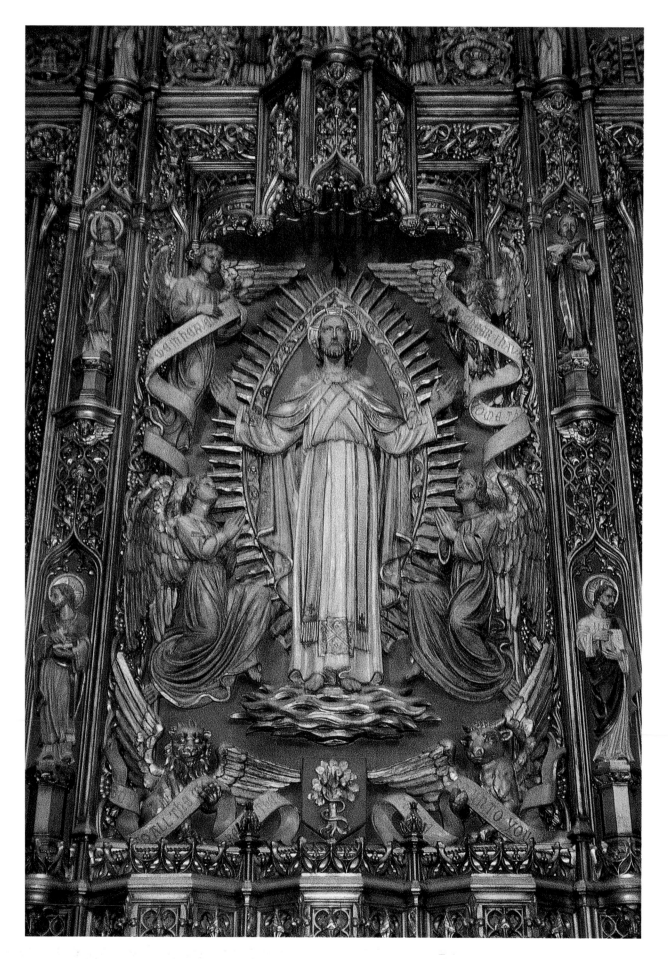

OPPOSITE *The Risen Christ in Glory is at the center of the high altar designed by Ralph Adams Cram for Saint James at Madison Avenue and 71st Street in New York. The Savior walks above the waters and beneath is an* arbor vitae, *the tree of life that symbolizes the Resurrection.*

RIGHT *The grouping around Christ the King above the fourteen-foot altar of Saint Columba's Church at St Catharines, Ontario, Canada, was designed by Faith Craft, London, in 1960. The Virgin Mary is at left, Saint John at right, and Saint Columba beneath.*

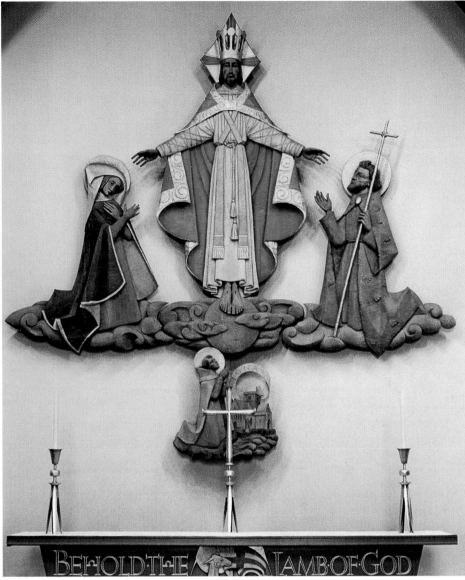

A wide border of carved open work interwoven with symbolic ears of corn and a grapevine, surrounds the reredos at Grace Church, Colorado. Dedicated in 1927, it is the work of Alexander Pelli who did similar wood carvings in Washington National Cathedral.

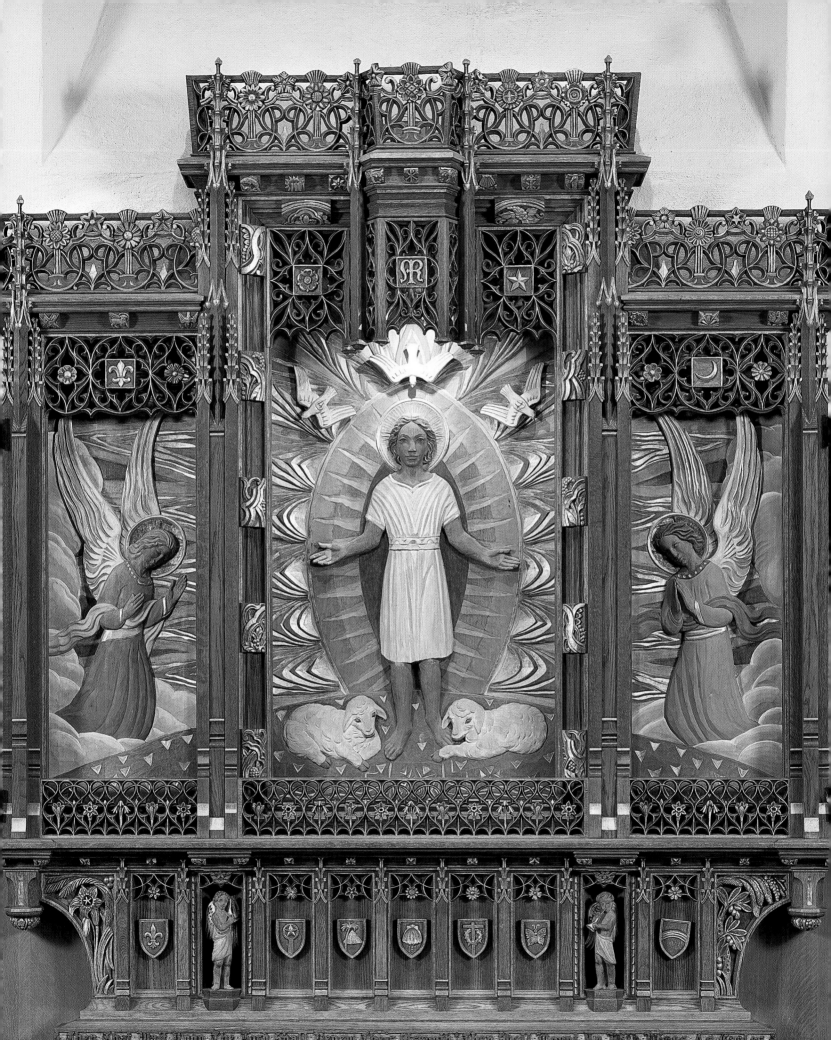

OPPOSITE *Sunday School children at Christ Church, Christiana Hundred, Greenville, Delaware, worship at an altar with a nine-paneled triptych carved in Germany by Thorsten Sigstedt and painted in the United States by Louis Ewald. It was given in 1953 by Mary Chichester du Pont Clark in memory of her son, Richard Chichester du Pont.*

At the recently completed Saint Andrew's Cathedral in the Minato-Ku section of Tokyo, an unusual figure of Christ the King, crowned and clad in gold, is suspended above the nave.

A crown of thorns is at the center of the altar cross at Saint Alban's, the English-speaking parish next door to Saint Andrew's in Tokyo.

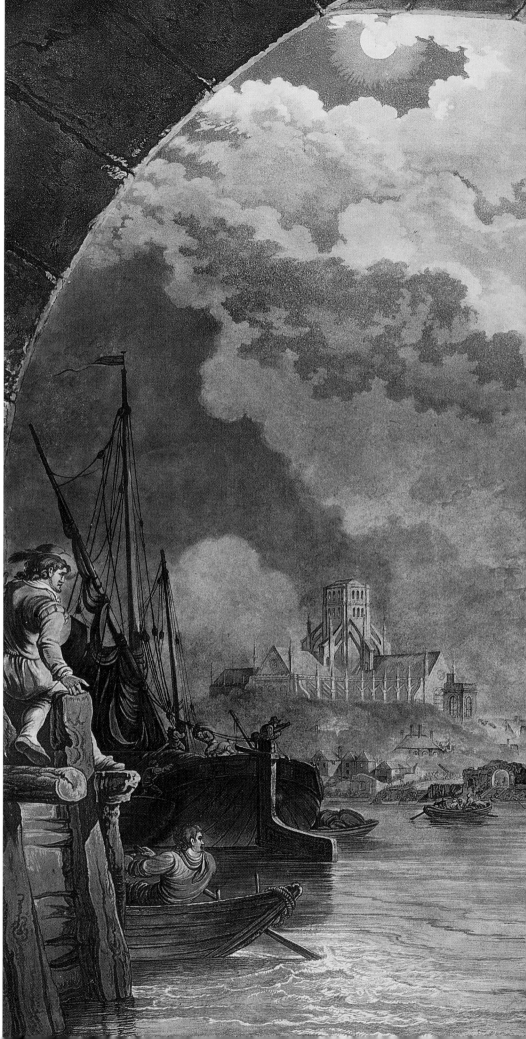

Anglican Life

J. C. Stadler's 1799 engraving of
The Great Fire of 1666 *was aquatinted
by Philippe Jacques de Loutherburg and
hangs in the Guildhall Library in London.
It captures the desertion of the city as raging
flames consumed Saint Paul's Cathedral,
the fourth built on Ludgate Hill since 604.
Within the year of the fire, Sir Christopher
Wren was asked to design the great domed
edifice that was to become a symbol of
indomitable London.*

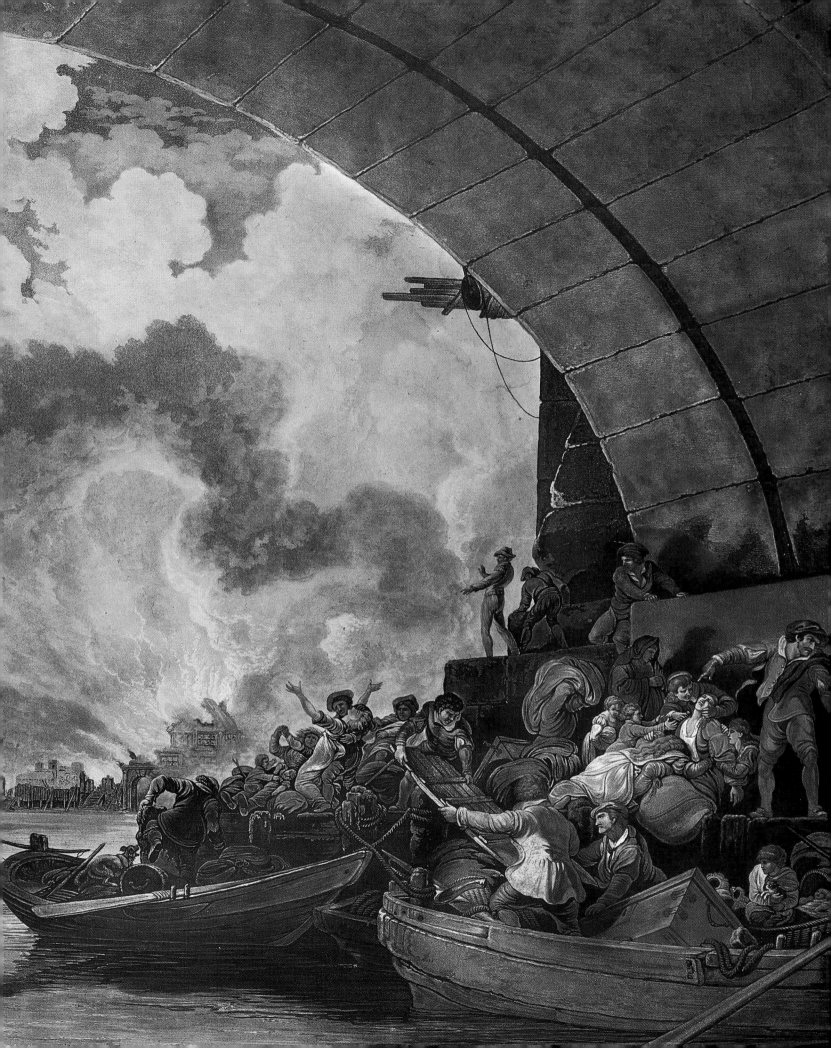

At the fifteenth-century Church of the Holy Trinity, Blythburgh, Suffolk, a bearded bell-jack in red hat, armor, and tights is ready to sound a bell when a preacher in the pulpit goes on for too long.

OPPOSITE Among William DeHartburn's few oils (he died at age thirty-seven in 1870) is The Christening set in 1868 in Grace Church on lower Broadway in New York. Purchased by the Knoke Gallery of Atlanta, Georgia, in the 1970s from an estate in Palm Beach, Florida, it was placed on loan to the Greenville County Museum of Art, Greenville, South Carolina.

T he foregoing pages have mainly concentrated on sacred figures in Anglican art. Now we turn to Anglicans in art, following them from birth to death, from baptism to burial.

As might be expected, if not forgiven, Anglican congregations have traditionally been well educated, wealthy, with impeccable social standing, a dubious distinction that, even if correct, it is fast losing. Truth to tell, Anglicans are not always well-heeled, nor is Anglican art without a note of humor: witness the monkey funeral in ancient glass at York Minster and the bell-jack to keep sermons mercifully short.

Whether for a Sunday Mass, a coronation at Westminster, or an enthronement at Canterbury, the choreography of great services has made Anglicans famous for mostly letter-perfect exactness of ceremonial under the sharp eyes of a master of ceremonies. Only at George VI's coronation was Archbishop Lang confounded to discover that some lackey had removed a tiny red thread that indicated the *front* of the crown with the result that King George was nearly crowned backward.

It could change tomorrow, but for centuries Anglican services have begun *exactly* on time with a clear understanding, for those in procession, on whether to turn left or right, to sit or stand, and who to bow to or

when to bow to dignitaries. Nowhere are those unwritten rubrics more evident than in an archbishop's enthronement. Yet a veteran acolyte, examining a photograph of deacons and priests crowding in from the sidelines in Trinity Chapel to witness an archbishop taking the oath of office, was heard to exclaim, "Clergy can be very *naughty*, you know."

In step with English custom, Anglicans have always commissioned portraits of its worthies—a few rectors, some deans, and many bishops. The most distinguished galleries are at Lambeth Palace, the London residence of Canterbury's archbishops since the twelfth century. From the walls of the Guard's Room, several scores look down, stern, ascetic faces, pale, tight-lipped, tranquil in the various robes of offices. William Laud, 1573-1645, was painted by Vandyck, looks down on visitors—as does William Warham, 1450-1532, as seen by Holbein. Twentieth-century holders of the office march down the palace's central corridor, colorful academic hoods resting lightly on their shoulders, billowing sleeves of enough lawn for a tent for a Billy Graham crusade.

Lastly, the paintings and pictures of Anglican life bring us full circle from its early days to a familiar scene in which a senior acolyte douses the candles at a High Altar, the walls still echoing with the dismissal, "Go in peace to love and serve the Lord."

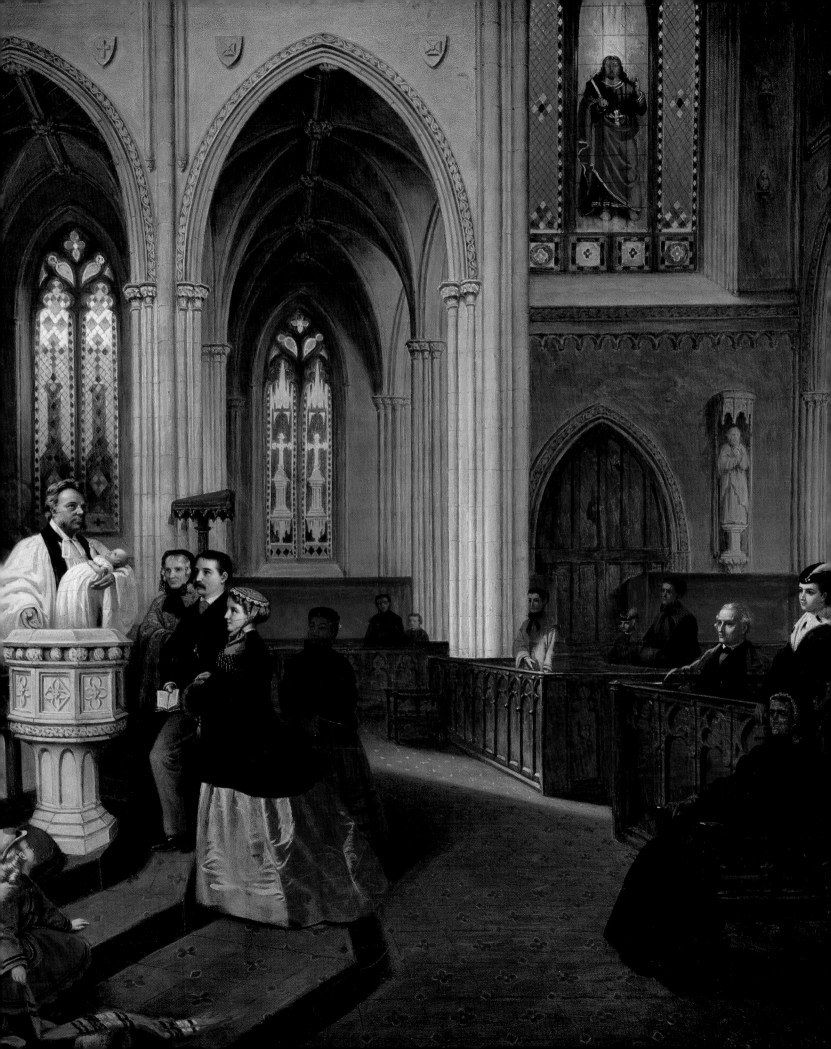

The snowy night scene of King Charles I's burial party approaching Saint George's Chapel, Windsor, in 1649. A long quarrel with Oliver Cromwell had led to the king's beheading. This was painted by Ernest Crofts in 1907. It hangs at the Bristol City Art Gallery and Museum.

The wedding of George Washington and Martha Custis, 6 January 1759, as imagined nine decades later by Junius Brutus Stearns, was recorded in the parish register by the rector of Saint Peter's Church, New Kent, Virginia. The spacious background in the painting suggests, however, that the ceremony was at her home, not at Saint Peter's. Acquired from the Abbot family of Richmond, Virginia, it was given to the Virginia Museum of Fine Arts, Richmond, by Bernice Chrysler Garbisch, and her husband, Edward William Garbisch, in 1950.

Prince Albert's red coat is the single note of color in Sir George Hayter's painting of the wedding of Albert and Queen Victoria at the Chapel Royal of Saint James's Palace, London, 10 February 1840. The officiant was the ninetieth Archbishop of Canterbury, William Howley. The portrait hangs at Kensington Palace, London.

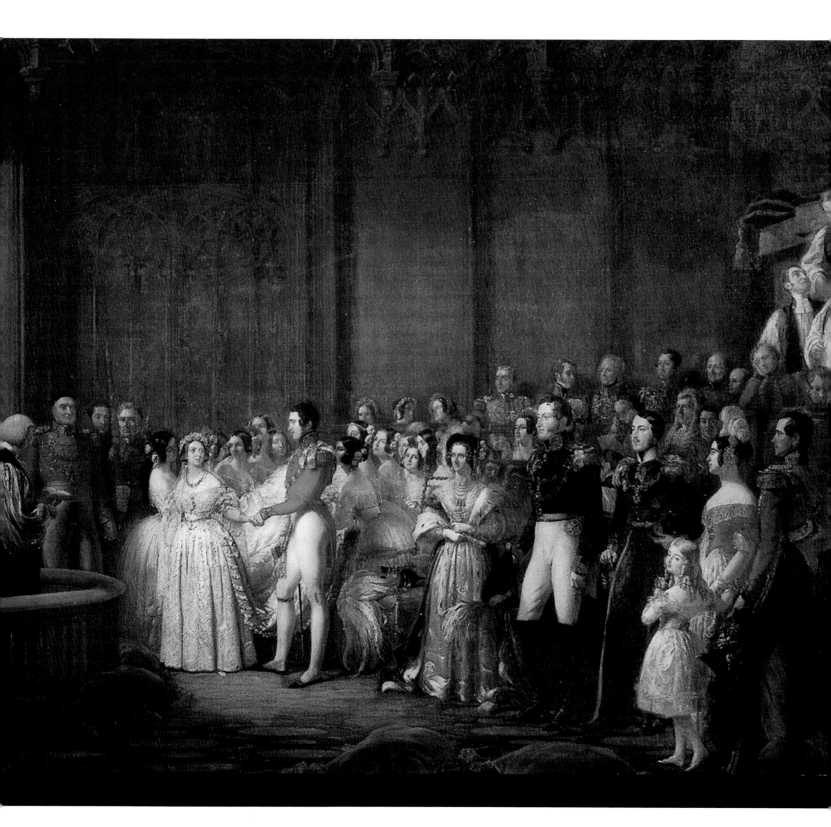

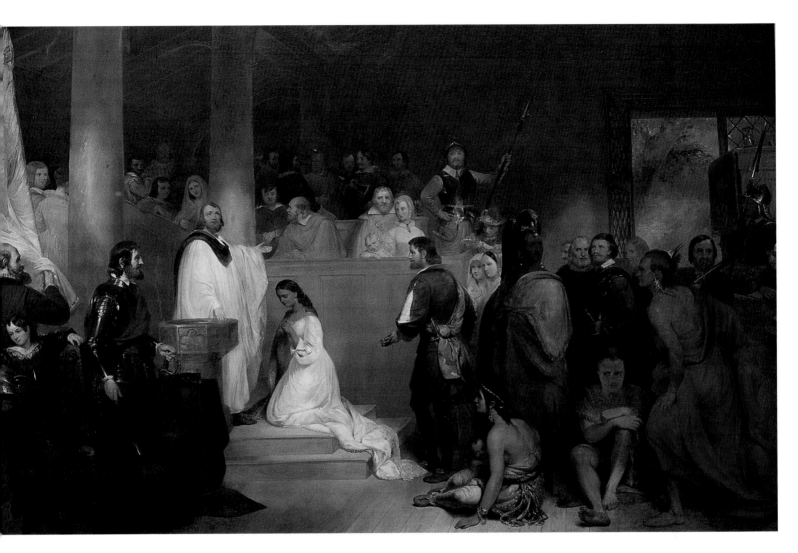

John G. Chapman's 1840 Baptism of
Pocahontas at Jamestown, Virginia,
*1613 in the U. S. Capitol rotunda, recalls
the role of the Indian princess in successfully
bridging a relationship between her people
and the colonists.*

The Lord Moves West, *ca. 1972, is by the Hungarian-born Lajos Markos. He came to the United States in 1952 and moved to Texas twenty years later. His scene of a celebration of Holy Communion on the plains may be allegorical but it at least partially belies the humorous observation that the Old West was settled by rugged men and women while the Episcopalians came later by Pullman. After Markos's death in 1993, the painting was sold by a Dallas, Texas, gallery to a corporate collection that has since been dissolved; the present owner is unknown.*

The Village Choir *(1847) by Thomas Webster, who specialized in paintings of street scenes and children, hangs in the Victoria and Albert Museum in London.*

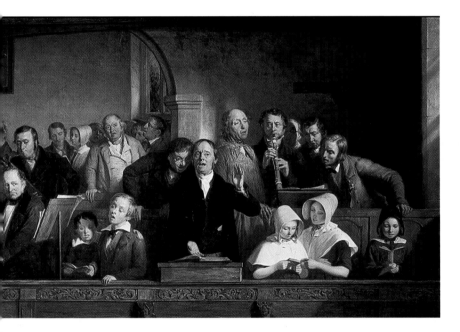

J. M. W. Turner's The Archbishop's Palace at Lambeth, *depicts a long-gone scene of the London area where the palace's brick gatehouse (at center) and the tower of the Church of Saint Mary-at-Lambeth still stand. Turner gave the watercolor in 1790 to a Bristol family, from whom it passed to five other owners before coming up for auction at Christie's in 1928 and in 1946. Once again on the auction block in 1968, at Thomas Agnew & Sons, London dealers in Old Masters, it was purchased by Indiana attorney Kurt F. Pantzer. He gave it as a family memorial, honoring his parents, to the Indianapolis Museum of Art in 1972.*

A *master in painting Parisian streets and boulevards, Jean Béraud portrays British and American expatriates in* After the Service at the Church of the Holy Trinity, Christmas 1890. *Holy Trinity cared for the picture during two World Wars. It was the centerpiece of a retrospective,* Béraud et le Paris de la Belle Époque, *held at the Château Bléraucourt in 1999. The Church was later renamed the Cathedral of the Holy Trinity, as the cathedral church of American Episcopal churches in Europe.*

The 6 x 10 foot painting of Commodore Vanderbilt's family, The Baptism, *painted by Julius Stewart in 1892, is owned by the Los Angeles County Museum of Art. "It is display painting about display people intended for a display-loving public," wrote* New York Times *critic Hilton Kramer. Fast-forward a few generations to Gloria Vanderbilt: She was baptized with fizzing White Rock soda from a silver bowl that a butler handed the bishop.*

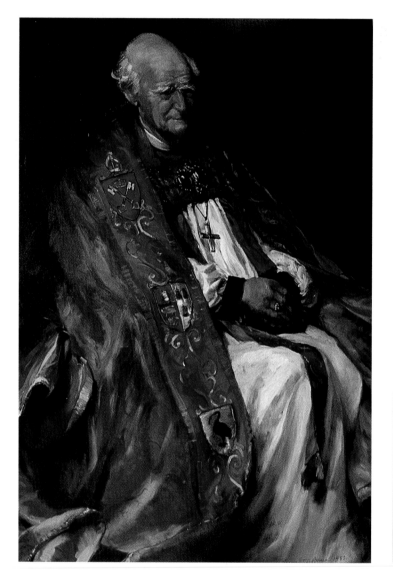

The hundredth Archbishop of Canterbury, Arthur Michael Ramsey, wears a 1961 gold and crimson enthronement cope that traced his life in the heraldry on its orphreys—adorned with (top to bottom), the coats of arms of York Minster, lecturer of Lincoln, and curate of Liverpool. The likeness is by George Bruce, R. A., who had painted Ramsey (in a cope with orange orphreys called "the shrimps"), at Bishopthorpe, the archiepiscopal palace near York. Clearly shown on Ramsey's right hand is the emerald and diamond ring, which Pope Paul VI stripped from his finger and pressed into Archbishop Ramsey's hand on 13 March 1966—at the conclusion of their unprecedented dialogue at the Vatican. The ring was given by Ramsey's widow, (according to his biographer), "into the keeping of Lambeth Palace."

OPPOSITE *In Taber Sears's*
The Consecration of Bishop Manning, *members of the episcopate crowd in for the laying on of hands that made William T. Manning their companion as successors to the apostles. It was the start of an eventful quarter century, 1921–1946, as tenth bishop of New York. The marble altar was later replaced and the old one moved to the crypt of the Cathedral Church of Saint John the Divine.*

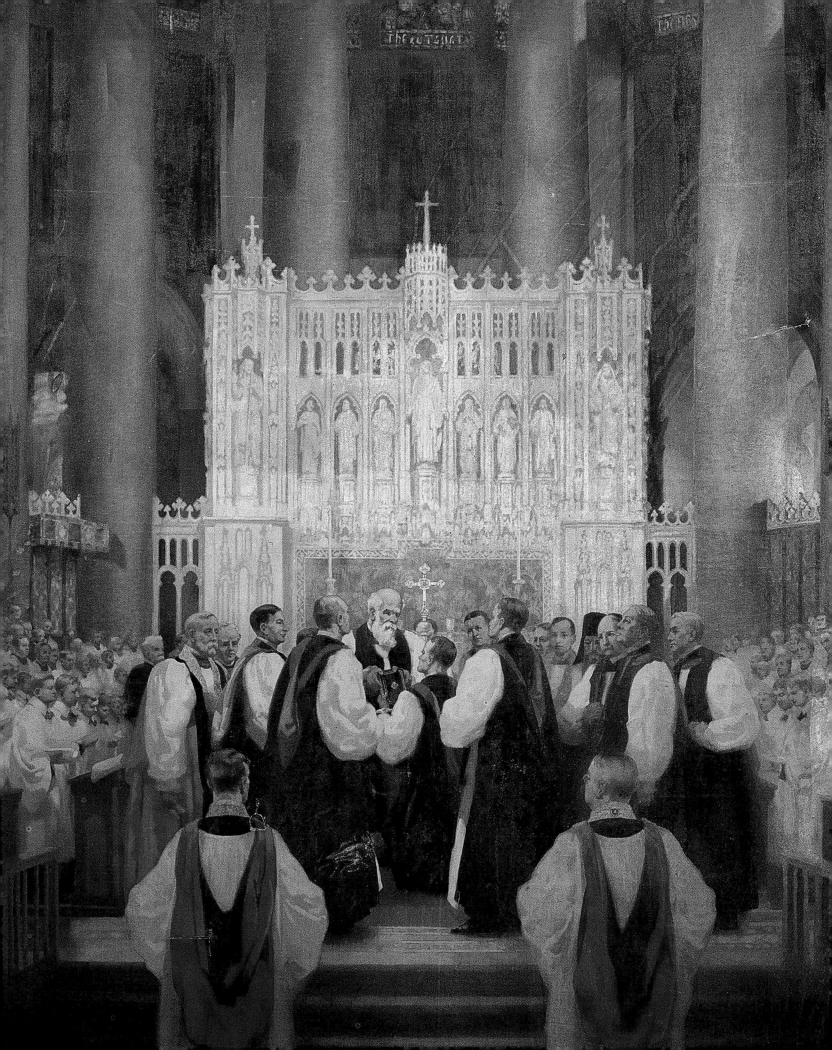

LEFT *The Church of Bethesda-by-the-Sea, Palm Beach, Florida, observes a Scandinavian custom relating to the deep by displaying a ship in petition for safe voyages and in thanksgiving for untroubled returns.*

OPPOSITE *Clean-cut and uncluttered Portsmouth Cathedral marks its many associations with the sea with a model of Henry VIII's flagship, the Mary Rose, suspended in the Navy Aisle in memory of its defeat of seven Algerian pirate vessels in 1669.*

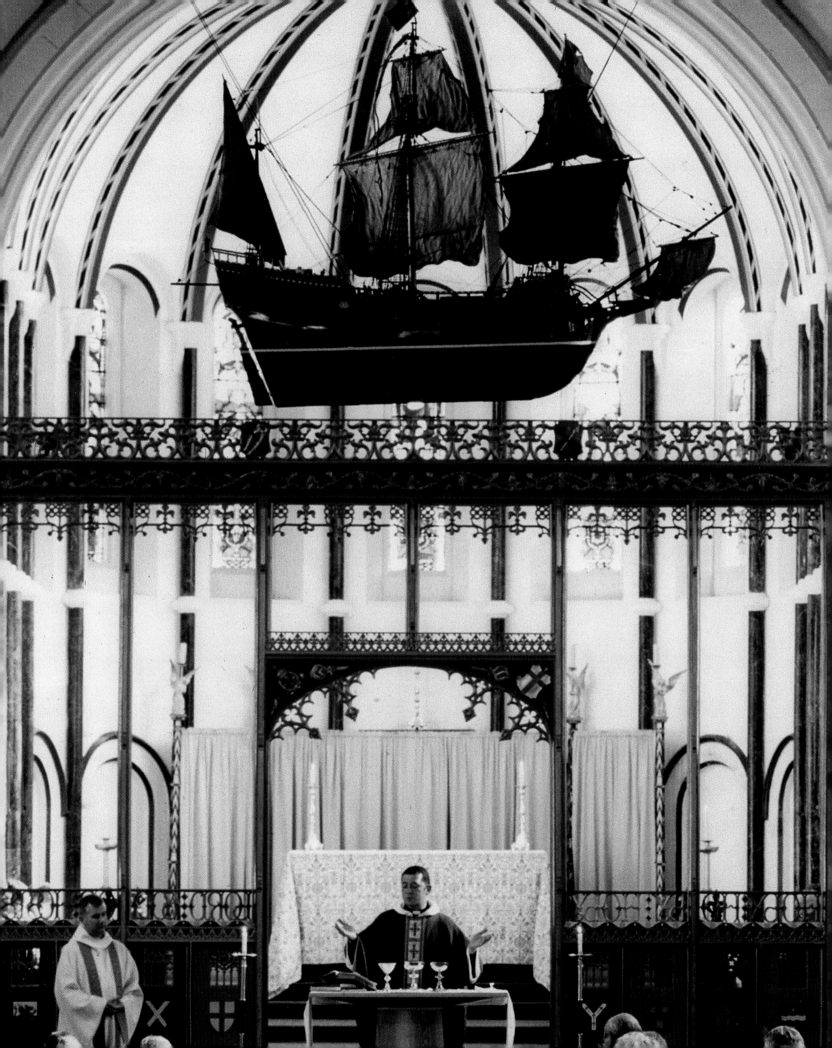

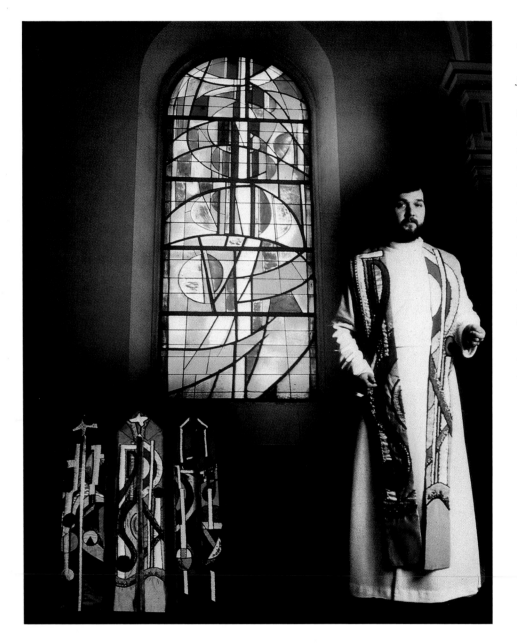

The abstract design of a stained glass window is repeated in the stole worn by a Church of England priest and in the altar frontal.

OPPOSITE *An acolyte extinguishes the last candle burning on the altar after a typical Sunday of Morning Prayer, Low Mass, two High Masses, and Benediction of the Blessed Sacrament at Saint Paul's Church, K Street, Washington, D. C. To the right of the Calvary group and tabernacle, figures in the reredos are (above), Saint Cyprian and Saint Athanasius and (below) Samuel Seabury, the first American bishop, and Alfred Harding, former rector of Saint Paul's, who became the second bishop of Washington, D. C. (1909–1923). The frontal is from the studio of the late Katherine Morgan Terry, Bordentown, New Jersey.*

INDEX

ILLUSTRATION CREDITS

In addition to the individuals below, all photography is courtesy of the Cathedrals, Chapels, Churches, and places from whence they came.

Antonia Reeve Photography, 130–31
Art Mark, Inc., 209
Ashworth, Gavin, 78

Beavis, Trevor, 180–81
Buck, June, ©Country Life, 140 top
Bloom, Mary, 40, 54 top, 141, 144, 145, 176, 177, 215
Bridgeman Art Library:
 Cover, by courtesy of Dean & Chapter of Westminster Abbey, UK; 10, © Courtesy of the estate of Leonard Campbell Taylor/Private Collection; 34 bottom, Convent of the Holy Name, Malvern Link, Worcestershire, UK; 114, Isabella Stewart Gardner Museum, Boston, Massachusetts, USA; 118–19, Victoria Art Gallery, Bath and North East Somerset Council; 200–01, Guildhall Library, Corporation of London, UK; 204–05, Bristol City Museum and Art Gallery, UK; 210, Victoria and Albert Museum, London, UK
Brosier, Jim, 159
Buchman, Tim, 170

© Canterbury Museums, 3
Clarkson, Frank, 178–79
© Country Life, 14–15
Cox, Whitney, 129

Echelmeyer, Rick, 198

Field, Elizabeth, 28 right
Fiennes, Mark, 17 top, 55, 107, 125, 174, 202
Francis, Donald, 137
Franck-Simon and Gardère, 149 bottom

Guiata, Ovidio, 31 left
Grace Cathedral Archives, 183

Hannau, Michael, 8, 102–03, 103 right, 216 top
Harvey, Nancy, 18–19 top
Howell, Herbert, 152

Jarrold Color Publications, 112
Jeff Krausse Photography, 128

Kovacik, Steven © Indianapolis Museum of Art, 210–11

Lampen, M., 51
Little, Christopher, 117 right

Manchester City Art Galleries, 108 left
Marks, Donovan, 101 top, 146 left
Marks, Herbert, 80 bottom
Maroon, Fred J., 208

O'Toole, Steve, 43 (with John Woo), 135 bottom, 168 top, 185
Overall, John E., 124

Rosenthal, James, 6, 20, 52, 57, 75, 104–05, 159, 214
Ross, John G., 5

Shiffner, George © Liverpool Cathedral, 23
Smith, Christine, 90–91

Taylor, John Bigelow, 2
Thompson, Thom, 33, 133

Vanderwarker, Peter, 100

Walsted, Father John H., 50, 58, 59
Warren, Andrew, 136
Woo, John, 32, 39, 41, 42, 43 (with Steve O'Toole), 48–49, 53, 89 top, 101 bottom, 140 bottom, 188 top
Wood, Rick, 116
© Woodlawn (a property of the National Trust for Historic Preservation), 206 left
Photo Copyright Woodmansterne 17 bottom, 22, 26, 27, 28 bottom left, 29, 35, 38 bottom, 46, 47, 60–61, 63 (courtesy Keble College, Oxford), 64, 68, 73, 85, 88–89, 89 bottom, 92, 94–95, 95 right, 106, 108–09, 115 bottom, 156–57, 163, 167, 187, 192, 216 bottom

Young, Tom, 30, 31 right, 36